PATINA

300+ Coloration Effects for Jewelers & Metalsmiths

PATINA
300+ Coloration Effects for Jewelers & Metalsmiths

Matthew Runfola

INTERWEAVE.
interweave.com

A QUARTO BOOK
Patina: 300+ Coloration Effects
for Jewelers & Metalsmiths

interweave.com

Published in North America by
Interweave Press LLC
201 East Fourth Street
Loveland, CO 80537-5655
www.interweave.com

Conceived, designed, and produced by
Quarto Publishing plc
The Old Brewery
6 Blundell Street
London N7 9BH

QUAR.GMP

Project Editor: Chelsea Edwards
Designer: Hugh Schermuly
Photographer: Chris Schneberger
Copyeditor: Sarah Hoggett
Proofreader: Sally MacEachern
Indexer: Helen Snaith
Picture Researcher: Sarah Bell
Art Director: Caroline Guest
Creative Director: Moira Clinch
Publisher: Paul Carslake

Library of Congress Cataloging-in-
Publication Data not available at time
of printing.
Includes index.
ISBN 978-1-62033-139-2

Color separation by Pica Digital Pte Ltd,
Singapore
Printed in China by Toppan Leefung,
China

10 9 8 7 6 5 4 3

1

contents

4 5

CHAPTER 4

CHAPTER 5

CHAPTER 6

Introduction

ABOVE RIGHT: **MATTHEW RUNFOLA**
From above
Color and color pattern take center stage on this wall hanging (90 x 42in/229 x 107cm), transforming a static two-dimensional triptych into a flowing continuum. The use of masked and layered patinas, pigments, and dyes give visual depth and a sense of movement to the panels.

In 2003 I was in my second year of what now has been a 12-year teaching position at the Evanston Art Center, located just north of Chicago, Illinois. The Metal Sculpture Department had a rebirth of sorts, and we were looking to expand the courses we offered our students. Most in our shop were working with fabricated steel and looking for finishing alternatives to rust, paint, or bare metal. I brought in Ron Young of Sculpt Nouveau to teach a ferrous metal finishing workshop at the school. This is how I became involved in the world of metal patination.

For me, patination is the right balance of science and art and it satisfies my dual-minded persona. Though I trained as a mechanical engineer I decided to delve into art full-time to better fulfill my creative ambitions. I enjoyed playing "mad" chemist with the various colorants while applying them in a meaningful, artistic manner to my objects. I immersed myself in the field: reading, sharing with other artists, and experimenting. For a time, metal patination was the most important part of my work. My fabricated forms were merely a vehicle or surface to display the colorations on. I became, and still am, a painter with chemicals. I love the ability to be expressive not just with the form, but with the finish as well. In 2004 I launched Runfola Studios, which focuses on patinated contemporary metal furnishings and accessories.

Today, I continue to teach, create, exhibit, and sell both sculptural and functional objects and perform metal finishing services for other artists and artisans. I teach metal finishing workshops that focus on the fundamentals of the patination process, with methods to personalize the colorations to the object at hand. I hope I have achieved those same goals in this book. Happy patinating to you all!

Matthew L Runfola

About this book

Structure
Chapter 1: Metal coloration in context
There are a multitude of different patination and coloration effects that can be applied to metals. This part features examples of work by the best jewelers and metalsmiths working with colored metals, and compares their methods and approaches.

Chapter 2: Safety, tools, and workspace
An in-depth discussion on the tools and equipment used for metal colorations, and how to set up a safe and efficient workspace.

Chapter 3: Aesthetic decisions
This chapter delves into the many factors influencing the metalsmith's decision about what coloration to use.

Chapter 4: Choosing and controlling coloration methods
Numerous elements can influence the overall outcome of the coloration result within the basic process chosen. Runfola covers the variables that can be controlled, easily or not so easily, so the jeweler can obtain the overall look and feel he/she requires. The base metal composition and surface quality, the coloration and application methods chosen, and the final metal protection method are covered.

Chapter 5: Surface preparation and colorant application
This section discusses and compares the most common, accessible coloration techniques, including patinas, pigments, dyes, and heat tempering, with notes on durability of each finish. The core techniques for applying coloration to the metal surface are explained using large format step-by-step pictures. Health and safety is an important aspect of these techniques and precautions that should be taken for each technique are fully explained.

Chapter 6: Patination directory
The patination directory chapter contains more than 300 colorations and is organized firstly by metal (nine in total) and secondly by general color. The numbers following each coloration name cross-refer to a recipe formula. The complete listing of formulas can be found on pages 242–249.

Colorant formulas (pages 242–249)
This section contains a listing of all the colorants used in the tile directory. Colorants are a combination of simple chemical formulas, branded pre-mixes, and household ingredients to allow for a broad spectrum of metal colorations on each of the seven metal families.

From chapter 4: Choosing and controlling coloration methods (pages 52–69)
Different coloration methods are compared in this chapter to enable choices to be made.

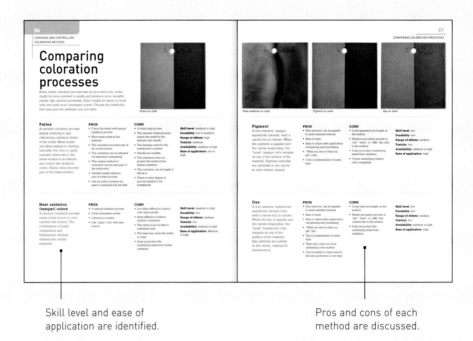

Skill level and ease of application are identified.

Pros and cons of each method are discussed.

From chapter 5: Surface preparation and colorant application (pages 70–105)
This is a comprehensive guide to applying reactive and non-reactive colorants. Using step-by-step photography, the author demonstrates surface preparation and various hot and cold application techniques.

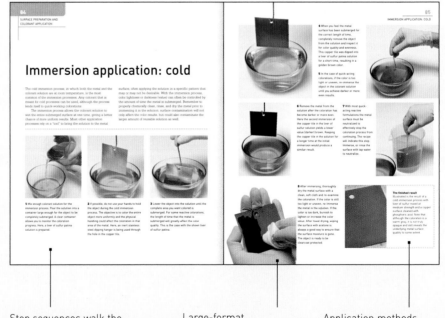

Step sequences walk the reader though all the various application methods.

Large-format photographs show exactly what is going on in the processes.

Application methods demonstrated on metal tiles.

From chapter 6: Patination directory (pages 106–241)

Each metal has an introductory essay that describes the metal's use in arts and crafts, both historically and in contemporary practice.

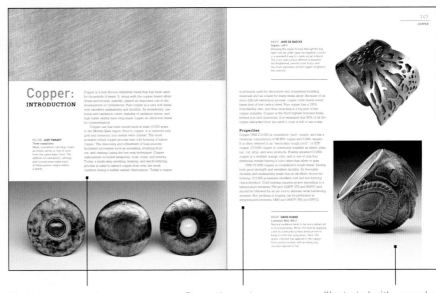

Technical data such as composition, specific gravity, melting temperature, strength, and durability.

Properties and applications, how well a metal takes a patination.

Illustrated with examples of works by artists using patination.

From chapter 6: Patination directory (pages 106–241)

Within each metal category, tile samples are organized by color.

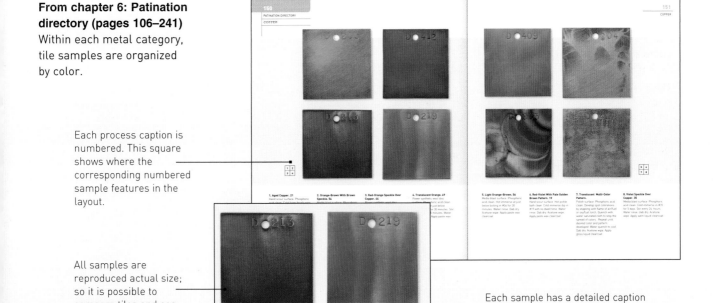

Each process caption is numbered. This square shows where the corresponding numbered sample features in the layout.

All samples are reproduced actual size; so it is possible to compare tiles and see the beauty and textural qualities of the surface.

Each sample has a detailed caption identifying: the recipe used (each recipe is numbered and can be found on pages 242–249), the surface preparation, application method, finish; and other pertinent information about the process.

Metal coloration in context

Jewelers and metalsmiths have always considered color an important aspect of their work. Coloration, whether it is simply the raw metal surface, or achieved through natural oxidation or chemical patination, can be used to enhance the form. This chapter showcases a collection of objects in various metals demonstrating the beauty of metal coloration.

Coloration gallery

Jewelers and metalsmiths have always had a strong relationship with color. From the raw beauty of precious metals to the natural colorations available through patination, metal artists have used color to affect the viewer's perception of the object. Contemporary artists are no different in their thinking, but may push traditional norms. Today, jewelers and metalsmiths are continually broadening their color palettes and methods used for coloring across a larger spectrum of materials. However, color has been, and will always be, used as a means for expression.

As the cost of precious metals continues to rise (namely, silver), many metal artists are looking to alternative metals and materials for construction. Jewelers and metalsmiths are increasing their use of less expensive copper, brass, bronze, aluminum, stainless steel, and steel. The use of these "non-precious" materials opens up the possibility to employ more surface color to add to the object's expressiveness. Not only are there more reactive colorations available with some of these metals, but there is less risk in allowing the surface color to override the material in importance. This is not as true with gold and silver, where the perceived status of the work comes in large part from identifying the precious metal itself.

The aesthetic finish of a piece is not reflected merely in the finished coloration, it is also coupled with the application process. Just as two-dimensional artists have always done, metal artists are purposefully choosing application methods that give the overall coloration the desired "feel" of the piece. The color application methods are used to further create visual interest and expression on the object's surface.

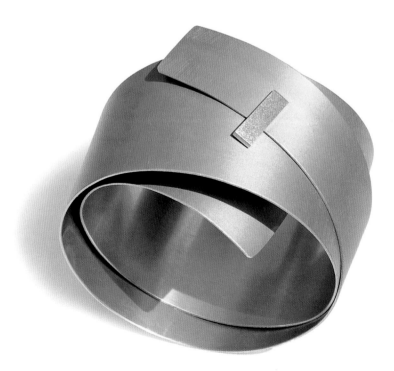

RIGHT: **HELEN SWAN**
Aluminum cuff 2
A uniform anodized coloration has been applied to this single strip of aluminum. The elegant wrap is held in place with a contrasting strip of bare silver. Color can be used to complement a form and bring about a sense of fashion or style.

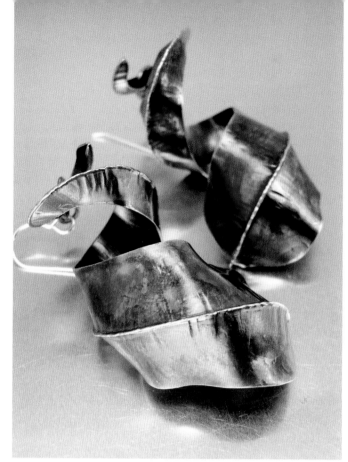

LEFT: **MELODY ARMSTRONG**
Freeform earrings
The multi-colored reactive coloration used on sterling silver complements the fold-formed, spiral structure. In this work, both the form and the color appear to be constantly in motion.

BELOW: **REBECCA HANNON**
Telephone line earrings
The addition of a dark coloration to a form can help add visual mass to an otherwise delicate form. The sterling silver birds and wire have a sense of being silhouetted on a summer's evening.

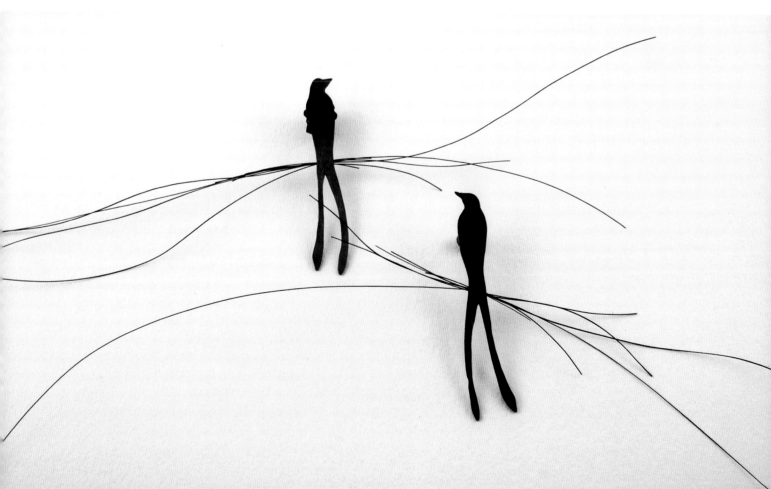

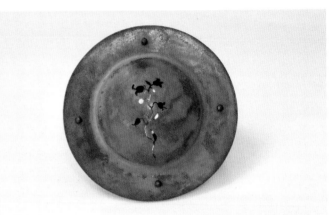

ABOVE: **KATJA FOX**
Finger rings and brooch
Having multi-layered, non-uniform patina colorations give these objects the feeling of having been untouched for centuries or unearthed from a lost civilization. Browns and blue-greens are classic natural patinas on copper.

RIGHT: **DOMINIQUE BRÉCHAULT**
October
The heat temper coloration on the copper leaf serves not only to differentiate the lid from the natural sterling silver box, but the reds and blacks give a sense of autumn and the feelings associated with it.

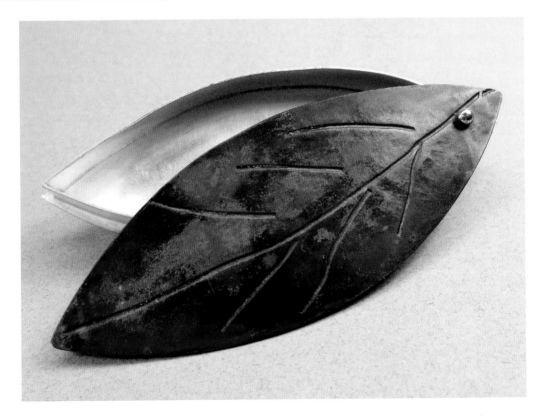

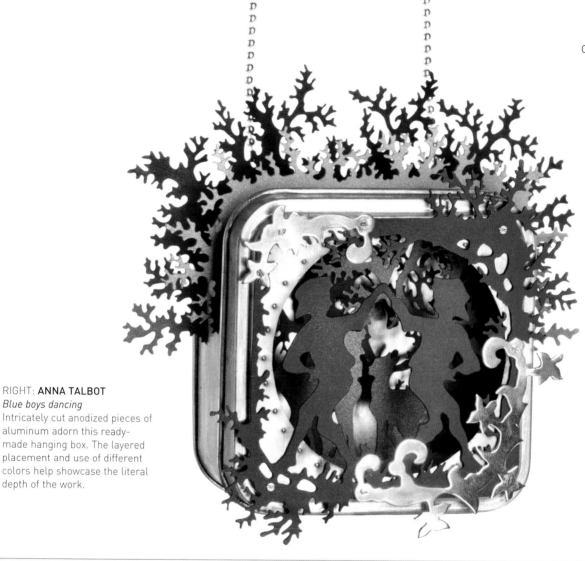

RIGHT: **ANNA TALBOT**
Blue boys dancing
Intricately cut anodized pieces of aluminum adorn this ready-made hanging box. The layered placement and use of different colors help showcase the literal depth of the work.

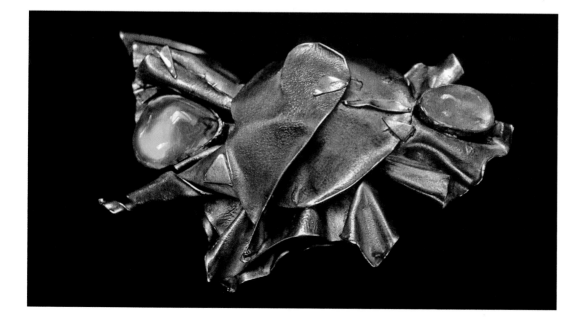

LEFT: **RUTA BROWN**
Amber and labradorite brooch
Using a reactive patina to darken and subdue the sterling silver allows the eye to be drawn to the warm, amber stones and gold detail of this brooch. Proper use of colorations can help showcase key elements of the object.

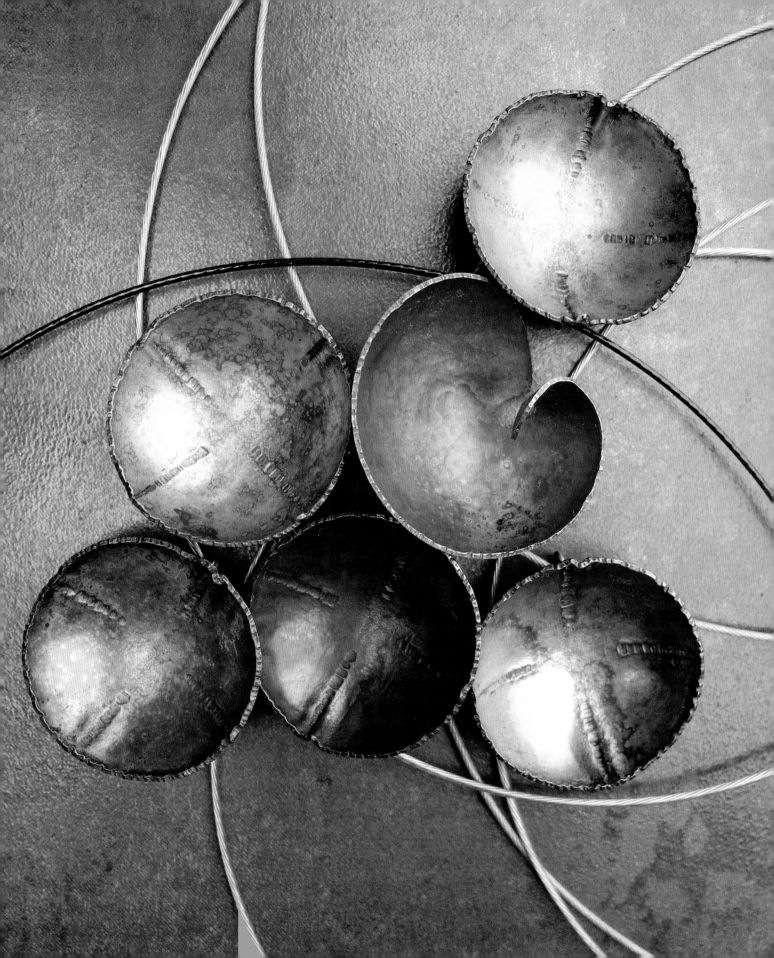

LEFT: ANN BRUFORD
Wave and wort pendant
Iridescent colors are achieved here with heat temper oxidation of the copper metal. Similar forms can be individualized with the use of different colorations.

RIGHT: LIETA MARZIALI
Cuff
For many metals, a torch heat source can bring about the most varied metal colorations. From surface effects to colorations, the torch can be used to "draw" finishes directly on the metal. The vibrant heat temper red, offset with the black texture is a striking look for this copper cuff.

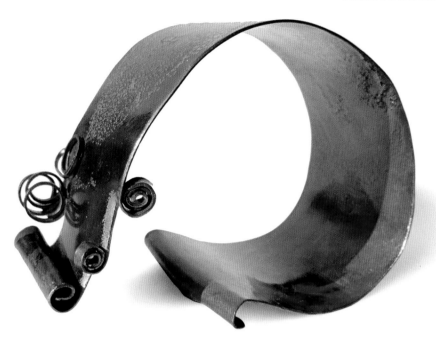

RIGHT: CHRIS & JOY POUPAZIS
"Creatures" pendants
Varying the colorations across a series can create an entirely different feel from one piece to another. The sterling silver pendants with a blackened patina have a more classical feel compared to the multi-colored pendants, which are more playful and full of energy.

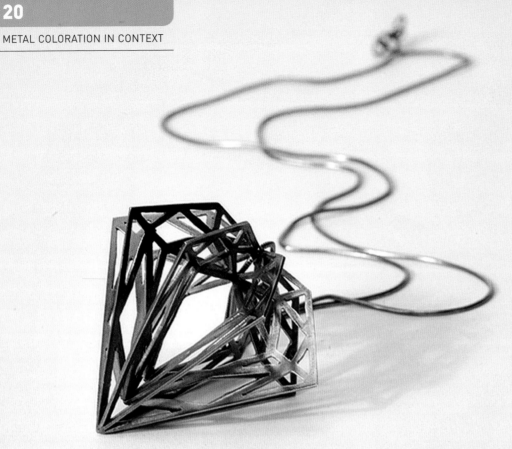

LEFT: MYIA BONNER
Classic diamond pendant
Use of differing colors or color values within a piece can help visually distinguish elements or layers for the viewer. With this silver necklace, each plane used to create the object's diamond shape is identifiable with the help of unique values.

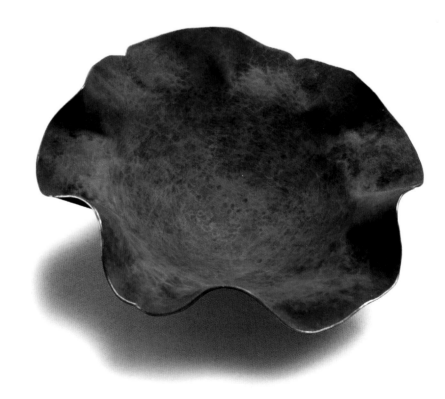

RIGHT:**DOMINIQUE BRÉCHAULT**
Water
This patinated copper bowl is another fine example of the form and coloration working together in harmony. The undulating rim coupled with the blue-green coloration evokes a sense of movement in nature. The burnished edge, exposing a line of the copper around the rim, helps visually define the shape.

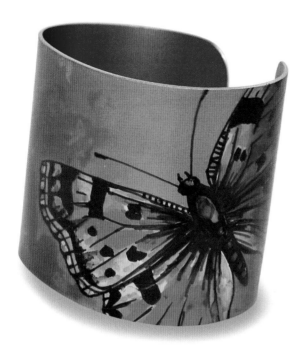

LEFT: **CLAIRE GENT**
Tortoiseshell butterfly cuff
Colorants can be used to draw or paint directly on the metal surface. With this aluminum cuff, a representational butterfly was drawn on the surface then layered with anodized soft red and violet dyes to complete the composition.

RIGHT: **MELODY ARMSTRONG**
Lines and rivet earrings
Simple square forms are livened up with the addition of a reactive colorant applied over masked areas of the sterling silver surface. The underlying silver serves as a nice contrast to the translucent blue.

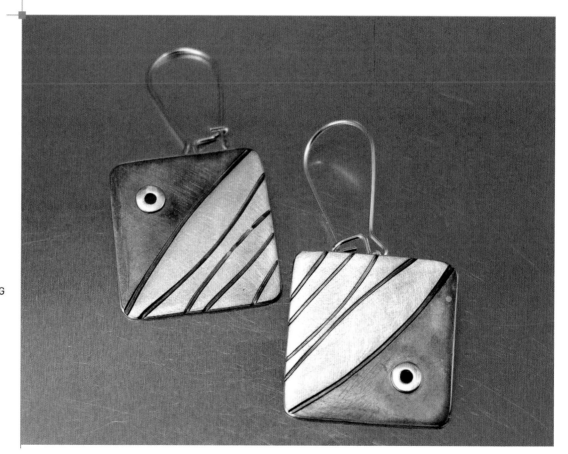

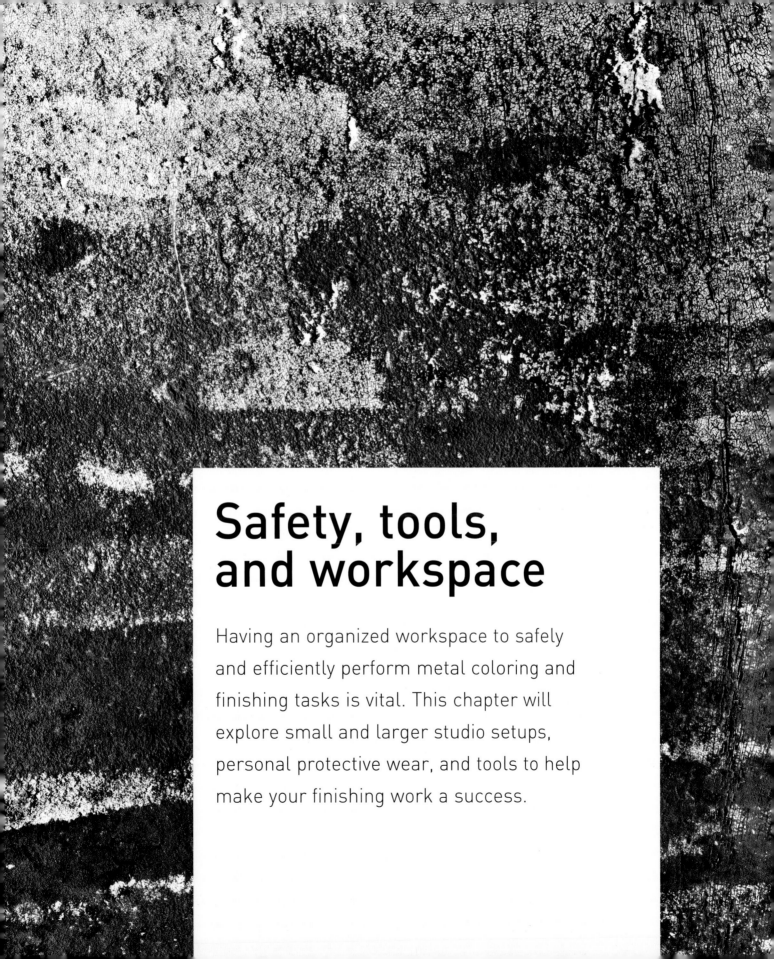

Safety, tools, and workspace

Having an organized workspace to safely and efficiently perform metal coloring and finishing tasks is vital. This chapter will explore small and larger studio setups, personal protective wear, and tools to help make your finishing work a success.

Finishing studio layout

Having a dedicated metal finishing studio is ideal, but not a necessity. With proper attention to workspace setup, safe work practices, and proper chemical and flammable material storage, the metal fabrication and finishing areas can coexist.

When deciding on a metal coloration/finishing workspace, there are two primary concerns: safety and cleanliness. Everything else is a factor of convenience. Both safety and cleanliness require planning and spatial organization. Metal finishing can involve the use of flammable and corrosive chemicals to clean, color, and protect the metal surface. Both the application and storage of flammables such as acetone and solvent-based liquid and paste wax clearcoats need to be kept well away from any source of heat. Also, reactive colorant liquids and fumes are corrosive and are best kept away from forming and fabrication tooling. Finally, working in an area with as little chance for contamination as possible will give the best chance for quality metal coloration and protection results. Airborne particles from the metal cutting, manipulating, and joining processes can settle onto a developing or curing finish, causing blemishes.

The ideal setup

There are a few options for setting up a metal finishing space. The first is to have unique rooms for both the fabrication and finishing processes. This may not be feasible for most, but it is the most ideal. If individual spaces are possible, have one room set up for all the "hot" and "dirty" work—the cutting, manipulating, and joining of metal. This is the best space to perform all the mechanical cleaning operations of the finish process, and torch heat temper coloring in as well. All materials and supplies associated with the fabrication process should be stored in this room. The second room can then be devoted entirely to the "clean" operations of the metal coloration and finishing processes, from the chemical cleaning through the coloration (except torch heat temper coloring) and clearcoat protection steps. This room should house all the chemicals and supplies associated with the coloration and protecting of metal surfaces.

Dividing a single space

If the total workspace is more limited and confined to one room, the second spatial option is to "temporarily" section off

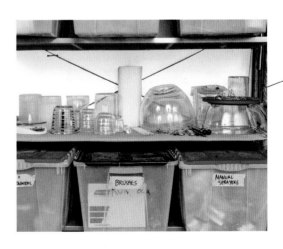

Tool storage area

Secondary work
surface/utility cart
(on castors)

Garbage

Fume hood

Plastic shower curtain
to section off finishing
area from fabricating
area as needed

Fresh air in

Window with
box fan

Chemical resistant
work table with heat
resistant surface
(on castors)

Fire extinguisher
(ABC)

First aid kit

Stool

Utility sink

Oxygen/fuel torch

Non-chemical
storage

Chemical
storage

ABOVE: **STUDIO LAYOUT**
This diagram shows an ideal
studio layout. The photographic
annotations help to show how
best to store tools and chemicals
in a safe and accessible way.

the space to create a separated fabrication area and a finishing area. A clear plastic shower curtain and rod system work well for this purpose as its transparency keeps the space feeling open, even when it's drawn closed. It's also inexpensive, easy to install, and the curtain is washable. Decide how much room you will need to work comfortably in each defined space before hanging the curtain rod. Ideally, the curtain should hang from floor to ceiling and completely stretch across the room width. Take great measures to physically separate the fabrication and finishing equipment, supplies, and processes within these defined areas, both for safety and contamination reasons. Treat each sectioned off area as if it were a separate room as discussed above. With awareness of heat, sparks, and flammables, the curtain can be opened and the space used as a whole when not performing finishing work.

Making a multi-use space

The third layout option again shares a room with the fabrication processes, however, unlike the option above, no sectioning off is done. This option is the easiest and the one most suited to very small workspaces, but is also the least efficient for working on multiple pieces at one time. Each time a metal coloration and finish process is to be done, the workspace needs to be transformed from a hot working, "dirty" space to a "clean" space. Fabrication tools and supplies should be mobile enough to move to one end of the area, opposite where the finishing will occur. Alternatively, and preferably, the tools and supplies should be removed from the space entirely. The studio should be swept clean. After the finish work is completed, the space must be set up again for hot work, with all finishing supplies ideally removed and stored in a different room completely.

Chemical and supply storage

It is essential that flammable chemicals used in the coloration and protection of metal surfaces are kept far away from any heat sources. Corrosive chemicals (airborne spray or fumes) should not be near tooling because it may cause them to rust over time. In general, it is best to store all finishing chemicals and supplies separately from the fabrication area, either well away in the same room, or stored in a separate room completely. Within that general guideline, there are other storage procedures that will make for a safer workspace.

It is best to keep chemicals stored and lidded in their original containers. If transferring chemicals to another container, make sure that container and lid material is suitable for the chemical or solution, and label the contents. Metal cans are well-suited for acetone and solvent-based clearcoats, while thicker High Density Polyethylene (HDPE) bottles work well for most reactive colorants. Containers holding corrosive liquids (reactive solutions) can be stored in a secondary tub or tray (of suitable material) in order to contain the liquid in case of a leak. Non-reactive colorants can be stored in most non-porous container materials. Refer to the chemical Material Safety Data Sheet (MSDS, or equivalent) from the chemical supplier for more information on specific suitable container materials.

Keep all chemicals in a clean, dry area away from direct sunlight and extreme temperatures. Dry chemical ingredients should be stored above liquid chemicals on a shelf, in case of a liquid spill. Always be mindful of the location of flammable liquids, and always keep all containers fully closed when not in use.

General finishing handheld tools, supplies, and personal protective equipment should be stored in lidded tubs, away from the chemical storage.

Hazard symbols

It is a good idea to familiarize yourself with the commonly used hazard symbols, which are used to warn of dangerous materials you may encounter in your workspace.

Flammable

Corrosive

Toxic

Oxidizing agent

Harmful

Explosive

Tools, equipment, and workspace

An adequately equipped metal finishing studio will help make the cleaning, coloration, and protecting tasks go more smoothly and yield the desired outcome, in a safe environment. The ideal finishing area is separated from the fabrication studio either by walls or floor-to-ceiling plastic curtains to keep it contamination-free during the entire process. Always be mindful of safe chemical handling, application, and disposal practices.

Health and safety equipment
Use proper protective equipment and ensure adequate studio ventilation for safe metal coloration practices. You should be prepared to handle minor accidents and injuries.

FIRST AID KIT
A basic first aid kit containing supplies to handle minor cuts, burns, and particles in the eyes should be readily accessible in the studio workspace. This kit should contain: various sized sterile bandages and gauze pads, first aid tape, burn gel, alcohol wipes, antibiotic ointment, and eye wash.

FIRE EXTINGUISHER
A fully charged fire extinguisher should be conveniently located in the studio for quick and easy access. Choose fire extinguishers suited for combustible materials, flammable liquids and electrical fires (type A, B, and C). Know how to use the extinguisher before the need arises.

RESPIRATOR (1)
A respirator is designed to filter out specific fumes in addition to particulates. Respirators should be worn when chemical or clearcoat vapors are present, namely during hot reactive patina applications, hot immersion applications, and spraying of clearcoats not under a fume hood. Choose the proper respirator for the fumes it needs to filter.

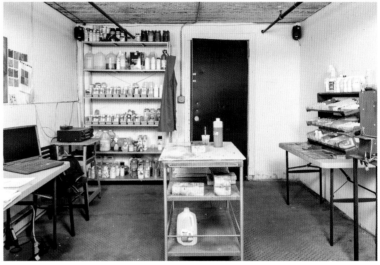

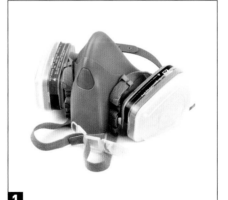

1

Respirators can either be disposable or have replaceable cartridges. Consult the respirator manufacturer's guidelines for proper fit and replacement information and the chemical Material Safety Data Sheet (MSDS, or equivalent) for proper respirator selection. The chart below gives a quick guide to the type of respirator that should be used for a range of different processes.

Activity	Respirator type
Most hot reactive coloration processes	Acid gases
Acetone use and solvent-based clearcoat applications	Organic chemicals
Cold or hot ammonia/ammonium hydroxide use	Ammonia gases
Mechanical cleaning processes using a power tool	Particulate filtration

DISPOSABLE GLOVES

Disposable gloves made of latex or nitrile material do an adequate job of protecting hands from incidental contact with most chemicals used in the coloring and finishing of metals. Protective gloves should also be worn when handling the metal object during the cleaning, coloring, and clearcoat stages to avoid contaminating the surface with oils and greases from the skin. Disposable gloves do not offer adequate protection with longer exposure to solvent-based cleaners, thinners, and acetone. Consult the chemical Material Safety Data Sheet (MSDS, or equivalent) for proper glove selection.

REUSABLE CHEMICAL GLOVES

When repeatedly or heavily using solvent-based cleaners, thinners, and/or acetone, thicker reusable nitrile, neoprene, or butyl chemical handling gloves should be used. These offer much better chemical resistance than disposable gloves. Consult the chemical Material Safety Data Sheet (MSDS, or equivalent) for proper glove material selection based on the specific chemical application.

CHEMICAL APRON

Aprons made of chemically resistant materials, such as polyvinyl chloride (PVC) should be worn when performing operations where chemicals have the chance to spill or splash, toward the body.

WORK APRON

A general-purpose work apron made of flame-resistant cotton material should be worn whenever handling a heat source such as an open flame torch. This apron is also a great way to keep clothing clean during many of the metal coloration processes not requiring chemical resistance, such as mechanical cleaning operations.

SAFETY GLASSES (2)

Clear impact-resistant safety glasses should be worn whenever performing operations where particles (solid or liquid) are propelled into the air, such as mechanical cleaning with power tools and colorant spraying.

SAFETY CHEMICAL GOGGLES (3)

Safety chemical goggles form a seal around the face and offer much better eye protection from chemical splashes and chemical vapors than regular safety glasses. Use chemical safety goggles when performing operations that emit chemical vapors, such as fume, hot application, and hot immersion processes. Chemical safety goggles should also be worn whenever ammonia/ammonium hydroxide and glacial acetic acid ingredients are involved.

FUME HOOD (4)

A fume hood, or spray booth, is a way to filter and extract fumes from the workspace. Use a fume hood when working with highly concentrated chemical fumes such as hot immersion processes, fume patina processes, when using ammonium hydroxide and/or glacial acetic acid, and spraying of solvent-based clearcoats.

2

3

4

Studio necessities

With only a relatively few necessities, a typical workspace can easily be converted to a metal finishing space.

UTILITY SINK

Make sure you have tap water accessible for neutralizing reactive chemicals, diluting excess water-based chemicals, and for cleaning containers, tools, and surfaces of water-based colorants. Clean running water and soap should also be used to clean any incidental chemical contact from the skin.

CHEMICAL-RESISTANT WORKTABLE (5)

A large, non-absorbent/non-porous work surface is a must-have for the metal finishing studio. Worktable surfaces should be made of chemical resistant materials (either stainless steel, or plastic), or be covered with such.

HEAT-RESISTANT WORK SURFACE

When using a heat source such as a heat gun or torch for hot applications, the metal object should be sitting on a heat-resistant surface large enough for the heat affected area. Material such as firebricks, soldering boards, cement boards, or metal offer adequate protection.

PAPER TOWELS/COTTON RAGS

Use absorbent, lint-free paper towels or rags for any drying, cleaning, wiping and polishing needs. Lay acetone- and solvent-soaked cloths out to air dry before disposing of them. Cloths saturated with these flammable chemicals buried in the garbage are a fire hazard.

CHEMICAL STORAGE

A well-organized finishing studio should have an area dedicated to storage of all chemical ingredients and mixed solutions in labeled, lidded containers. This area should be away from direct sunlight, heat sources, and in a dry, relatively clean area. In general, it is best to store liquid chemicals with nothing else below them in case of a leak in the container.

GARBAGE

It's a good idea to keep a refuse container handy during metal coloring processes. Be sure to dry out any acetone- or solvent-soaked cloths before discarding. It's advisable to empty the refuse container daily to remove any article with chemical remnants that could emit vapors into the workspace.

VENTILATION

Good ventilation is vital for the metal finishing studio. Ensuring a constant fresh air supply (intake) as well as an air exhaust will make for a safe work environment. It is best to use a speed controlled, forced air fan for both intake and exhaust in order to establish a cross-flow of air to keep small amounts of particulates and vapors from accumulating. An alternative is to keep the studio door open and use a window fan to exhaust through an open window. Always position yourself in such a manner where the "dirty" air moves away from your breathing zone, not into it. One way to accomplish this is to face the exhaust fan with the work positioned in front of your body.

GENERAL WORKSPACE: FINISHING AREA

The finishing studio should be orderly and clean, with ample room to perform the necessary tasks. Ideally it should be physically separated from the fabrication studio for fire safety and to prevent particle contamination during the finishing process. This separation can be done with a plastic shower curtain hung as a divider. The ideal workspace flooring is a non-porous surface such as sealed concrete, tile, or linoleum, as these won't absorb spills and can be cleaned up easily.

Heat tools

Having access to heat tools can expand the coloration process options to include hot applications, heat temper colorations, and hot immersions.

HEAT GUN (6)

A lower heat source like an electric heat gun or hair dryer can be used for hot application colorations or paste wax application on thinner metals. These heat sources are also great for drying the metal after water rinsing or neutralizing.

AIR/FUEL TORCH

Air/fuel torches should be used when a greater process heat is required, due to object size or metal thickness. The main fuel sources are propane, polypropylene, butane, or acetylene, each having a different maximum temperature. Torch heat sources typically have pressure or flow valves controlling the fuel and interchangeable tip sizes to control the heat affected area. Choose the fuel pressure, flow, and torch tip size based on the particular heating needs of the process.

OXYGEN/FUEL TORCH

Oxygen/fuel torches differ from air/fuel torches in that the system is a two-gas system. Rather than rely on the oxygen in the atmosphere for flame combustion, like the air/fuel, oxygen/fuel torches use pure oxygen mixed with a fuel source, such as acetylene, to produce an even higher heat. The oxygen/fuel torch should only be used for the most demanding of heating needs. Care must be taken as oxygen/fuel torches may produce heat higher than the melting temperature of the metal being heated.

HOTPLATE, OVEN, OR KILN (7)

Electric hotplates, ovens, or small kilns can be used for more uniform heat temper colorations across a larger surface. Hotplates are also used to heat solutions for hot immersion processes. Choose an electric hotplate, oven, or kiln that is sized appropriately, reaches the maximum temperature required, and has temperature adjustability built in.

IMMERSION THERMOMETER (8)

Many hot immersion processes require the reactive solution to be kept at a consistent temperature while the object is immersed. Use a good quality digital immersion thermometer that is appropriate for the temperatures required (often at or near boiling).

Inert measurers and containers

An assortment of inert measuring devices and containers are essential for mixing, applying, and storing colorants.

BOROSILICATE GLASS VESSELS

Borosilicate glass (Pyrex, or other) vessels should be used when directly heating the colorant solution on a hotplate. Take care to ensure that there is a small amount of air space between the heating element and the bottom of the borosilicate glass vessel to reduce the risk of thermal shock cracking. Most inexpensive laboratory hotplates have ceramic spacers available for this purpose. A 32 oz or 1000 ml

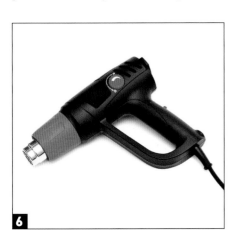

6

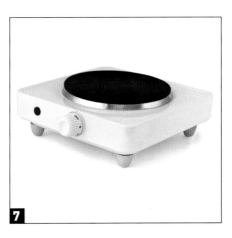

7

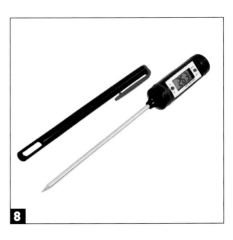

8

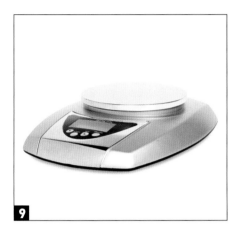

borosilicate, wide-mouth beaker should be sufficient for smaller works.

WEIGHT SCALE (9)

A good quality weight scale is essential for accurately weighing chemical components. Choose a digital scale with a maximum capacity of approximately 5 lb with a resolution of 0.01 oz (2,000 g x 0.1 g resolution). The scale should have zero-out, or tare ability. The tare feature allows accurate measures of solids or liquid ingredients placed directly into a container on the scale, the container having been tared or zeroed so the weight reflected is that of just the ingredient.

LIQUID MEASURE (10)

Volume liquid measures made of glass, plastic, or stainless steel should be used when mixing up solutions. Have a range of vessel sizes to accurately measure from 2 fl oz to 32 fl oz (50 ml–1000 ml), with appropriate graduated markings.

MORTAR AND PESTLE (11)

Some raw colorant ingredients are sold in solid chunk or flake form (namely liver of sulfur and cupric sulfate) and are best broken down to finer particles before mixing. For these substances it is best to use a non-porous glass or marble mortar and pestle.

MIXING, WEIGHING, AND APPLICATION CONTAINERS (12)

A variety of inert plastic, glass, or stainless steel container sizes can be used for weighing and mixing colorant ingredients, and to hold solutions during application processes not requiring direct heating of the solution.

MEASURING SPOONS (13)

If you're using recipes that list dry ingredients as volume measures you need to use appropriate inert plastic or stainless steel measuring spoons. It is best to have a range of measures from ⅛ teaspoon to 1 tablespoon.

FUNNELS (14)

Funnels are used to transfer liquid ingredients from one container to another. Choose appropriate sized, inert material funnels made of plastic or stainless steel for the required needs.

CHEMICAL STORAGE CONTAINERS (15)

Excess mixed liquid colorants should be stored in containers with leak-proof lids. Reactive colorants must be stored in inert containers with inert lids. Thick high-density polyethylene (HDPE) material will work for most colorant solutions. Solvent-based chemicals such as cleaners and thinners, and acetone are best stored in suitable metal or glass containers. If you are ever unsure, always choose a container of the same material as the original.

Application tools

There are a wide variety of application tools available to help achieve a whole host of effects with each colorant, reactive or non-reactive.

BRUSH TOOLS

Application tools are considered brush tools if they are loaded with colorant and physically come in contact with the metal surface. Brushes can range from foam, bristle, sponge, and synthetic wool pads. Choose a brush head and size appropriate for the surface size and the desired application effect. Use natural brush head materials (such as hog's hair) when performing hot applications, as they withstand heat better than synthetic materials.

SPRAY TOOLS

Spray tools are any that propel the colorant onto the surface without the tool itself coming into contact with the metal surface. Spray tools can range from anything that drips or flings the colorant onto the surface, through to pump or trigger sprayers, and airbrush sprayers. Choose the appropriate spray tool for the coverage needed and application effects desired. Take care to clean reactive water-based chemicals from sprayers thoroughly after each use by spraying clean water through them to keep any metal parts from corroding.

COMPRESSED AIR SOURCE (16)

A consistent supply of compressed air allows for very uniform spray applications with an air sprayer, and allows the use of a media blaster to mechanically clean the metal surface. Choose an air compressor that is appropriately sized with pressure and volume for the air tools it will operate. Small airbrush compressors or canned air propellants are suitable for small air sprayers and small, portable media blasters.

MASK TOOLS

Masking tools resist or block the colorant from reaching the underlying surface. Masks can be adhered to

14

15

16

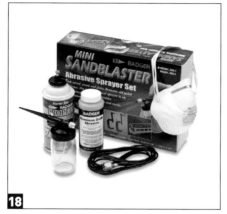

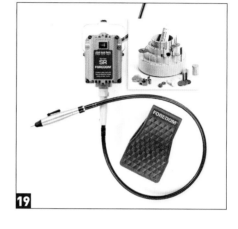

the surface as in tape, liquid latex (rubber cement, liquid frisket, or removable latex coatings) or improvised materials. Masks need to be removable and care must be used when choosing a mask for a hot process application. Choose a mask that best covers the area, in the manner desired, with the least amount of disruption to the underlying surface.

Cleaning equipment

Consistent and durable metal colorations begin with a proper surface cleaning. This will involve both a mechanical and chemical process.

SANDBLAST CABINET (17)

A sandblast cabinet houses a pneumatic abrasive blaster used for mechanically cleaning metal. Most cabinets can use a variety of blast media including walnut shells, glass beads, and aluminum oxide "sand". Each has a different cleaning ability and resulting aesthetic. The cabinet keeps the abrasive material contained as it is propelled with compressed air

from a blast gun. Choose a cabinet size and blast media that best suits the work to be blasted and the surface quality you desire.

PORTABLE SANDBLASTER (18)

Smaller abrasive blasters are portable and therefore more convenient for smaller works. They also require a much smaller compressed air source. With no cabinet, it is best to spray blast into a "catch-box" to keep the blast media contained. Most airbrush-style blasters are limited to aluminum oxide media. Choose the blast media that best suits the work to be blasted and the surface quality you desire. Always wear a respirator or dust mask and safety glasses to protect you from the fine airborne particles.

POWER ROTARY TOOL (19)

A power rotary tool (grinder or flexshaft) is an indispensible tool for many mechanical cleaning and conditioning processes. Choose a power rotary tool that is appropriately sized to the work, is speed adjustable, and has the ability

to use many different wheel attachments for more versatility.

ROTARY TOOL WHEELS

Many accessory wheels for different metal surface preparations are available for the power rotary tool. Commonly used wheels include: bristle brushes, grinding, sanding, flap disc, synthetic wool, and polishing. Each has a different rate of surface metal removal, or cleaning, and leaves a distinct surface aesthetic. Choose the wheel type, abrasiveness, and size that best matches the cleaning and surface quality you require.

SYNTHETIC WOOL PADS

Synthetic or "plastic" wool pads are used to manually mechanically clean and prepare the metal surface prior to coloring, and for wet and dry burnish techniques. Heavy cleaning to light blending can be accomplished with synthetic wool pads by choosing the appropriate coarseness pad and applying pressure while abrading the surface.

Aesthetic decisions

There are a variety of reasons for applying color to the metal surface as a finishing step. This chapter delves into the most important of these reasons, looks to everyday sources for color and pattern inspiration, and discusses basic color theory to help identify color harmony. The importance of metal selection on the coloration options will also be explored.

The importance of the finish

The overall aesthetic of a metal object does not end with the form alone: both the surface finish and the color play a significant role in the look and feel of a piece. The term "finish" refers to work done as final steps to enhance or preserve the form—namely surface treatments, surface colorations, and protective coatings. Finishing processes are typically performed after all hot work and metal manipulation are complete; heat, hammering, bending, shaping, and forming all can destroy the aesthetics and functionality of the final finish. Some metal finishes are considered to be extensions of the fabrication process (namely, surface finishes such as grinding, sanding, wire brushing, and polishing), but the addition of color can be a powerful way to add significance and beauty to a piece. The most cohesive designs are created with both the form and desired aesthetic finish in mind.

Reasons to color metal

The obvious reason to color your metal object is to enhance the look or feel of the piece. Color can be added to bring greater beauty, a sense of fashion, or visual interest to the form. The color may follow market trends, be cohesive with surrounding visual elements (as in home décor, clothing, other jewelry pieces worn as a grouping), or simply be pleasing to the eye. The coloration itself can add visual depth or texture to the surface of the object. Colored metal can be used to give the appearance of age, as age often elevates the perceived importance of the object. Another reason to color metal is to add artistic merit or meaning, especially if the coloration process is emphasized as an important factor to the work (as with unique patinas). Color can help set a mood or give a specific feeling to the viewer. Lastly, when used as a protective coating (color plus sealing binder in one), color can act to protect the metal surface from unwanted oxidation and offer abrasion resistance.

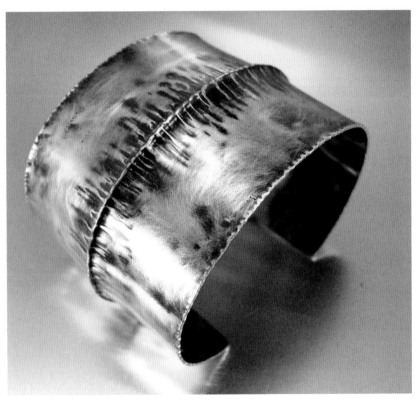

ABOVE: **MELODY ARMSTRONG**
Freeform cuff
This sterling silver, fold-formed cuff has a beautiful multi-colored patina, which has been burnished to showcase the center spine and texture of the piece. Many colorants can be added to the surface, and then selectively removed to highlight a given feature.

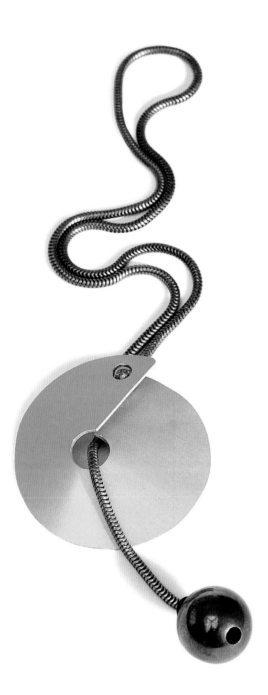

Colored protective coatings

A colored protective coating can be applied to a metal surface and act both as coloration (opaque or translucent) and as protection for the underlying surface. Examples of colored protective coatings include paints, dyed liquid clearcoats, and colored paste waxes. Colored protective coatings can be used as stand-alone colorations, or in combination with other types of colorants. The content of this book focuses on "loose" colorants, i.e. those not mixed with a sealing binder. Loose colorants allow for easier color adjustments by the artist, but often need a clear protective coating for coloration durability. However, these colored coatings can play a key role in the finishing process.

Compare the above bare copper tile to the colored copper metal tile on the right. Both have had an abrasive surface treatment to create a visual pattern, but the right-hand tile has had a green dyed liquid clearcoat applied to the surface, resulting in a translucent "tint" to the copper. The dyed liquid clearcoat also acts as a protective layer against abrasion and unwanted oxidation or discoloration.

The above steel tiles have had a chemical patina applied to accelerate the orange-brown rust formation. The rusted steel tile on the right has then had a red dyed liquid clearcoat applied over the rust, resulting in a translucent "tint" of the opaque rust. The dyed liquid clearcoat also seals and protects the surface.

Observing

COLOR AND PATTERN INSPIRATION

Color and pattern influences can be found in nearly everything visible. Much of color and color pattern has to do with adding emotion or feeling to a work. Be critical with your observations: determine if the object or composition is engaging to your eye, then identify why it is so. Does the color or pattern help generate feelings toward the object? Do not discount negative emotions or feelings, as these are just as powerful as positive ones. Use the appropriate colors and patterns to convey the feelings you want with your work. For example, calm and soothing colors may be the wrong choice if applied to a work that speaks of energy.

NATURE Nature produces a wide variety of colors and shapes. Look to flora, fauna, and fungi for earth tone colors, curved shapes, and interesting textures.

DEGRADATION Decomposition, decay, and erosion can all have powerful visual impact. Whether natural or man-made, look for dark color inconsistencies, heavy eaten-away texture, and a sense of reduction.

VISUAL TEXTURE Tree bark, manhole covers, and loose-knit fabrics all have strong tactile qualities that can inspire and become the basis for jewelry and metalwork pieces.

ORGANIC Look out for flowing lines and curves suggesting movement and growth when thinking about an organic feel. Growth rings of trees, wave sets on the ocean, petals on a flower are all fine organic examples.

CALMNESS Smooth surfaces, cool colors, and gentle curves all evoke a sense of calmness when added to a form.

ENERGY Visually busy lines and patterns, diagonals, and warm colors can be used to indicate feelings of energy.

MOVEMENT Movement can be suggested by using flowing lines or patterns across a surface, either vertically or horizontally. Use lines and patterns to convey myriad types of movement.

ARCHITECTURE Look to architecture for repetitive patterns, geometric forms, and neutral colors. Smooth and ornate surfaces abound in buildings and provide a great source of inspiration.

WARM COLORS Warm colors such as reds, oranges, and yellows tend to advance from cool colors when adjacent to each other. Warm colors have a sense of energy, excitement, and passion.

COOL COLORS Violets, blues, and greens are considered cool and recede from warm colors when adjacent to each other. Cool colors are associated with calmness and relaxation.

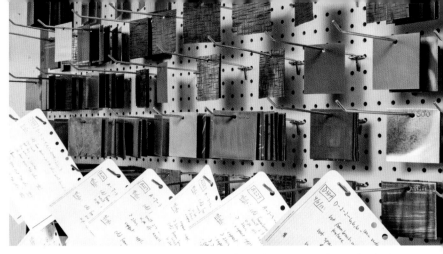

Recording

COLOR AND PATTERN INSPIRATION

Have individual note papers for each coloration. Record, in detail, all the variables using a shorthand code to identify each step performed (with dates), and any notes on the final outcome.

Like most things creative, color and pattern inspiration can come at any time, from anywhere. The single most useful recording tool is the digital camera. With good-quality digital cameras built into mobile phones, there is hardly a time when a camera is not available. Remember to think critically about what is important to capture. The purpose of these quick shots is to act as reminders of how the color and patterns enhanced the form or setting. Would this be better captured at a wide angle to show how the color and form interact? Or is it best as a zoomed-in shot, showcasing surface and color detail?

Another way to stay reminded of color and pattern influences is to collect physical samples of surfaces that have desirable tactile qualities, aesthetics, or feelings. Fabric swatches, rocks, handmade paper samples, corroded metal objects, wood, sea glass, and so on—all can be great visual sources for color and patterns. Having actual objects to look at and touch can help when you are trying to match their look and feel with metal colorations.

Finally, keep a notebook (paper or digital) with design ideas, sketches, and, of course, color and pattern thoughts. Give a more detailed description of what was captured with the camera or collected with the physical samples. Describe the feelings evoked by the samples and images, and what qualities defined the feelings. Keep records and stay organized.

Recording the working process

As you begin to experiment with colored metal samples, it is imperative that you have a method for recording all the process information that will help with identification and repeatability.

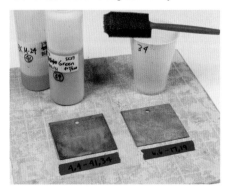

When performing the coloration process, it is useful to temporarily note the colorant formula, layer number, and date, especially when developing a coloration over several days. Here a strip of tape is used to identify one patinated tile from the next.

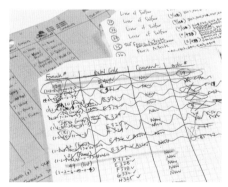

Creating a shorthand code to quickly identify variables such as metal type, surface quality, chemical cleaning, application process, colorant formula, effects, and surface protection type can make note taking much easier when performing sample colorations.

Transferring the handwritten notes into a spreadsheet or database is not necessary, but can be extremely helpful when searching for particular information from a list of colorations.

Case study: Mariko Sumioka

Good design draws upon inspirational ideas and objects that, once arranged into a new context, become one's own. Mariko Sumioka creates wearable art inspired heavily by Japanese culture and traditional architecture. In this series of work, Mariko focuses on Japanese homes and the countryside for color, pattern, and texture concepts that can be carried into her jewelry designs.

Mariko begins by outputting digital images of Japanese buildings with special attention to their tiled rooftops. Her initial sketches alongside the images break down the overall composition into simple, "building-block" elements which will eventually form her jewelry.

As Mariko's design process continues with sketches, she begins to take the elemental building blocks and arrange them into patterns using color to differentiate between the roofs and the natural surroundings.

When Mariko shifts her attention from the overall concept to specific jewelry designs, her sketches become more about arrangements of color fields with notations to help guide her designs. Mariko can easily design multiple pieces within this same series by altering the arrangement and number of elements, the metal types used, and the surface textures and colors throughout the composition.

RIGHT: **MARIKO SUMIOKA**
Mosaic roof brooch 2
The repeating square elements assembled to create this brooch are visually grouped with the help of coloration and texture. The green of the patinated bronze gives a sense of oxidized rooftops, while the adjacent silver evokes the sun glinting off of roof tiles.

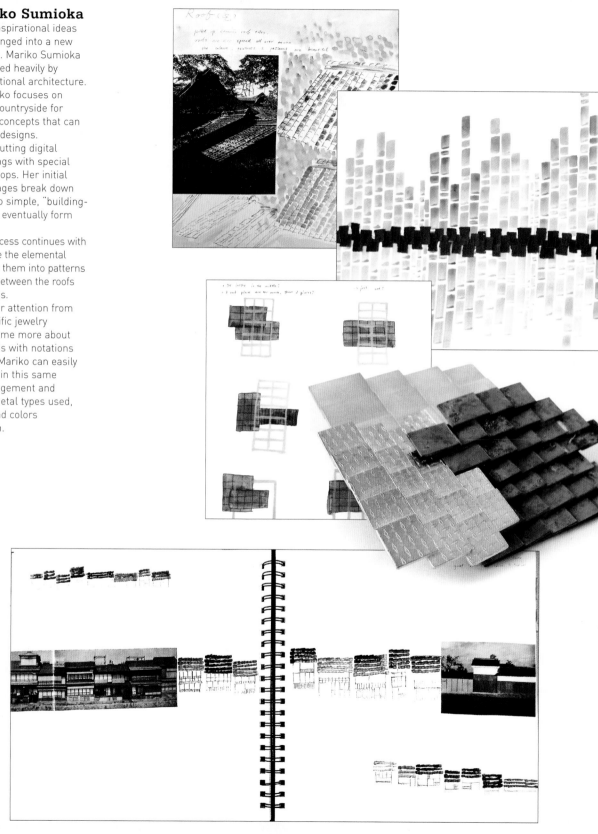

Color theory

Understanding the influence color has on the viewer can obviously be helpful when determining which finishing colors to use. Being able to use the vocabulary of color will help you to make adjustments to obtain the look you want. For anyone working with color, the color wheel can be a very useful tool. It helps define the parameters of color and color mixing and shows color relationships that are deemed harmonious. You can choose whether to follow the color wheel guidelines or to go against them—so long as your color choices are purposeful and satisfactorily enhance the form.

The vocabulary of color

Every color has three defining characteristics: hue, value, and intensity. **Hue** is the name for the color (hue = pure color). **Value** refers to the relative lightness or darkness of a color. **Intensity**, or saturation, is defined as the purity of a color, which determines the relative brightness or dullness. A pure color will always be brightest, having the greatest intensity or saturation.

Mixing a color with white creates color **tints**. Color tints always have a higher value, being lighter than the original color. Mixing black with a color creates color **shades**. The resultant shade will be darker and have a lower value than the original color. Mixing the color with a gray creates color **tones**. Tints, shades, and tones will always be duller, with a lower intensity or saturation than the pure color.

There are twelve hues available, comprised of primary, secondary, and tertiary colors on the wheel. The three **primary colors** are red, yellow, and blue. Primary colors are basic colors that cannot be created by mixing other colors. Then there are three **secondary colors** of orange, green, and violet. Mixing two primary colors together creates a secondary color. Lastly, mixing one primary color with one adjacent secondary color on the color wheel creates the six **tertiary colors** of red-orange, red-violet, yellow-orange, yellow-green, blue-green, and blue-violet.

Color can evoke a feeling and set a mood. Red, orange, and yellow colors generally have a warm feel, invoking a sense of energy, excitement, and passion. These command attention, and advance from cool colors when used in combination. The typically cool colors of green, blue, and violet are associated with calmness and relaxation, and tend to recede from warm colors. The **warm colors** range from yellow to red-violet

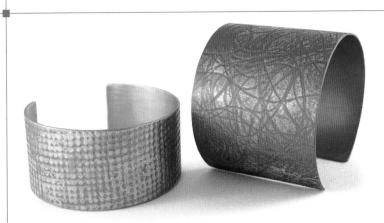

ABOVE: **JOANNE COX**
Weave and Wisp cuffs
The anodized aluminum cuffs shown use both color and pattern to create visual interest and style. Most reactive and non-reactive colorations can be applied with many methods to easily create variations.

The color wheel labels (clockwise from top):
- Red Primary
- Red-orange Tertiary
- Orange Secondary
- Yellow-orange Tertiary
- Yellow Primary
- Yellow-green Tertiary
- Green Secondary
- Blue-green Tertiary
- Blue Primary
- Blue-violet Tertiary
- Violet Secondary
- Red-violet Tertiary

on the color wheel. Colors from yellow-green to violet on the wheel are considered **cool colors.**

Established color schemes

There are many ways to choose colors that work together on a single object or with the surrounding environment. Harmonious color schemes can be found using the wheel, as follows:

Monochromatic color scheme

Using any tint, tone, or shade of one color.

Analogous (related) color scheme

Using colors adjacent to each other on the color wheel (any three to five colors).

Complementary (opposite) color scheme

Using any two colors directly opposite each other on the color wheel. Note that each warm color has a cool complement, and vice-versa.

Split complementary color scheme

Using any color with the two colors on each side of its complementary color.

Triadic color scheme

Using three colors spaced an equal distance apart on the color wheel.

Tetradic color scheme

Using a combination of four colors on the wheel, made up of two sets of complementary colors.

Choosing the level of color coverage

Although not strictly color theory, this is a good time to define opaqueness and translucency. Opaque colors completely cover the underlying surface, not allowing anything from underneath to be seen. Translucent colors visually allow the under layer to come through to some extent. It is easiest to think of dyes as examples of translucent colors, and use the term "tint" to mean to add a translucent color to. (Note that the use of the term "tint" is different here than used previously with color theory.)

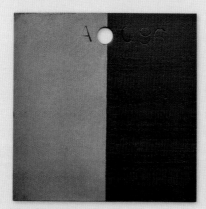

Opaque pigment on steel
Black pigment has been applied to the right half of this tile. Notice how the density of this pigment completely covers the underlying silvery gray steel color.

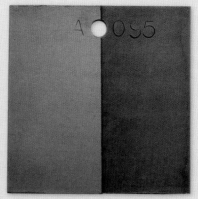

Translucent dye on steel
This steel tile has had a black dye applied to the right half. The translucency of the dye allows the steel color to show through, effectively adding a black tint to the silvery gray.

Comparing common metals

Throughout this book, we'll be looking at seven families of metals used in contemporary jewelry and metalsmithing, each of which has different physical properties, raw material aesthetics, and reactive coloration possibilities.

Before discussing finish colorations, it is important to understand the impact your choice of metal has on the finish possibilities. The choice of metal is based on a number of factors: economics (the cost of the raw materials and the price of the finished work), the workability of the metal (its malleability, ductility, relative strength, and so on), your familiarity with the fabrication processes required for the specific metal (forming and joining processes), and the desire to be consistent within a product line or to meet a specific style. Most of these factors relate to the construction of the metal form. When considering the overall aesthetic of the piece, however, you should also think about the color quality of the metal itself and the coloration options that each metal type offers.

The color quality of the bare metal can play an important role in the overall aesthetic of the piece in two main ways: first, if the colorant is translucent, the metal color will show through; and second, if only selected areas are colored (as when masking), or if the applied color is abrasively removed in certain areas (burnishing), the underlying metal color will be revealed. All of these processes will be illustrated later in the book.

Each metal has a host of colorations available. Metal coloration options can be grouped into two general categories: reactive and non-reactive processes.

Reactive color spectrum
These color bars represent the reactive coloration spread possible for each metal family. The actual color quality is strongly based on metal composition, colorant formula, and application method used.

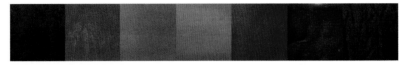

Steel

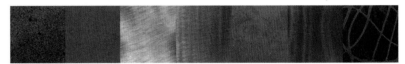

Stainless steel

Aluminum

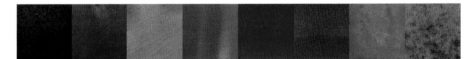

Copper

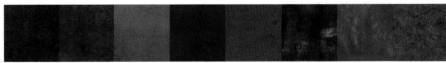

Brass

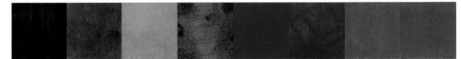

Bronze

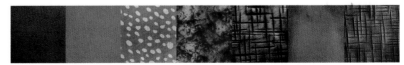

Sterling silver

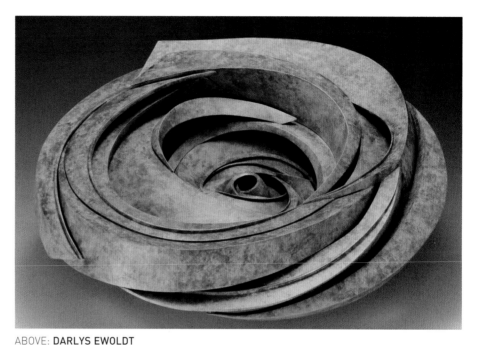

ABOVE: **DARLYS EWOLDT**
Wrapped around myself
This multi-layered copper object has total continuity, due in part to the
enveloping concentric forms and in part to the consistent coloration
from piece to piece. The green shades complement the reddish
orange coloration.

Reactive colorations are colors that are developed through chemical reactions with the metal itself. Oxidation (natural and accelerated chemical patinas) and chemical plating are examples of reactive colorations. The color depends not only on the chemicals and application process, but also on the type of metal to which they are applied. Each metal composition has a specific range of reactive colors; anything beyond these must be developed with non-reactive processes.

Non-reactive colorations are independent of the metal they are applied to, and can be thought of as pure, superficial colorants. Pigment products (opaque colors) and dye products (translucent colors) are examples of non-reactive coloration processes. In general, the non-reactive color remains the same no matter what metal it is applied to—although you should keep in mind that, if the coloration is translucent, the underlying color and luster of the metal will strongly influence the overall look. The use of non-reactive colorations opens up the color possibilities with every metal; there is literally a rainbow of colors to choose from. Non-reactive coloration processes can be used as stand-alone colorations or used to augment a reactive coloration process.

Understanding how the metal type can affect the coloration both in available color options and the resultant color quality can help you make sound decisions when thinking of the aesthetic finish.

Metal families

The metal families featured in this book are designated according to the Unified Numbering System (UNS), which groups alloys together based on composition. The UNS is for reference only and does not indicate metal specifications.

Metals are either pure elements or alloys (a combination of two or more elements). Alloys are formulated to bring the desired qualities of separate elements together in a new metal. Common examples of pure metals are iron, copper, aluminum, and silver. Typical alloyed metals that a metalsmith might use are steel (an alloy of iron and carbon), brass (an alloy of copper and zinc), bronze (traditionally an alloy of copper and tin), sterling silver (traditionally an alloy of silver and copper), and stainless steel (an alloy of iron, carbon, chromium, and nickel).

It should be noted, although gold is a traditional precious metal used in jewelry it is rarely "finished" beyond its natural metal color and available luster. Therefore, colorations on gold are not discussed in this book.

Steel (UNS G10100)

Steel is a metal alloy defined by its iron and carbon content. Other elements are introduced to gain the overall physical properties of the alloy desired. UNS G10100 is a commercial grade of low-carbon steel characterized by a carbon content between 0.08 and 0.13 percent of the total mass. It is widely available, is inexpensive, and has very good hot and cold workability, with relatively high strength. The hot joining processes of soldering, brazing, and welding can all easily be performed with low-carbon steel, although only welding will yield a color match at the joint. Most low-carbon steels can be either hot or cold rolled, the difference being mentioned here for aesthetic reasons.

Hot-rolled steel is a result of the mill using heat to soften the steel before rolling the thickness of sheet or the shape of the bar. This heat produces a tough, colored oxidation layer (mill scale) that is rolled into the surface of the steel. The uneven, dark bluish black color of the mill scale is a distinctive characteristic of all hot-rolled steel products. The mill scale resists corrosion to some extent, but also can inhibit reactive coloration processes. The mill scale can be chemically removed in a pickling solution, or abrasively removed to reveal the unoxidized steel layer beneath.

Cold-rolled steel is rolled and formed at the mill without the use of heat. The resultant steel is a silvery gray in color (natural steel color), with a slightly higher strength than comparable hot-rolled products. Cold-rolled steel shapes are dimensionally more accurate and generally have sharper physical features (corners, inside angles, and so on) than their hot-rolled counterparts.

Steels can be polished to a high luster, but require a clear protective coating to keep the surface from oxidizing. All low-carbon steels have reactive colors of blacks, browns, yellows, oranges, reds, violets, and blues although the orange-brown of rust (iron oxide) is the natural oxidation state.

Hot-rolled steel

Cold-rolled steel

Stainless steel (UNS S30400)

The UNS S30400 family of 300-series stainless steels are steel alloyed with chromium and nickel (18 and 8 percent by mass), primarily for corrosion-resistant properties. S30400 stainless steel is commonly available as sheet and shapes, with the cost approximately twice that of cold-rolled steel. Stainless steel can be readily worked hot and cold, but care must be taken with heating and cooling to maintain the corrosion resistance. Stainless steel can be soldered, brazed, and welded, all producing a near-perfect or perfect color match at the joint. Stainless steel has a bright, silvery gray color.

Stainless steel can be polished to a high luster, and is generally stable in the polished state. Stainless steels are formulated to resist corrosion, however reactive colors of blacks, browns, yellows, oranges, reds, violets, and blues are possible.

Aluminum (UNS A93003)

Aluminum is an elemental metal, but it is most often alloyed with other elements to create characteristics (namely hardness) that are favorable for practical use. UNS A93003, a 3003-series aluminum alloy, is primarily alloyed with manganese and copper, and is widely used for general-purpose sheet products. These basic aluminum alloys cost just slightly more than cold-rolled steel. Aluminum is relatively soft, yet has moderate strength. It is lightweight and malleable, making it easy to work even in thicker sections. Aluminum can readily be hot worked or cold worked, although care must be taken when cold working aluminum as it work hardens and can develop stress cracks. Periodic annealing helps to alleviate this problem. Aluminum can be soldered, brazed, and welded, each giving a close, if not exact, color match. Aluminum alloys are whitish silver in color.

Aluminum can be brought to a high luster, but quickly forms a tough, clear oxidation layer that dulls the finish. This clear aluminum-oxide helps prevent further oxidation from forming on the aluminum surface, but makes it difficult for many coatings to adhere. The oxidation layer must be removed prior to any reactive coloration process; this can be done either mechanically or chemically. Aluminum is limited in its true reactive color range to blacks.

Copper (UNS C11000)

Copper is an elemental metal, used in nearly pure form. UNS C11000 is used often in architecture, and is readily available. Copper is a much more expensive metal, costing nearly seven times more than cold-rolled steel. Copper is soft and lacks strength, making it best suited for decorative works. It has excellent hot and cold workability, with proper annealing to overcome work hardening. All three common hot joining processes of soldering, brazing, and welding can be used on copper, but only welding gives a true color match at the joint. Copper has a reddish orange color.

Copper can be brought to a high luster, but requires the use of a clear protective coating to keep it shiny. When left exposed to natural elements, the bright color of the copper begins to dull and darken, turning toward a brown. Depending on the atmospheric conditions, copper can then turn to a beautiful verdigris after many years. The reactive colors possible with copper are black, brown, yellow, orange, red, violet, blue, and green, although some are difficult to achieve consistently.

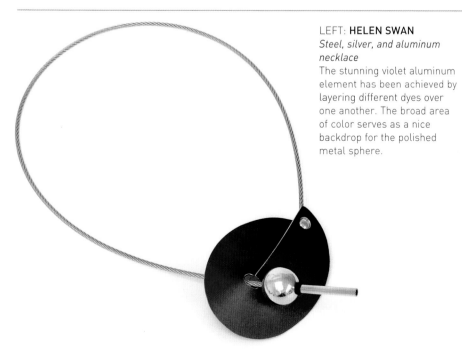

LEFT: **HELEN SWAN**
Steel, silver, and aluminum necklace
The stunning violet aluminum element has been achieved by layering different dyes over one another. The broad area of color serves as a nice backdrop for the polished metal sphere.

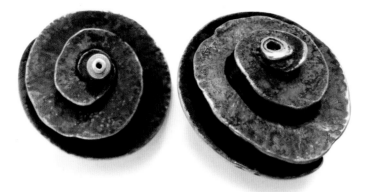

LEFT: **JANE DE BAECKE**
Spiral earrings
The dark, opaque patina coloration over these brass earrings has been burnished along the edges to highlight the three-dimensional spiraling form. The burnished edge adds to the sense of depth and motion of these pieces.

Brass C23000

Brass C26000

Brass (UNS C23000, C26000)

Brass is traditionally defined as any metal alloy comprised primarily of copper and zinc, although the nomenclature does not always follow the rule. Because of the alloyed zinc, brass is generally stiffer, stronger, and tougher than copper, but also more brittle. Brass can be soldered, brazed, and welded, although welding is a bit more challenging due to the differing melting temperatures of the copper and zinc. Some brazing and all welding processes give a color match at the joint.

C23000 goes by many names: red brass, rich-low, jeweler's brass/bronze, Merlin's Gold, and NuGold. It has a chemical composition of 85 percent copper and 15 percent zinc by mass. It has similar characteristics to C22000, comercial bronze, but is stronger. The real reason this metal is used by jewelers and metalsmiths is that the color resembles that of gold when it is highly polished. Alloy C23000 is approximately five to six times the cost of cold-rolled steel. The color of C23000 is a brownish yellow.

Alloy C26000, called yellow or cartridge brass, contains 30 percent zinc by mass. It has the highest ductility and strength of all the yellow brasses, and is the most readily available. The cost of yellow brass is five to six times that of cold-rolled steel. C26000 is readily cold worked, with only a fair hot workability. Alloy C26000 is golden yellow in color.

All brasses can be polished to a high luster. They do not naturally oxidize (or tarnish) as easily as copper, but have a reactive color spectrum similar to copper C11000.

Bronze C22000

Bronze C65500

Bronze (UNS C22000, C65500)

Bronze was traditionally a copper-based alloy comprised of copper and tin, but today the term bronze has a much less specific definition. Bronzes can easily be soldered, brazed, and welded with some brazing and all welding yielding a color match at the joint.

UNS C22000, or commercial bronze, has a zinc content of 10 percent by mass. Because of the low alloy content, C22000 has a cost similar to that of copper, or seven times that of cold-rolled steel. Commercial bronze has good hot workability and excellent cold workability when done with proper annealing. The raw material color for C22000 is a golden brown.

The high-silicone bronze C65500 is comprised of 97 percent copper and 3 percent silicone, by mass. Alloy C65500 has a raw metal cost four to six times that of cold-rolled steel. It has excellent hot and cold workability. High-silicone bronze has a reddish brown color.

Bronzes can be polished to a mirror-like finish and have a reactive oxidation color spectrum similar to C11000 copper.

Sterling silver (UNS P07932)

Pure silver is a very soft elemental metal. UNS P07932 sterling silver, a silver-copper alloy, is used in much more abundance because it has more stiffness and maintains its form better than pure silver. Sterling silver is defined as having 92.5 percent silver and 7.5 percent alloying element, the alloy often being copper. Silver is a precious metal and priced as such: the cost of P07932 sterling silver is approximately two hundred times that of cold-rolled steel. Sterling silver is most often cold worked with proper annealing. It can be readily soldered and brazed, both yielding a color match at the joint. The as-rolled color of sterling silver is a bright, whitish gray.

Sterling silver can be polished, but tarnishes quicker than pure silver. The reactive colors of P07932 sterling silver are black, brown, yellow, red, violet, green, and blue, with black being the easiest to produce consistently.

Metal Comparison Chart

The following at-a-glance chart is designed to be a resource to aid deciding what metal to work with for a given design. Every metal has a unique set of properties that can be important to the metalsmith, from the fabrication to the finishing. Raw metal color, ease of forming and joining, and reactive colors available are just a few details listed below.

Metal	Steel	Stainless Steel	Aluminum	Copper
UNS	G10100	S30400	A93003	C11000
Temper	Cold-rolled	-	H-14	H01
Common Names	Low-carbon steel, Commercial-quality steel	304 Stainless, 18-8 Stainless	3003 Aluminum	110 Copper, Electrolytic Tough Pitch (ETP) copper
Nominal Composition (% weight)	Fe = 99.18–99.62 C = 0.080–0.13 Mn = 0.30–0.60	Fe = 66.35–74.0 C </= 0.08 Cr = 18.0–20.0 Ni = 8.0–10.5	Al = 96.7–99.0 Mn = 1.0–1.50 Cu = 0.050–0.20	Cu = 99.90 O = 0.04
Approximate Relative Cost (Steel = 1)	1	2	1	7
Freshly Abraded Metal Color	Silvery gray	Bright, silvery gray	Whitish silver	Reddish orange
Specific Gravity (water = 1.00)	7.87	8.00	2.73	8.89
Melting Temperature (°F / °C)	2498–2552 / 1370–1400	2550–2651 / 1400–1455	1190–1210 / 643–654	1949–1981 / 1065–1083
Tensile Strength, Ultimate (ksi / MPa)	45.0–52.2 / 310–360	73.2 / 505	22.0 / 152	37.7 / 260
Tensile Strength, Yield (ksi / MPa)	26.1–34.8 / 180–240	31.2 / 215	21.0 / 145	29.7 / 205
Modulus of Elasticity (ksi / GPa)	29000 / 200	28000–29000 / 193–200	10000 / 68.9	16700–18900 / 115–130
Ductility	good	good	excellent	excellent
Malleability	good	good	excellent	excellent
Hot Workability	excellent	excellent	excellent	excellent
Hot Working Temperature (°F / °C)	200–900 / 93–482 Forging: 1800–2300 / 982–1260	2100–2300 / 1149–1260	500–950 / 260–510	1400–1600 / 761–872
Cold Workability	excellent	excellent	excellent	excellent
Anneal Temperature (°F / °C)	1600–1800 / 871–982 w/ slow cool	1850–2050 / 1010–1121 w/ rapid cool	775 / 413 w/ rapid cool	700–1200 / 371–649 w/ rapid cool
Fusibility: Solder (s) Braze (b) Weld (w)	s=good b=excellent w=excellent	s=good b=good w=excellent	s=good b=excellent w=excellent	s=excellent b=good w=fair
Reactive Colors	black, brown, yellow, orange, red, violet, blue	black, brown, yellow, orange, red, violet, blue	black	black, brown, yellow, orange, red, violet, blue, green

Ultimate Strength: Point at which failure occurs
Yield Strength: Point at which permanent deformation begins to occur; below YS is elastic region of material

Modulus of Elasticity: Stiffness
Ductility: Ability to deform permanently with tensile stresses without failure
Temper: Degree of hardness

Malleability: Ability to deform permanently with compressive stresses without failure
Plasticity: Combined ductility and malleability; opposite of strength

230 Brass	260 Brass	220 Bronze	655 Bronze	Sterling Silver
C23000	C26000	C22000	C65500	P07932
H01	H01	H01	H01	Annealed
230 Brass, Red brass, Rich-low, Jeweler's brass/bronze, Merlin's Gold NuGold	260 Brass, Yellow brass, Cartridge brass	220 Bronze, 90-10 Bronze, Commercial bronze, Gilding metal	655 Bronze, High-Silicone bronze A	925 Silver, Sterling silver
Cu = 84.0–86.0 Zn = 15.0	Cu = 68.5–71.5 Zn = 28.5–31.5	Cu = 89.0–91.0 Zn = 10.0	Cu = 97.0 Si = 3.0	Ag ≥ 92.5 Cu ≤ 7.50
5	5	7	4	200
Brownish yellow	Golden yellow	Golden brown	Reddish brown	Bright, whitish gray
8.75	8.53	8.80	8.53	10.4
1810–1877 / 990–1025	1680–1750 / 915–955	1870–1913 / 1020–1045	1780–1877 / 970–1025	1450–1635 / 788–891
50.0 / 345	53.7 / 370	45.0 / 310	68.2 / 470	30.0 / 207
39.2 / 270	39.9 / 275	34.8 / 240	34.8 / 240	18.0 / 124
16700 / 115	16000 / 110	16700 / 115	15200 / 105	10900 / 75.0
good	good	good	good	excellent
good	good	good	good	excellent
good	fair	good	excellent	n/a
1450–1650 / 788–900	1350–1550 / 733–844	1400–1600 / 761–872	1300–1600 / 705–872	n/a
excellent	excellent	excellent	excellent	excellent
800–1350 / 427–732 w/ rapid cool	800–1400 / 427–760 w/ rapid cool	800–1450 / 427–788 w/ rapid cool	900–1300 / 482–704 w/ rapid cool	1200–1300 / 649–704 w/ rapid cool
s=excellent b=excellent w=good	s=excellent b=excellent w=good	s=excellent b=excellent w=good	s=good b=excellent w=excellent	s=excellent b=excellent w=good
black, brown, yellow, orange, red, violet, blue, green	black, brown, yellow, orange, red, violet, blue, green	black, brown, yellow, orange, red, violet, blue, green	black, brown, yellow, orange, red, violet, blue, green	black, brown, yellow, red, violet, blue, green

Choosing and controlling coloration methods

There are many ways of adding color to the metal surface. The following pages will compare the reactive and non-reactive coloration processes commonly associated with the patination of metal surfaces, and discuss the variables to control for more consistent results.

Choosing a coloration method

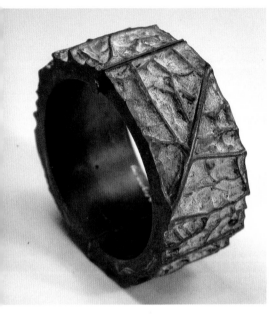

ABOVE: **BARBARA PAGANIN**
Foglia Primordiale
Uniform colorations can hide texture, but by
burnishing the high spots you can selectively
remove color and reveal that underlying
texture. This technique has been used to
great effect on this beautiful bracelet.

Once you've decided to color the metal
piece and worked out which color(s),
patterns, and levels of opacity best
enhance it, you need to shift your
attention to choosing the most
appropriate coloration process(es). It
is important to point out that there are
many ways to color a metal surface,
and often more than one path to a
similar aesthetic result. The method
you choose can be based on a number
of factors, and it is up to you to decide
which is the most pertinent.

Reactive or non-reactive colorations?

First, define which reactive colors are
available with the chosen metal(s) of
your object. Reactive processes develop
colors on the surface through a
chemical reaction with the given metal.

This can occur through the natural
oxidation of the metal surface when
it is left exposed to air and humidity,
or through accelerated reactions such
as patination, heat oxidation (temper)
coloring, and chemical metal plating.
Each metal has a definitive range of
reactive colors—so if the color you
want does not fall within this range,
you will have to create it using a
non-reactive coloration process.
Non-reactive colors are superficial
colorants that lie on the surface rather
than react with the surface. Pigments,
dyes, and paints are examples of non-
reactive colorations.

The importance of process

Is the end color the most important
thing, or is it the combination of the
process and the color? One could, for

Different approaches for achieving the same result

There is usually more than one
approach to obtaining a desired metal
coloration. Sometimes both reactive
and non-reactive colorants are
available which can be used to achieve
a similar end result. Choosing one
process over another can be a decision
between the importance of the coloring
process versus simply adding color to
the metal. Make the decision that best
fits you and your work.

Reactive colorant on copper yielding a
verdigris coloration

Non-reactive colorant on copper
yielding a verdigris coloration

example, apply a chemical patina to develop an opaque verdigris color on copper (a reactive process) or apply a verdigris pigment on the surface (a non-reactive process). The quality of color obtained by reactive versus non-reactive methods might be different, but both would yield a verdigris color on copper. Most choose to use a reactive process because there is some value to doing so. The reactive process has built-in variability for a one-of-a-kind work. Reactive colorations showcase the material; the colors developed are based on oxidation states of the metal itself, natural or accelerated, and are contingent on the composition of the metal. With artist-made pieces, the story behind the work can have as much of an influence as the object itself. Having a reactive coloration helps build this story; it is process driven. With reactive processes, colors are developed rather than applied directly; these developed qualities can also add more meaning or feeling to the work.

Working with reactive processes

The main drawback to reactive coloration processes is that they require a bit more understanding to achieve the best results. When a light blue paint is applied to a surface, the color will look exactly as the color of the visible pigmented paint. When a light blue patina is applied to a copper surface, however, the chemical formula and the metal composition both have a significant role in the final coloration. The quality of the color can vary depending on factors such as the application method and the surface quality of the metal. The patina reaction also requires time for the light

blue color to develop fully. Working with reactive coloration processes involves some basic chemistry understanding and a lot of experimentation with variables. It is not difficult, but it does require patience and step-by-step work habits.

The coloration processes focused on with this book are the more unique reactive colorations such as chemical patinas. Non-reactive colorations involving "loose" pigments and dyes will also be discussed, as these are often used to augment a patina or plating color, or broaden the color

options with some metals. Loose pigments or dyes are those that have no binder and can easily be mixed, applied, layered, and once on the surface, adjusted. Colored protective coatings with binders such as pigmented paints and dyed clear coats will be discussed as comparisons only.

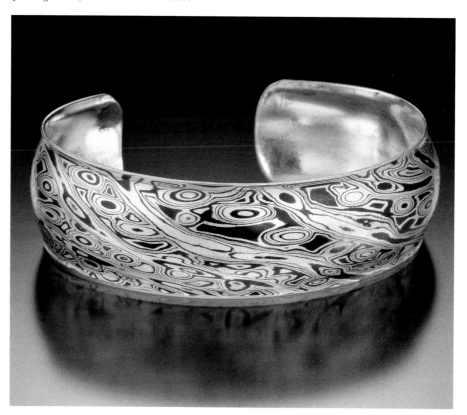

ABOVE: **JAMES BINNION**
Mokumé cuff bracelet
This striking look is achieved by combining a variety of metals and is known as mokumé gané. This translates from the original Japanese as "wood grain".

Comparing coloration processes

Every metal coloration process has its pros and cons; some might be more involved to apply and produce more variable results, like reactive processes. Some might be easier to work with and yield more consistent colors. Choose the method(s) that best give the aesthetic you are after.

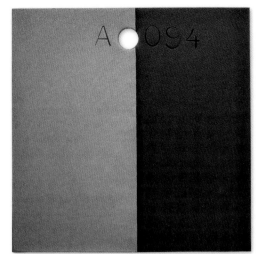

Patina on steel

Patina

A reactive coloration process simply meaning to age; referencing oxidation states of the metal. Metal artists can allow patinas to develop naturally over time or apply reactant chemicals to the metal surface to accelerate and control the oxidation colors. Patina colors become part of the metal surface.

PROS

- Colors the metal with natural oxidation process
- Showcases metal as the material
- The coloration becomes part of the metal surface
- The coloration can be adjusted via layering or burnishing
- This unique method of coloration can become part of the artist-story
- Variable results enhance one-of-a-kind process
- Can be used to achieve an aged or antiqued look and feel

CONS

- A multi-step process
- The reactant chemical must match the metal for the desired color results
- The learning curve for the metalsmith is greater
- Results are variable
- The coloration does not protect the surface from further oxidation
- The coloration can be fragile if left as is
- There is some degree of process hazard to the metalsmith

Skill level: medium to high
Durability: low to medium
Range of effects: high
Toxicity: medium
Availability: medium to high
Ease of application: low to high

Heat oxidation (temper) colors

A reactive coloration process using a heat source to color (oxidize) the surface. The combination of metal composition and temperature reached dictates the color(s) achieved.

PROS

- A natural oxidation process
- Gives immediate results
- Coloration is stable
- Can "paint" color with heat source

CONS

- It is often difficult to control color band spread
- More difficult to achieve uniform colorations
- The object must be able to withstand heat
- The heat may cause the metal to warp
- Does not protect the underlying metal from further oxidation

Skill level: medium to high
Durability: low
Range of effects: medium
Toxicity: low
Availability: medium to high
Ease of application: Medium to high

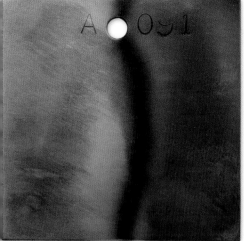

Heat oxidation on steel

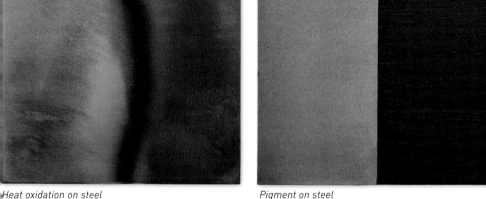

Pigment on steel

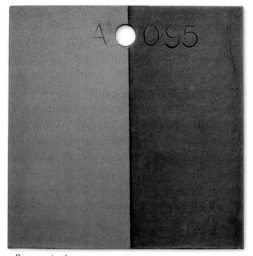

Dye on steel

Pigment

A non-reactive, opaque superficial colorant, with a carrier but no binder. When the pigment is applied and the carrier evaporates, the "loose" opaque color remains on top of the surface of the material. Pigment particles are insoluble in the carrier, so they remain opaque.

PROS

- Non-reactive; can be applied to most material surfaces
- Easy to layer
- Easy to adjust after application via layering and burnishing
- "What you see is what you get" color
- Color is independent of metal type

CONS

- Loose pigments are fragile on the surface
- Needs a secondary process to "set", "bind", or "affix" the color to the surface
- Does not protect underlying metal from oxidation
- Covers underlying surface color completely

Skill level: low

Durability: low

Range of effects: medium

Toxicity: low

Availability: medium to high

Ease of application: high

Dye

A non-reactive, translucent superficial colorant (tint), with a carrier but no binder. When the dye is applied and the carrier evaporates, the "loose" translucent color remains on top of the surface of the material. Dye particles are soluble in the carrier, making for translucency.

PROS

- Non-reactive; can be applied to most material surfaces
- Easy to layer
- Easy to adjust after application via layering and burnishing
- "What you see is what you get" tint
- Tint is independent of metal type
- Tints only; does not cover underlying color surface
- Can be added to clearcoats for tint and protection in one step

CONS

- Loose dyes are fragile on the surface
- Needs secondary process to "set", "bind", or "affix" the colored tint to the surface
- Does not protect the underlying metal from oxidation

Skill level: low

Durability: low

Range of effects: medium

Toxicity: low

Availability: medium to high

Ease of application: high

Chemical metal plating on steel

Paint on steel

Chemical metal plating

A reactive, coloration process where an applied chemical reacts with the metal surface, resulting in a secondary metal precipitation that is chemically bonded to the surface of the parent metal. This secondary metal is real metal available for coloring.

PROS

- Can change the look of the surface to be that of a different metal
- Precipitates actual second metal layer available for reactive and non-reactive coloring
- Achieves differing patina results than original parent metal would yield

CONS

- Thin plated layer is easily worn through with abrasive burnishing or highlighting
- Aggressive reactive processes will go beyond the thin second metal layer into the parent metal
- There are only a few chemical plating choices
- The application method dictates the uniformity of the plated metal
- May not protect the underlying metal surface from oxidation

Skill level: medium to high
Durability: low to medium
Range of effects: low
Toxicity: medium
Availability: medium to high
Ease of application: low to high

Paint

A non-reactive, layered coating system providing an opaque color and protection in one. Pigment is mixed with a sealing binder that becomes a durable layer on the material surface. Underlying metal protection strength comes from the combination of applied layer thickness, adhesion to the base surface and subsequent paint layers, and the opaqueness of the color (UV protection).

PROS

- Opaque color and protection in one step
- Uniform colorant
- Repeatable coloration process
- Many color options are available
- Color is independent of material type
- Can be applied to most materials

CONS

- Opaque colorant; covers and "hides" the base material
- Uniform coloration
- Little ability to adjust color once it has been applied to the surface

Skill level: low
Durability: high
Range of effects: low
Toxicity: low to high
Availability: high
Ease of application: high

Dyed liquid clearcoat on steel

Dyed paste wax on steel

Dyed liquid clearcoat

A non-reactive, layered coating system providing a translucent (tint) color and protection in one. Dye is mixed within a clear, sealing liquid binder that becomes a durable layer on top of the material surface. Underlying metal protection strength comes from the combination of applied layer thickness, adhesion to the base surface, and the UV inhibitors present in the dyed liquid clearcoat.

PROS

- Translucent color and protection in one step
- Showcases the underlying surface
- Can be used to tint underlying colorations
- Uniform colorant
- Repeatable coloration process
- Many color options
- Color is independent of the base material type
- Can be applied to most materials

CONS

- Uniform tinted coloration
- Little ability to adjust the color once it has been applied to the surface

Skill level: low

Durability: high

Range of effects: low to medium

Toxicity: low to high

Availability: medium to high

Ease of application: high

Dyed paste wax

A non-reactive, layered coating system providing a tint color and protection in one. Dye is mixed within a clear, sealing paste wax with binders that form a semi-durable layer on the material surface. Underlying metal protection strength comes from the combination of hardness of the cured wax, adhesion to the base surface, and the UV inhibitors in the dyed paste wax.

PROS

- Translucent color and protection in one step
- Showcases the underlying surface
- Can be used to tint underlying colorations
- Uniform colorant
- Repeatable coloration process
- Many color options
- Color is independent of the material type
- Can be applied to most materials

CONS

- Uniform tinted coloration
- Underlying surface/coloration must be stable before applying
- Little ability to adjust the color once it has been applied to the surface
- Not as durable as other colored coatings

Skill level: low

Durability: low to medium

Range of effects: low to medium

Toxicity: medium to high

Availability: medium to high

Ease of application: high

Metal coating on steel

Color anodizing on aluminum

Metal coating

A non-reactive, coating system containing real metal filings suspended in a clear binder. Coating is applied onto most any material surface, much like paint, but the filings are available for reactive chemical patina applications.

PROS

- Can be applied to most material surfaces
- Can change the look of the surface to be that of a different metal
- Achieves metal patina reactions on non-metallic or non-reactive substrates
- Achieves differing patina results than the actual parent metal would yield

CONS

- A multi-step process
- Relies on good surface layer adhesion for durability
- Binder may not be very abrasion resistant
- Filings may add texture to the surface
- May not stand up to hot processes
- Best patina results are achieved when applying to wet coating; may limit application methods
- Porous materials will need to be sealed before application

Skill level: low
Durability: medium
Range of effects: high
Toxicity: low
Availability: medium
Ease of application: high

Color anodizing

Anodizing is a reactive, electro-chemical process that forces accelerated oxidation of the metal surface. This clear oxidation build-up is porous and tightly metallurgically bonded to the metal. Dyes can be introduced into this porous layer to provide an attractive and durable finish color. Aluminum is the most commonly anodized metal.

PROS

- Translucent color and added protection in one step
- Uniform colorant
- Repeatable coloration process
- Dye process showcases the underlying surface
- Many color options are available
- Very durable coloration process

CONS

- Uniform tinted coloration
- Limited metal applications
- Little ability to adjust color once it has been applied to the surface
- Scale of application is based on size of process tanks

Skill level: medium to high
Durability: high
Range of effects: low
Toxicity: medium to high
Availability: low
Ease of application: low to medium

A NOTE ON COLORATION PROCESSES USED IN THIS BOOK
This chapter discusses a number of reactive and non-reactive coloration processes available to jewelers and metalsmiths, but by no means is it an exhaustive listing. Some processes have been mentioned here only for comparison purposes—to help the reader understand enough to make sound decisions on which method is most appropriate to you and your work.

The focus of this book in subsequent chapters is metal coloration through more unique reactive processes, namely patinas, and a few coloration methods that can be used in lieu of available reactive colors or to augment the patinas. The processes chosen to discuss at length are most accessible to the metal artist, while still showcasing the metal in some manner. Furthermore, the colorations detailed in this book can all be adjusted after they are applied, either in an additive or subtractive manner. Some additional information is warranted for the following coloration processes not used in the book:

Paint
Most people understand how paint is applied and can be used to visually color a surface. Paints are coating systems that may require a primer to be applied as the first layer. Ensure you choose paints that are appropriate for metal surfaces. Paints are opaque and will completely cover the applied surface. A well-painted surface may hide clues that the material is in fact metal. Paint is not easily manipulated after application because it consists of a pigment plus a binder that adheres to the surface. Paints will however color and protect the surface all at once.

Dyed liquid clearcoat and paste wax
Using translucent colored clearcoats can be a great way to tint the underlying surface color. Dyed clearcoats can be purchased or made by adding a soluble dye to a liquid or paste wax clearcoat. The translucency still showcases the underlying surface, unlike opaque paint. They also have the advantage of tinting and protecting all-in-one, but like paint, are more difficult to adjust the color once applied.

Metal coating
Metal coatings, sometimes called metal surfacers, are usually acrylic solutions with metal filings mixed in. The filings can be copper, brass, bronze, iron/steel, etc. and are best purchased from a patina or finishing supplier. The real advantage of the coatings is that once applied to any surface, the metal filings are available for reactive and non-reactive colorants. This process has limitations, but can be used to create patina colorations on the surfaces that do not typically yield the reactive colors desired.

Color anodizing
Anodizing is a durable dyeing process. Small anodizing equipment can be purchased for jewelry scale objects. Anodizing takes advantage of the porous clear oxidation found on select metals, namely aluminum, in which a dye is introduced to tint the surface. The anodizing process does not work for most metals, and is a difficult coloration to adjust once applied.

Variables affecting colorations

There are some key variables to be aware of that can affect the overall quality and aesthetic feel of metal colorations. These variables become more important to control when looking for consistent results. Some variables are specific to reactive colorants, but most apply to both reactive and non-reactive colorants.

Metal composition

Coloring metal with a reactive process involves two primary components: the chemicals specific to the process and the composition of the metal the chemicals are to be applied to. An identical chemical patina solution may yield a completely different coloration when applied on one metal family type to the next (i.e. copper versus steel), but also may have a different coloration quality when applied to metals within the same family (i.e. 230 brass versus 260 brass, each with differing amounts of alloyed copper and zinc).With the alloys, the percentage of each element can strongly influence the natural metal color and the reactive patina coloration or plating process. There are many alloys available and, if your goal is consistent coloration results, it is best to be consistent with the alloy type you use.

Reactive colorant on steel

Identical reactive colorant on copper

Reactive colorant on 230 brass

Identical reactive colorant on 260 brass

Metal color and luster

The bare metal color and luster, or shine, can have an influence on the overall coloration anytime it is allowed to show through the overlaid color. This is true with reactive colorants as well as non-reactive colorants. Translucent colorations and techniques such as burnishing to remove the color, masking, and any application method that does not uniformly cover the metal surface with colorant can all showcase the bare metal color and shine.

Burnished coloration on copper

Coloration over masked aluminum

Translucent coloration on bronze

Bury application on brass

Surface quality

Surface quality refers to the relative smoothness, or lack thereof, of the metal object. Surface texture can be a result of hammering, or abrasive processes such as sanding or media blasting. Reactive and non-reactive colorations that are allowed to set into a depression, or crevice, will appear darker to the eye. The colorant pools in the valley of the surface, effectively increasing the colorant concentration. Metalsmiths often take advantage of this to purposely add variegated results to the work. Sometimes, added contrast between the high and low surface is amplified by brushing back, or burnishing the high spots to further remove color. Uniform colorations can visually hide surface texture; ensure that the purposeful texture on the metal object stands out to the viewer.

Coloration on abraded steel surface

Coloration on hammer-textured copper

Poor initial chemical cleaning on steel

Fingerprint contamination on copper

Chemical formulations

Reactive and non-reactive colorants will yield different coloration qualities based on the concentration of the solution used. Water-based colorant solutions are part colorant to part distilled water, with increased colorant amount making for a more concentrated, stronger solution. A more concentrated solution may speed up the coloration process, decrease the value (darken the color), or may change the color completely.

Surface cleanliness

Metal surface cleanliness may be the biggest and most easily dealt with variable of all, but the variable most metalsmiths do not pay enough attention to. Thorough cleaning of the metal is necessary to ensure quality and consistent coloration results. Metal cleanliness should be thought of in two parts: mechanical cleaning and chemical cleaning.

Mechanical cleaning, if necessary, is typically the first step in the finish process. It's used to remove unwanted discoloration, oxidation, and loose scale from the surface of the metal. Mechanical cleaning brings the metal to a uniform base color quality and removes unstable material that could flake off after the finish is applied, taking the finish color and coating with it. Mechanical cleaning processes include: grinding, sanding, polishing, and power brushing, each having a specific tool mark aesthetic. Make a purposeful decision about what should be cleaned mechanically, and with what process to ensure you have the proper surface quality to start the coloration process on. In general, a more uniform surface will equal a more uniform finish color—but some discoloration from the fabrication process and natural oxidation may be desirable. All that is absolutely necessary to mechanically clean is the poorly adhered components on the metal surface; everything else is an aesthetic decision.

A thorough chemical clean of the metal surface should be done after all the necessary mechanical cleaning has been completed and just prior to the finish coloration process. Chemicals such as pickling solutions can be used to clean the surface of flux residue and oxides from the fabrication process, achieving similar results to some mechanical cleaning methods. The other purpose of chemical cleaning is to remove oils and greases from physical handling. It is safe to say that all coloration processes will be negatively affected if the surface is left with contamination. At the very least, this will cause poor adhesion of any coating system. However, with water-based products, the oils will impede the wetting of the surface with the colorant. Oil and water do not mix, and a poorly chemical cleaned surface can yield spotty coloration results.

Color change on bronze:
1x ammonium chloride

Color change on bronze:
10x ammonium chloride

Oxidation speeds on brass:
1x ammonium hydroxide

Oxidation speeds on brass:
3x ammonium hydroxide

Color value on copper:
1x sulfurated potash

Color value on copper:
3x sulfurated potash

5 mins 10 mins 20 mins 30 mins

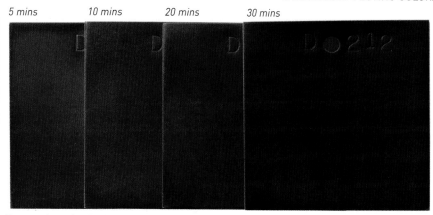

Progressive color development with longer durations on copper

Environmental factors

Some environmental factors that can have a slight effect on reactive colorations (such as ambient temperature and humidity) are too difficult to control. These conditions are best allowed to naturally fluctuate within normal limits and contribute to the variability of the process.

However, there are two factors in the reactive process that can easily be controlled: the chemical reaction time allowed and the temperature of the reaction process. With certain types of reactive processes, both can be important in determining the final outcome of a reactive coloration.

Many reactive processes continue to develop while the solution is in contact with the metal surface. Some processes even require a step to rinse, or neutralize the chemical from the surface to completely stop the reaction. Often, the longer the chemical is allowed to react, the more developed the coloration becomes.

Also, certain reactive chemicals can be applied either cold or hot, often with the coloration quality being quite different between the two methods.

Application method and quality

Different colorant application methods will be discussed at length in the next chapter, but you should be aware that varying the application method and quality can have a significant effect on the coloration. The various application methods and tools all lay the colorant on the metal surface in unique ways. Choose the method that best provides the desired colorant coverage and application effect you desire.

Brushed colorant on sterling silver

Sprayed colorant on sterling silver

Metal surface protection

Many metal colorations do not act as protection against further metal oxidation which can change the surface color over time. Furthermore, the coloration may be fragile, having a "loose" or "chalky" consistency requiring a binder to "set" it to the metal surface, similar to a fixative used with charcoal and pastel media. For these reasons, clearcoats are often used as a final layer over the coloration (or even over the bare metal surface). You must choose the appropriate clearcoat for your purposes.

Clearcoats can be simply categorized as liquid and paste wax. A further breakdown into carrier and binder-type can be made, but is beyond the scope of this book. Liquid clearcoat lacquers,

urethanes, acrylics, and varnishes are indeed chemically different, but can be thought of as similar for most applications. Choose a liquid clearcoat that is good for bare metal use, has the desired level of gloss, and has an appropriate level of abrasion and ultra-violet (UV) light resistance. Durable paste waxes used for metal protection are usually a mix of natural and synthetic wax types, with hardeners and UV inhibitors added.

Most clearcoats tend to darken a color slightly, due to the different light refraction compared to an uncoated color. For this reason, it is always best to test the clearcoat on a sample to see how it affects the specific coloration.

Clearcoats can be tinted with a suitable dye. Remember, mix like into like. If you are using a solvent-based clearcoat, you must use matching solvent-based dyes. If you are using water-based clearcoats, water-based dyes will work. The relative value of tint coloration can be directly controlled with either the dyed clearcoat concentration or with the number of dyed clearcoat layers applied. Note that a clearcoat (tinted or not) can be perfectly durable for the given application, but it is never as durable as an appropriately painted finish. This has to do with the UV light eventually breaking the bond between the transparent or translucent clearcoat and the underlying surface. The opacity

Layering dyed clearcoat

Using a translucent, dyed clearcoat is one way to add color directly to the metal surface or augment another coloration process. The overall color value (light to dark) of dyed clearcoats can be adjusted in two ways, both yield the same translucent coloration results. Method one is to mix a stronger solution by adding more dye to the same volume of clearcoat. The more dye added, the darker the tint will be. Method two is to apply multiple layers of the dyed clearcoat, each tinting the underlying coloration slightly more, getting darker with each layer.

One layer of brown dyed liquid clearcoat on steel

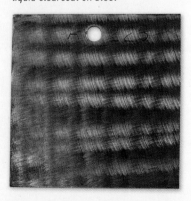

Two layers of brown dyed liquid clearcoat on steel

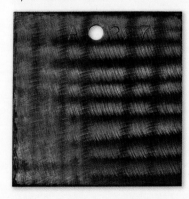

Three layers of brown dyed liquid clearcoat on steel

of paint absorbs the UV light before it reaches the underlayer, making for better coating adhesion, and a more durable finish.

If you decide to forego adding a protective layer you should be aware that the coloration and/or underlying metal surface will be vulnerable to further oxidation (color change) or degradation from physical contact.

Visual effects of different clearcoats on blackened copper

Each of these tiles had a blackening patina coloration applied to it before being finished with a clearcoat. Notice how applying a clearcoat, or omitting one can have a real impact on the appearance of the coloration.

No clearcoat on blackened copper

Gloss liquid clearcoat on blackened copper

Satin liquid clearcoat on blackened copper

Matte liquid clearcoat on blackened copper

Paste wax clearcoat on blackened copper

Four layers of brown dyed liquid clearcoat on steel

Liquid clearcoats These can be brush or spray applied, with spraying usually resulting in a finer finish. Multiple lightly applied layers help set chalky colorations and protect the surface from physical contact and abrasion. It is important to follow the clearcoat manufacturer's application recommendations for best results. Liquid clearcoats are available in matte (flat), satin (semi-gloss), and gloss, but keep in mind that each may vary from brand to brand. A matte clearcoat will dull any existing shine of the metal surface or coloration. UV inhibitors are more prevalent in higher-priced clearcoats, and should be considered when protecting objects that are exposed to high amounts of sunlight. Two-part liquid clearcoats are more expensive and involved to use, but offer better durability than a comparable single-part liquid clearcoat. Choose what is most appropriate for your application.

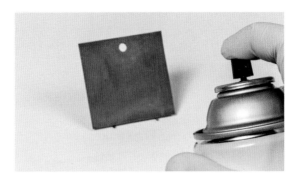

1. Choose the gloss, satin, or matte that best fits your coloration. Shake aerosol can for time specified on instructions. Point the nozzle perpendicular to the metal, at a distance of 8–10 inches (20–25 cm) from the surface.

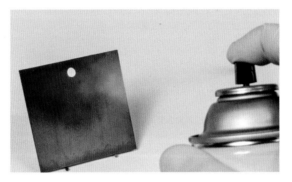

2. Spray with a smooth motion along a horizontal or vertical line, from one end of the surface to the other. Release the nozzle. Return to starting position and spray another path, slightly overlapping the first. Continue until the entire surface has been uniformly covered.

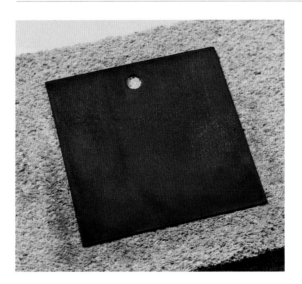

3. Allow the first coat to dry for the time specified by the manufacturer before applying the second coat. Apply 2–3 light coats, each at 90 degrees to the preceding, for maximum protection. Allow the clearcoat to cure for full hardness.

Paste waxes Most durable paste waxes are a mixture of hard and soft waxes, hardeners, and UV inhibitors, in a solvent-based carrier. Waxes form a translucent, clear, protective coating when applied to the metal or colored surface and the excess buffed out. The look can be best described as a "soft luster," due to wax being visually less clear than most liquid clearcoats. Once hardened, wax offers a reasonable amount of protection against handling and abrasion, but never as much as properly applied liquid clearcoats. Paste wax must be applied using physical contact with the metal or colored surface, which could smudge fragile, chalky colorations. Often a color is "set" first with a spray liquid clearcoat and then wax is applied as a second layer for aesthetics once the first has cured.

The process of waxing a metal surface is like waxing anything: lightly apply the paste wax to the surface in a uniform manner, allow the wax to set (initial hardening), and buff off the excess wax. Excess wax build-up that is allowed to stay on the surface will usually turn chalky as it cures and is more difficult to remove.

Paste waxes can be found specifically formulated for metal art, with a higher degree of hardeners and inhibitors, or be more easily sourced as common furniture or car paste waxes. Choose the wax appropriate to your application needs.

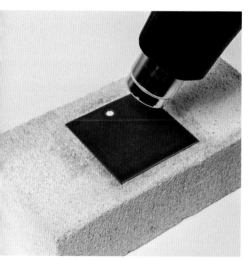

1. Warm the surface of the metal either with a heat gun or air/fuel torch depending on metal thickness. The surface should be warm to the touch, opening the metal pores to accept the wax.

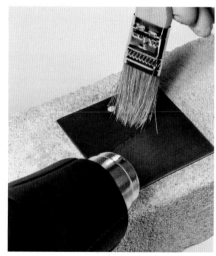

2. Load a bristle brush with the paste wax and lightly apply the wax uniformly to the metal surface. Properly warmed metal will melt the wax on contact, but will not burn the wax. If the surface smokes when applying the wax, the metal is too hot.

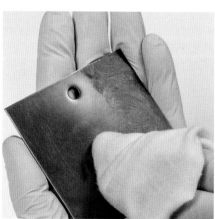

3. Allow the metal to cool to room temperature and the wax to set. Do not wait too long as the wax will become more difficult to buff out. Buff the excess surface wax using a clean, soft, lint-free cloth.

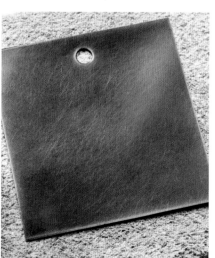

4. A properly waxed metal surface will have a soft luster compared to liquid clearcoats.

Surface preparation and colorant application

The methods you choose to clean the metal surface and apply colorants yield vastly different aesthetic results. This section begins by looking at the metal surface quality and at the functional and aesthetic reasons for different surface cleaning methods. The variety of colorant application methods and surface effects that are available to the metalsmith are also explored here.

Surface preparation: mechanical cleaning

Typically, the first stage of preparing the metal surface for a satisfactory coloration is to mechanically clean it. With mechanical cleaning, an abrasive medium is physically moved across the surface of the metal. The coarseness of the abrasive medium, the pressure applied, and the movement across the surface all control the cleaning action, and dictate final surface quality. All methods of mechanical cleaning affect the metal surface quality to some degree that may or may not be visible under the coloration. A mechanical clean is not always necessary if you want to retain the as-fabricated surface; in these cases, only perform a chemical clean.

Mechanical cleaning is used to remove any loose substances from the surface that could affect coloration adhesion. Mechanical cleaning is also used to unify the bare metal surface quality in color, shine, and smoothness. Uniform colorations start with a uniform bare metal surface. A mechanical clean will provide a "tooth" for better coloration development and adhesion, especially with certain cold-process patinas. The abrasive tool creates peaks and valleys on the metal surface. The more coarse the abrasive action, the greater the peaks and valleys (or tooth) developed. The tooth increases the surface area for the colorant to act upon. However, this tooth can also be noticeable. Coarser abrasives leave a rougher surface.

A mechanical clean should always be followed with a chemical clean to remove any abraded residues.

Hand scouring

Hand scouring is a manual mechanical cleaning method where an abrasive pad is hand-rubbed on the metal surface. Manual cleaning has the advantages of better control of the abrasive action and better ability to work on delicate and irregular surfaces compared to powered mechanical cleaning methods, but is slower and requires more effort. Hand scouring will yield a very small, or light tooth. The abrasive pad can vary in coarseness and be synthetic (or plastic) wool, steel wool, emery cloth, etc. Choose the material and coarseness that best suits your functional and aesthetic needs.

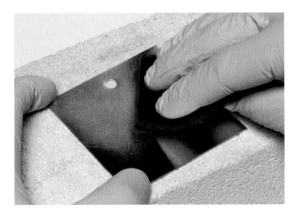

Firmly rub the abrasive pad on the surface in a pattern that ensures uniform cleaning with the appropriate abrasive "toothed" pattern. For less of a patterned look, abrade a second time at 90 degrees to the first. Here, a medium grit synthetic wool pad is worked in a small, overlapping circular motion across the copper surface.

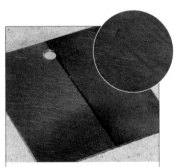

The finished result
The medium grit synthetic wool leaves a matte finish on the bare copper, with the visible pattern developed by the circular scouring movement (left side). This pattern and surface quality are still evident under the translucent liver of sulfur patina (right side).

Media (sand) blasting

A media blaster is an air-powered sprayer that propels abrasive particles at the metal surface. The combinations of abrasive media type, air pressure, and proximity of the spray nozzle to the surface dictate the abrasive cleaning power and the developed tooth. The more coarse and aggressive the blasting, the quicker the cleaning and the greater the tooth left on the metal surface. Common mediums used for blasting include (from more coarse to fine): aluminum oxide sand, glass bead, and walnut shells. The advantages of media blasting are the uniformity of cleaning action and developed tooth, the ability to clean otherwise difficult to reach areas, and the ability to change media and blast velocity for heavy cleaning to fine, delicate work. Surface quality aesthetics aside, media blasting prepares the metal surface best of all the mechanical cleaning methods.

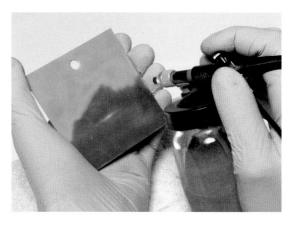

Fill the media blaster with the chosen abrasive (here, aluminum oxide is being used for bare copper) and set the air pressure to the manufacturer's recommended setting based on medium used. Hold the blaster nozzle approximately 3 inches (7.5 cm) from the metal surface and begin cleaning. Remember that air pressure and nozzle distance can be adjusted to alter the cleaning characteristics. Move the blaster spray across the metal until a uniform clean has been achieved.

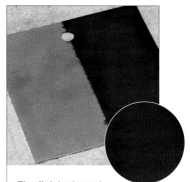

The finished result
Most blast mediums will leave a matte, somewhat "grainy" texture on the metal surface. The bare copper (left side) has this typical sandblasted look: uniform, matte, textured to the size of the abrasive particles. This sandblasted aesthetic is noticeable under the translucent liver of sulfur patina (right side), especially when compared to other mechanical cleaning methods.

Power bristle brushing

Using a bristle brush attachment on a power rotary tool is a great way to clean metal surfaces of loose scale and heat discolorations. Unlike most other mechanical cleaning methods, power brushing is not considered an abrasive process. With the proper bristle material selection (softer than the metal surface) no metal is removed during the brushing operation. This makes it an ideal method to unify the base metal surface quality prior to coloring. Power brushing leaves an "as-brushed" surface; the brush markings dictated by the bristle material, the brush configuration, and the way in which the tool is moved across the surface.

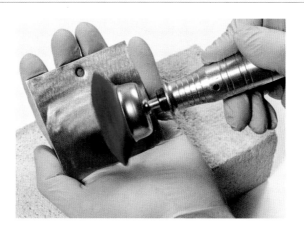

Choose a power brush suitable for the cleaning job at hand. For more aggressive cleaning and pronounced brush marks, use a stiff bristle configuration with a bristle material equal to or harder than the metal surface. For less noticeable brush patterns, use a more flexible bristle of equal or softer material. Here, a plastic bristle cup brush is used at a medium speed on the bare copper surface.

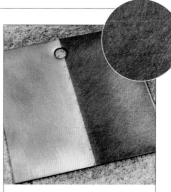

The finished result
The as-brushed surface from the softer, flexible plastic bristle power cup brush leaves a surface quality with only slight circular scratches in the copper surface (left side) but that can still be noticeable under even a darker, translucent liver of sulfur coloration (right side).

Power grinding wheel

Power grinding using an abrasive stone wheel is considered the coarsest of the abrasive processes. It is typically reserved for quick removal of relatively large amounts of metal, and leaves the roughest surface of all the cleaning methods. Because of the coarse abrading nature, grinding exposes fresh, shiny metal with a heavy tooth that is very noticeable to the eye and touch. Choose a grinding stone if you want the heavy toothed surface to become part of the aesthetic, even with darker, more opaque colorations.

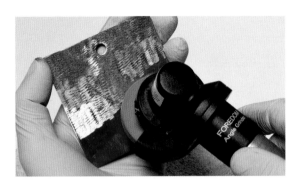

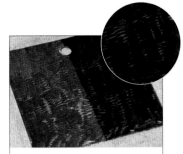

Set the rotary tool to a medium–high speed and move the wheel across the metal surface with light pressure. Too much pressure will result in unwanted gouges. Here, a grinding wheel is worked in short, vertical patterns on the bare copper.

The finished result
The heavy-toothed, typical "as-ground" surface of the bare copper (left side) is rough enough to catch it with your fingernail. This coarseness is still obvious after a dark, liver of sulfur patina coloration (right side).

Power sanding disc

The next set of abrasives finer than grinding is sanding. Like wood sanding, metal sanding abrasives come in grit numbers, with the higher numbers leaving a finer finish. The sanding operation is still quite abrasive, so it will not only leave a toothed surface but will also create a shiny surface. Sanding discs have the abrasives bonded to a stiff backing paper suitable for use with high-speed rotary tools.

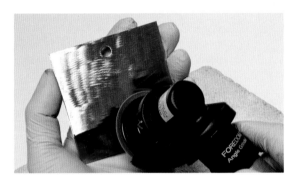

Choose the appropriate sanding grit for your purposes. Set the rotary tool to a medium–high speed and work it across the metal uniformly. Here, an 80-grit sanding disc (medium grit) is moved in short lines on the copper surface.

The finished result
Compared to the grinding wheel, this method yields a lighter tooth on the bare copper (left side), but is still rough. This affects the look of the translucent liver of sulfur patina (right side).

Power flap disc

A flap disc is a sanding disc with overlapping multiple flaps of abrasive paper rather than the single flat paper of the conventional sanding disc. Flap discs are sold in grit coarsenesses as well, but for a given grit—say 120-grit—the flap disc will leave a finer, smoother surface than a comparable sanding disc. Most colorations will cover the surface pattern created by this method.

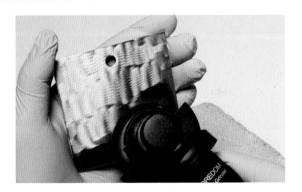

If heavy surface cleaning is required, start with a coarser method, then overlay the flap disc process for aesthetics. Choose the appropriate grit flap disc. Set the tool to a medium–high speed. Work the disc across the surface.

The finished result
The 120-grit disc gives a shiny, smooth surface with light tooth on bare copper (left side). These qualities are seen only with the lightest, translucent coloration as per the liver of sulfur patina (right side).

Power synthetic wool disc

Using an abrasive similar to the hand scour cleaning method, the synthetic or "plastic" wool disc on a power rotary tool blends the surface to a smoother, more uniform surface quality. Synthetic wool discs come in a variety of grits, from very fine to coarse, but all are considered more of a blending abrasive. If heavy surface cleaning is necessary, it may be best to start with a more aggressive method. The abrasive grit and rotary tool speed will dictate the surface finish.

Pick the appropriate grit of synthetic wool disc. Set the rotary tool on medium–high speed and work the disc across the metal surface. Move the disc in a motion that develops the surface pattern desired. Here, a medium-grit synthetic wool disc is moved randomly on the bare copper surface to clean uniformly, with a directional, linear pattern created as a following step.

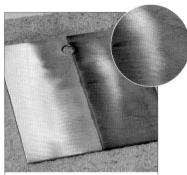

The finished result
The slight circular patterned tool marks left by the medium-grit power synthetic wool disc are consistent, but still evident both on the bare copper metal (left side) and under the light, translucent liver of sulfur patina (right side). The tooth is light enough for a darker, or more opaque coloration to conceal the surface markings.

Polishing

Polishing is the finest of all abrasive surface treatments. Progressive grit polishing compounds and polishing wheels are used to eliminate surface scratches and tooth from previous abrasive processes. The polished surface also has the greatest luster, or shine, with mirror-like reflective qualities possible. Some reactive colorations yield more brilliant results with high-luster surfaces. Because of the lack of tooth, polished surfaces are the most difficult for colorations to adhere to. Perform a thorough chemical cleaning of the surface to remove the waxy polishing compounds before any coloration is applied.

Most coloration processes will hide the light tooth of other fine abrasive processes. Choose to polish the metal only if the luster and smoothness really affect the overlying coloration. For the highest polish, progress through polishing compounds from coarse to smooth, using a separate polishing wheel for each. Here, a suitable intermediate compound is used on the bare copper, with the rotary tool on high speed.

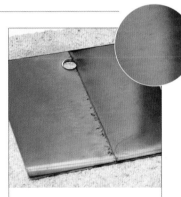

The finished result
Notice how the surface quality of the polished bare copper (left side) with the shine and smoothness is allowed to influence the very light, translucent liver of sulfur patina coloration (right side).

Surface preparation: chemical cleaning

Chemically cleaning the metal involves bathing the surface in a cleaning solution to remove any oils and greases left from the fabrication process or physical handling. The most aggressive chemical cleaning solutions are acidic and can remove light scale and oxidation along with the oils and greases. The acidic bath also slightly etches the metal surface yielding a light tooth for the colorant to act upon. The most gentle cleaning solutions use ordinary mild soap and water to remove the contaminants. Choice of which chemical cleaning method to use can depend any of the following:

• Metal type
• Size of your metal piece
• How much cleaning is necessary
• Accessibility
• Desired final surface quality

 If the metal surface is highly oxidized, consider mechanically cleaning the surface first so a less aggressive chemical cleaning method may be used.

 Always perform some chemical cleaning of the metal surface immediately before applying a colorant, whether the metal has been mechanically cleaned or not. Even the oils from your fingers can impede a colorant (reactive or non-reactive) from wetting the metal surface, and poor coloration results will follow. Wear clean gloves anytime you handle the metal object to avoid contaminating the surface. Put the gloves on before you begin the chemical cleaning process, and always have them on throughout the coloration process until after the clearcoat has been applied and is cured.

Hot pickle bath

A hot pickle solution is traditionally an acidic warm bath used to dissolve flux residue and oxides and remove oils and greases from the metal surface. The acid also slightly etches the surface, giving microscopic peaks and valleys, or tooth, for better color development and adhesion. Pickle solutions are readily available, but most are suitable for non-ferrous metals only, as the acidic pickle will rust the ferrous metal too quickly. The main drawback with hot pickle baths is that your metal object must be immersed in the solution; pickle baths become impractical for larger objects.

1 Immerse the metal object in the warmed pickle bath at the temperature and for the period of time specified by the pickle manufacturer. Choose a solution and strength appropriate to your metal and cleaning needs. Follow the pickle manufacturer's instructions and safety precautions closely.

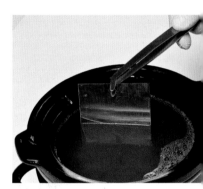

2 After the pickle cleaning process is complete, rinse the metal object thoroughly in clean tap water to neutralize the acid and wash off the contamination. Once dry, the surface is ready to accept the coloration process.

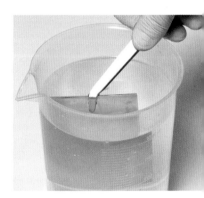

SURFACE CONTAMINATION
No matter how good the mechanical clean, a poor (or non-existent) chemical clean is likely to result in poor coloration results as oily contamination from the fabrication process or from fingerprints will impede the water-based colorants from "wetting" the surface of the metal.

Inefficient cleaning
Note how a poorly chemically cleaned surface causes the colorant to "bead" when applied, not allowing the colorant to sit on those areas of the surface.

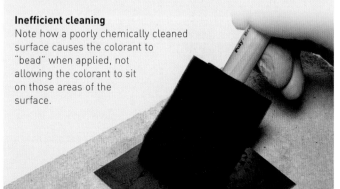

Phosphoric acid and trisodium phosphate

Both phosphoric acid and trisodium phosphate (TSP) are readily available solutions (sold as cleaning preparations for painting metal surfaces) that can be used to clean any metal surface, ferrous or non-ferrous. The advantage of each is that both can be applied cold with a brush or sprayer, so are more suitable for larger surfaces.

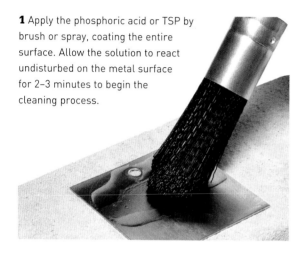

1 Apply the phosphoric acid or TSP by brush or spray, coating the entire surface. Allow the solution to react undisturbed on the metal surface for 2–3 minutes to begin the cleaning process.

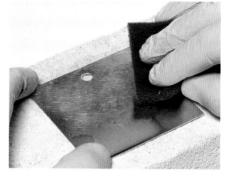

2 After the phosphoric acid/TSP has reacted for a few minutes, wet burnish the surface with a synthetic wool pad. Use a fine grade abrasive pad and light pressure for general cleaning. More oxidized metal surfaces may require a coarser abrasive pad and/or multiple cycles of new solution wetting to thoroughly clean. The more aggressive the burnishing, the more visible the tooth of the abrasive will be.

3 Thoroughly rinse the metal in tap water to neutralize the chemical and remove any contamination or residue. Dry the surface well before beginning the coloration process.

Acetone wipe

Acetone is an industrial chemical with various purposes in metal finishing. First, it removes oils and greases. Acetone will not dissolve scale or flux residue, and by itself will not alter the quality of the metal surface. Use the acetone cleaning method as a light-duty oil- and grease-only cleaner, and as a quick re-clean prior to the coloration process. Acetone also evaporates immediately and removes much of the surface moisture, leaving no residue. A quick acetone wipe after any other chemical cleaning method involving a water rinse will ensure the metal surface is moisture free before coloration.

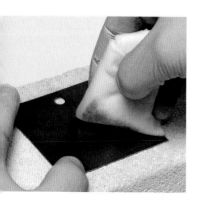

Saturate a rag with acetone and liberally wipe the surface of the metal until no residue is seen on the rag. Use a fresh rag, applying more acetone as often as necessary to ensure cleanliness.

Mild detergent and water

The most benign of all cleaning processes, mild detergent and water is great for light-duty cleaning of oils and greases. Common liquid dish soaps work well as the detergent.

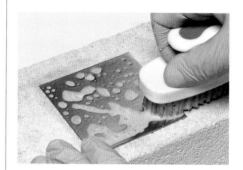

1 Choose a soft-bristled brush, such as a fingernail brush, and work the soapy solution onto the metal surface in small, overlapping circular patterns to ensure uniform cleaning.

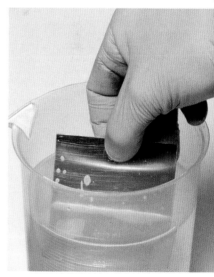

2 Rinse the detergent off the metal surface with tap water to remove the residue and oils that have been loosened. Any detergent solution that is left behind could affect the coloration process, so rinse well and dry before starting the coloration process.

Preparing colorant solutions

Whether reactive or non-reactive, many colorants have to be mixed as a multi-component recipe, diluted to a suitable strength, and/or made into a more application-friendly form. This involves measuring of liquid and solid components and thorough mixing of all the ingredients to a uniform colorant solution.

For safety, consistency, and contamination reasons, always use clean, inert metal (stainless steel), plastic, or glass measuring devices, mixing bowls, stir rods, etc. Colorants in concentrated form should always be mixed into the diluting water. The first opportunity to vary the final color quality (hue, value, intensity, or saturation) is with the solution strength; experiment and record your results. In general, weaker solutions of either less colorant or more distilled water will yield a lighter initial coloration and allow for a more gradual build-up of color. Mix only the estimated amount of colorant solution needed for the project, as most dry, raw colorants have a longer shelf life than mixed solutions. Be sure to store excess color solutions in suitable glass or plastic containers with tight fitting lids for future use, and to dispose of the waste solution properly. Remember, "If in doubt, throw it out" – contaminated colorants or solutions will yield inconsistent results. It's best to start with fresh if you may have accidentally cross-contaminated a batch.

Measuring distilled water by volume or weight

When mixing colorants (reactive patina chemicals or non-reactive pigments or dyes), always use distilled water rather than tap water; distilled water is free of minerals that could have an adverse effect on consistent colorations. The given recipe will call for a specific amount of distilled water, either as a volume or weight.

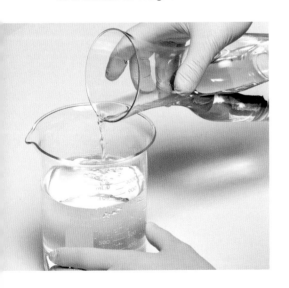

Pour the distilled water into a beaker with a graduated scale until the required volume for the recipe is met. Read the liquid measure at the bottom of the meniscus, the lowest point of the liquid level. If given as a weight, pour the distilled water into a zeroed out container on a weight scale until the proper amount is reached.

Pulverizing dry colorant

Some dry colorants are in larger chunks or lumps. To speed the dissolution in the distilled water, the lump should be broken down into smaller pieces. A non-reactive, non-porous pestle and mortar work well, such as those made from glass, sealed porcelain, marble, or stainless steel.

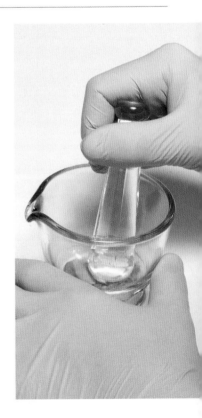

Without regard to exact quantity, place the lump colorant in a pestle and pound with the mortar until it is broken down to a fine powder. Continue breaking down lump colorant until the desired mass or volume has been reached.

Measuring dry colorant by volume

Some older colorant solution recipes will specify the amount of ingredients (dry or liquid) by small volume measurements, typically in teaspoon (tsp) or tablespoon (tbsp) units. For this you will need plastic or stainless steel measuring spoons.

Measure out the correct volume of each colorant with a measuring spoon. A proper dry volume is measured flush with the graduated mark or the level of the spoon. Use a clean spoon for each colorant and place the measured colorant into separate inert bowls to avoid cross-contamination.

Measuring dry colorant by weight

Solution recipes may specify ingredients (dry or liquid) by weight, in ounces or grams. For these, it is best to have a scale with proper resolution at lower weights; 0.1 gram or 0.01 ounce resolution. A small, dual unit digital scale with tare/zero ability is best.

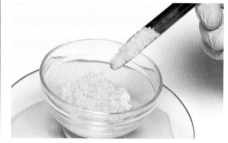

Place an inert, empty container on the scale. Change the scale to the proper units. Zero out the scale with the empty container on top. This will allow for accurate, ingredient-only weights. Add colorant to the container until the desired weight is reached.

Colorant into distilled water

Reactive colorants typically have acidic components to them. As a safety precaution, always pour acid into water and not vice versa. To be consistent and make it easier to remember, pour all colorants (reactive and non-reactive) into distilled water when mixing a solution or tap water when diluting for disposal.

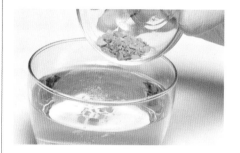

Pour the measured distilled water into an inert mixing bowl. Make sure this bowl is large enough to mix all ingredients without spilling. Dump the measured colorant(s) carefully into this mixing bowl. If multiple ingredients are to be mixed in the solution, follow the instructions for order of mixing.

Mixing the colorant solution

The final step of preparing the colorant solution is to mix the concentrate and the distilled water thoroughly to ensure that the solution is of equal strength throughout for consistent results. As a habit, remix the solution just prior to using in case any separation has occurred.

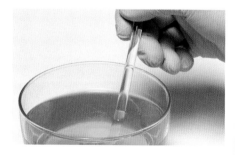

After all the ingredients have been added to the distilled water, thoroughly mix the solution until all the dry components have dissolved and the mixture looks uniform in color. Use a clean glass or plastic stir rod. The solution is now ready to be applied to the metal surface.

Storing excess solution

Many solutions have a long shelf life; if stored properly and remixed, they will have just as good coloration quality at a later date. Some recipes indicate if the colorant solution's effectiveness changes negatively over time, the result being a weakening in solution strength with a lighter or less developed coloration.

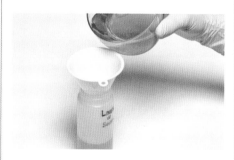

Use an inert container and lid of proper material for storing the colorant solution. Make sure the container is clean and large enough to hold all the excess solution. Use a plastic funnel to avoid spillages. Label the container with the solution strength and date for identification later.

Disposing of excess, contaminated, or waste solution

Waste solution should first be diluted by pouring into a larger container of tap water, and then poured down the drain. Small amounts of highly diluted solutions deserve respect, but are no more dangerous than household chemicals.

Fill a large inert container with tap water. Carefully pour in the waste colorant solution, avoiding splashes. If the container is large enough to dilute more solution, keep it handy until all the waste colorant has been diluted.

Heat oxidation coloration

Aside from allowing mother nature to oxidize the metal surface, using a heat source to color the metal is the simplest method, albeit more difficult to control. When heat is applied to metal, oxidation begins. These heat oxidation (or temper) colors are highly dependent on the metal composition and the temperature to which the metal is heated.

Other variables that affect the outcome are the shininess of the metal surface, the size of the heat source, and the thickness and heat conductivity of the metal, which determine the rate of the temper color development and spread.

Temper coloring as a finish is very durable although, like all reactive colorations, it does not protect the metal from further oxidation. Unfortunately, clearcoats may have a visual effect on the temper colors, with some loss of more faint colors due to the difference in light refraction through the clearcoat layers.

Coloring with the torch

The air-fuel or oxygen-fuel torch is a small source of intense heat, enough to temper color the metal. Common torch types include air-propane, air-acetylene, oxygen-propane, oxygen-acetylene, etc., each having interchangeable tips that can be used to vary the size and pattern of flame. Like painting colors with a brush, choose a torch tip size to produce the desired pattern. Move the torch across the metal surface like you would a paintbrush.

Always wear the appropriate safety equipment when using the torch (goggles and leather gloves) and work on a heat and flame resistant work surface. Be careful when handling the hot metal. Some torches are hot enough to melt the metal; pay attention to your work and only put enough heat into the piece for the coloration.

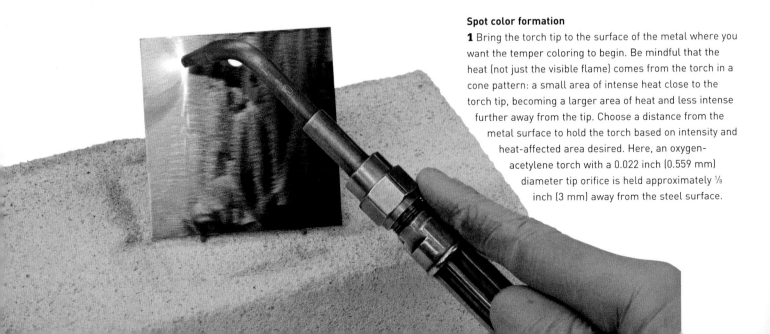

Spot color formation
1 Bring the torch tip to the surface of the metal where you want the temper coloring to begin. Be mindful that the heat (not just the visible flame) comes from the torch in a cone pattern: a small area of intense heat close to the torch tip, becoming a larger area of heat and less intense further away from the tip. Choose a distance from the metal surface to hold the torch based on intensity and heat-affected area desired. Here, an oxygen-acetylene torch with a 0.022 inch (0.559 mm) diameter tip orifice is held approximately ⅛ inch (3 mm) away from the steel surface.

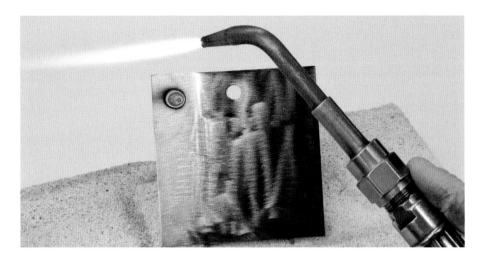

2 Hold the torch tip in one spot above the metal surface. Watch the development of radiating ringlets of color. Once color begins to develop, remove the torch from the metal. Note that the more brilliant colors are further spread from the spot of heat. This is typical of heat temper colorations on most metals.

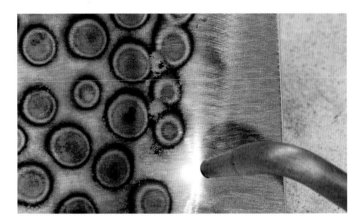

3 Be mindful of the spread of coloration. The intensity of heat on a given metal will dictate how quickly the colors radiate outward. Experiment with tip size, flame size, and distance off the metal surface to control this spreading. Here, the radiating colors have overlapped. If this is not desired, take care to space the central points of heat far enough apart to allow for the banding to spread. It requires some practice to be able to control the color development and spread of colors on the metal.

4 To freeze and lock the temper colors in place, have a tap-water saturated rag ready and spot quench the surface, effectively stopping the heat (and color) spread. Smaller pieces of metal can be submerged in water to control the spread of color.

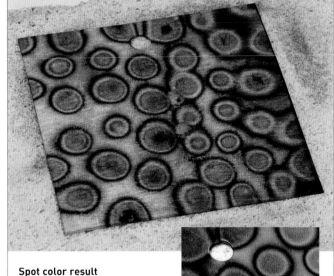

Spot color result
Pictured is a steel tile that has been mechanically cleaned with a flap disc for a high luster quality with minimal abrasive markings prior to the temper coloring process. The temper colors are most brilliant against this luster surface and are translucent, revealing the underlying surface quality of the metal. The spot color pattern is a direct result of the torch "stipple" movement on the surface of the metal.

Here is the reverse side of the same steel tile. The side opposite the heat application can have a slightly different feel to the color development, possibly free of overheated central points and quench blemishes. Although not always possible, decide which side of your metal to heat and rag quench for the best results.

Linear band color

1 Create linear band patterns by using a larger tip size and/or holding the torch further from the surface. Rather than the in/out "stippling" torch motion of spot coloring, move the torch along the surface, "drawing" the color. Here an air-propane torch with a standard tip is held approximately 1½ inches (4 cm) from the steel surface to develop a broader band of coloration.

2 As with spot coloring, quenching the metal to cool and control the spread of temper colors is essential. Again, use a tap-water saturated rag or full immersion to quench the heated area and lock the colors.

3 Note how far above the surface the torch tip is held here: the further away from the surface, the more spread out the heat affected area and the developed temper colors are. Experiment with torch height and travel speed to vary your results.

Linear band results

The steel tile has been prepped with a flap disc for a high-luster, little tool mark quality. Moving the torch from top to bottom, in three distinct columns, created the vertical banding coloration. The organic nature of the color spread is one of the beautiful aspects of heat temper coloring.

Hotplate, oven, or kiln

For more uniform heat temper colorations choose a larger heat source. Any suitably sized hotplate, oven, or kiln can be used as long as it reaches sufficient temperatures for the coloring effect.

The enclosed heat sources of ovens and kilns have the best chance to produce uniform results as they heat the entire object at the same time. An electric or flame hotplate is a directional heat source. The flat surface of the hotplate is heated and the metal placed on this surface. Heat is conducted from the hotplate to the metal to develop the temper colors. Hotplates are an inexpensive heat source for temper coloring. However, they may not produce the most uniform colorations on larger, three-dimensional objects due to the single surface heating design.

The heating element or burner in electric or gas ovens and kilns heats the enclosed air, which in turn heats the metal surfaces. The advantage is a more uniform heat. The disadvantages are cost and availability of ovens or kilns that can reach the heat oxidation color temperatures for all metals.

Practice proper safety by wearing gloves and using tongs when handling any heated metal. Keep all flammables away from these heat sources while they are in use.

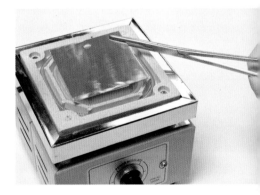

1 Using tongs, place your metal object into or on the heat source. Here, a flap disc prepped steel tile is placed on an electric hotplate. Having a uniform, shiny metal surface quality will help achieve brilliant temper colorations.

2 Keep the metal in or on the heat source and monitor the color change. As with any heat temper coloring methods, the color will change as the metal temperature increases. Here, the steel tile has been non-uniformly heated. Hotplates can have hotspots, i.e. uneven temperatures across the heated surface. The steel is hotter on the left and center portions, as indicated by the color difference. If a hot spot occurs, move the metal on the hotplate to achieve more uniform colorations.

3 When the proper coloration has been achieved, remove the metal object from the heat source with tongs. Discontinuing the heat will slow the heat temper colors from changing and spreading.

4 Immediately quench the metal using tap water. The quench locks the coloration. Use whatever quench method is most appropriate to your object size: an immersion into a quench bath or a wet rag quench. Make certain the quench container can handle the thermal shock of the hot metal object and resultant spike in water temperature. Beware of hot steam arising directly over the quench container opening.

Each metal has its own temper colors achieved at certain temperature ranges.

Steel at 430–445°F (220–230°C)
The temper colors for steel begin with the yellows and browns at approximately 425°F (218°C). Shown is the temper color transitioning from pale yellow to straw color on a high-luster steel surface.

Steel at 470–490°F (245–255°C)
By allowing the temperature of the steel to increase, a deep, golden-brown color is achieved. Note how the metal's surface quality can still be seen through the translucent temper color.

Steel at 530–550°F (275–285°C)
The central portion of the steel tile has a beautiful metallic, dark blue color with a purple radiating ring, indicative of elevated temper temperatures. The center portion saw the greatest heat.

Steel at 565–610°F (295–320°C)
As the steel sees higher temperatures, the temper blues increase in value (become brighter and paler). Shown is the transition into pale blue, which is one of the hottest temper colors available with steel.

Immersion application: cold

The cold immersion process, in which both the metal and the colorant solution are at room temperature, is the most common of the immersion processes. Any colorant that is meant for cold processes can be used, although the process lends itself to quick-working colorations.

The immersion process allows the colorant solution to wet the entire submerged surface at one time, giving a better chance of more uniform results. Most other application processes rely on a "tool" to bring the solution to the metal surface, often applying the solution in a specific pattern that may or may not be desirable. With the immersion process, color lightness or darkness (value) can often be controlled by the amount of time the metal is submerged. Remember to properly chemically clean, rinse, and dry the metal prior to immersing it in the solution; surface contamination will not only affect the color results, but could also contaminate the larger amount of reusable solution as well.

1 Mix enough colorant solution for the immersion process. Pour the solution into a container large enough for the object to be completely submerged. A clear container allows you to monitor the coloration progress. Here, a liver of sulfur patina solution is prepared.

2 If possible, do not use your hands to hold the object during the cold immersion process. The objective is to color the entire object more uniformly and the physical handling could affect the coloration in that area of the metal. Here, an inert stainless steel dipping hanger is being used through the hole in the copper tile.

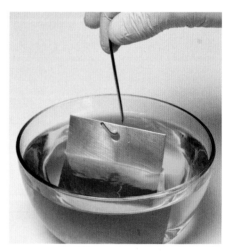

3 Lower the object into the solution until the complete area you want colored is submerged. For some reactive colorations, the length of time that the metal is submerged will greatly affect the color quality. This is the case with the shown liver of sulfur patina.

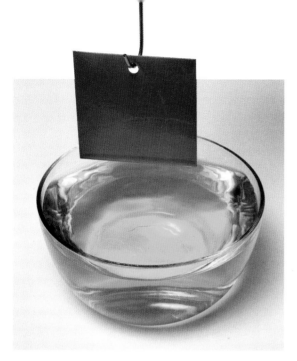

4 When you feel the metal surface has been submerged for the correct length of time, completely remove the object from the solution and inspect it for color quality and evenness. This copper tile was dipped into a liver of sulfur patina solution for a short time, resulting in a golden brown color.

5 In the case of quick-acting colorations, if the color is too light or uneven, re-immerse the object in the colorant solution until you achieve darker or more even results.

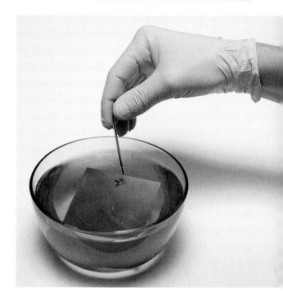

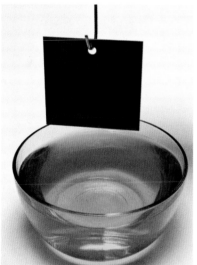

6 Remove the metal from the solution after the coloration has become darker or more even. Here the second immersion of the copper tile in the liver of sulfur solution yields a lower value (darker) brown. Keeping the copper tile in the solution for a longer time at the initial immersion would produce a similar result.

7 With most quick-acting reactive formulations the metal surface must be neutralized to effectively stop the coloration process from continuing. The recipe will indicate this step. Immerse, or rinse the surface with tap water to neutralize.

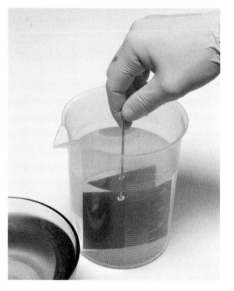

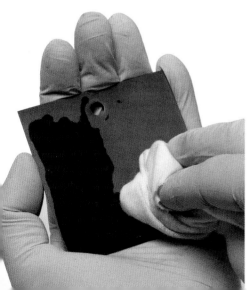

8 After immersing, thoroughly dry the metal surface with a clean, soft cloth and re-examine the coloration. If the color is still too light or uneven, re-immerse the metal in the solution. If the color is too dark, burnish to lighten or increase the color value. After towel drying, wiping the surface with acetone is always a good way to ensure that the surface moisture is gone. The object is ready to be clearcoat protected.

The finished result
Illustrated is the result of a cold immersion process with liver of sulfur mixed at medium strength and a copper surface cleaned with phosphoric acid. Note that although the coloration is a warm gray, it is not truly opaque and still reveals the underlying metal surface quality to some extent.

Immersion application: hot

The hot immersion process is a very specific reactive coloration process that is much less common than cold immersion, but can yield wonderful colors. It differs from cold immersion not just in the use of heat, but with the chemical solution as well. The metal, heat, and solution all work in concert to obtain the desired color results. Not all solutions can be used effectively as a hot immersion process, and it is best to follow recipes closely.

The hot immersion process involves heating a reactive solution to a specified temperature (often boiling) and immersing the metal surface for a prolonged period of time. Multiple solutions and hot water rinses may be involved. More care should be taken because of the heated liquid and increased acid vapors from the hot solution. As with all hot reactive processes work in a well-ventilated space and wear a proper respirator.

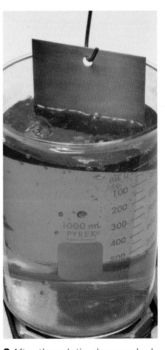

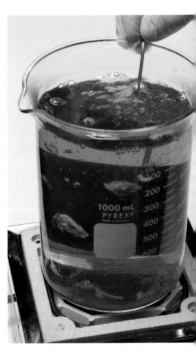

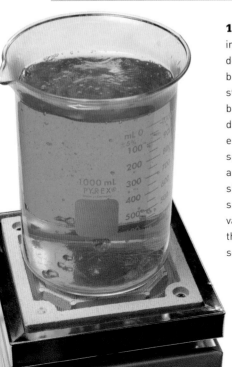

1 Heat the solution (per recipe) in a non-reactive container designed to be heated, such as borosilicate glass or stainless steel. Never position a borosilicate glass container directly on an electric heating element. Create a slight air space between the glass bottom and the heating element (as shown here with the ceramic spacer). Be mindful of acid vapors from the hot solution and the potential for splashes if the solution is overheated.

2 After the solution has reached the temperature indicated by the recipe, lower the room-temperature metal object into the hot solution using an inert (stainless steel) hanging wire. Bend the wire into an S-hook so that it can hang on the container rim while suspending the object in the solution. Make sure the object is centrally placed in the container so the solution can act on all surfaces equally.

3 Keep the metal suspended in the hot solution for the amount of time specified by the recipe. Here, copper is suspended with the stainless steel S-hook wire in a boiling solution of cupric sulfate and distilled water for 15 minutes.

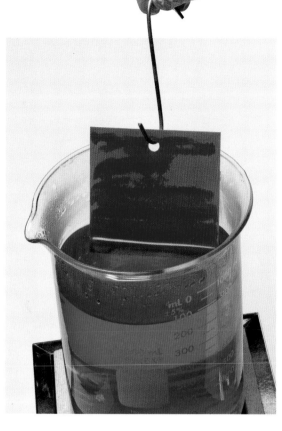

4 After the specified time has elapsed, and the reaction has taken place, completely remove the metal from the hot solution. Turn the heat source off, and allow the solution and container to come to room temperature before handling.

5 The reactive solution on the metal surface must be rinsed to neutralize and fully stop the reaction. Immerse or rinse the metal with tap water, being mindful of any splashes or vapors that might occur as a result of the hot metal quenching.

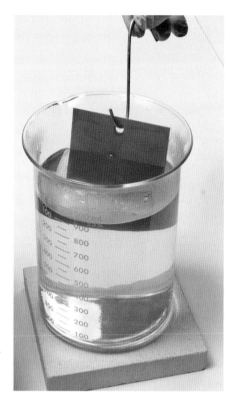

6 Remove the metal object from the water and dry it with a clean, soft cloth.

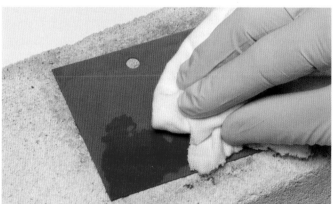

7 Wipe the metal surface with an acetone-soaked, soft cloth to remove any remaining surface moisture. The surface is ready to be clearcoat protected.

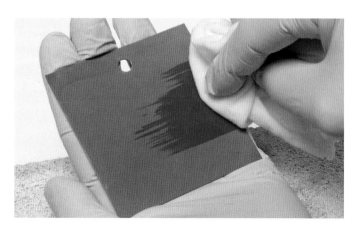

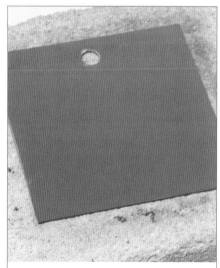

The finished result
Shown is a uniform, matte, opaque red-orange coloration on copper created with a two-step hot immersion of cupric sulfate solution and ammonium chloride solution. The hot immersion process is a typical reactive process to yield reds on copper and copper alloys.

Brush application: cold

A "brush" application is defined as any tool loaded with colorant that comes into physical contact with the metal surface. How uniformly the colorant covers the metal is controlled by the type and size of the brush tool as well as by the movement of the tool across the surface. Wiping, stippling, sponging, and burnishing techniques, with the proper brush tooling, can yield vastly different results. The brushing technique can be used with both cold and hot coloration processes. Decide for yourself: mimic mother nature's oxidation patterns, uniformly cover the metal surface, or create unique textures based on the type of tool and application technique.

Wiping

The most familiar of the brushing techniques, wiping with a brush tool, is used to cover surface areas with a strip or strips of colorant, similar to painting or staining a wood board. The loaded brush tool is put in contact with the metal surface and the brush lightly dragged across the surface, leaving the colorant behind. The brush size relative to the surface size dictates how many overlapping strokes are needed for complete coverage, if desired.

1 Pour a small amount of well-mixed colorant solution into a suitable container. Keep only a small amount of fresh solution in the container at a time as continued brush use and re-loading may contaminate it. Dip the brush head into the solution until saturated. Here, a 2-inch (5-cm) foam brush is loaded with a brown patina for copper. Squeeze out the excess solution from the brush head by pressing it into the side of the container. Excessive solution on the brush may cause unwanted runs and puddles.

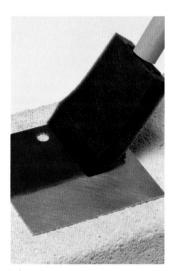

2 Wipe the brush across the metal surface. Use even pressure and speed for the most consistent colorant application. Re-load your brush tool before any dry streaks are left from the wiping motion. For a uniform coloration value, avoid overlapping brush strokes as much as possible, as this may lead to darker bands of color. Apply only one cold brush "wetting" of the surface until the coloration is stable; premature additional wipes could smear the under layer.

The finished result
The result of a 2-inch (5-cm) foam brush, loaded with a brown patina solution, wiping horizontally across the 3-inch (7.5-cm) copper surface. Note the two differing values of brown along the brush paths. For more uniformity, either brush additional colorant on the lighter area to darken, or burnish the dark area to lighten it.

Stippling

The stippling technique is a series of brush "dabs" onto the surface of the metal. The brush head is loaded with colorant and pressed against the metal surface. The coloration takes on the pattern of the compressed brush head. The overall stippled look is controlled by brush head size and type, and the number of dabs across the surface of the metal. Uniformity is not the objective with the stippling technique, rather the sense of overlaid "blooming" spots of color.

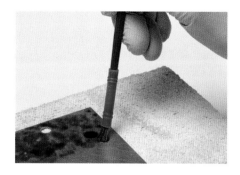

Choose an appropriate brush size. Round bristle brushes (as shown here) will "bloom" outward when dabbed on the metal surface. Load the brush with colorant, squeeze out the excess and begin stippling across the metal surface. Re-load the brush as necessary.

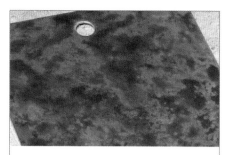

The finished result
The cold stipple application of a brown patina on the copper leaves a bloomed, spotted coloration. Often the negative spaces (under layer color) between dabs are important as they contrast and visually define the stippled pattern.

Sponging

Sponging is a specific stippling technique using a heavily textured, absorbent sponge as the brush tool. The coloration pattern comes from the texture of the loaded sponge as it is dabbed onto the metal surface. Natural sea sponges are typically used, as they have very large open cells for great texture. But any textured, absorbent material will work including crumpled paper balls. Choose a material, texture, and sponge size that best fits your application.

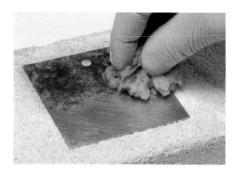

Load the sponge material with the colorant and squeeze out the excess. Dab the loaded sponge onto the surface, working across in a pattern that suits your aesthetic. Re-load the sponge with colorant as necessary.

The finished result
Illustrated is a cold sponge application of a brown patina on bare copper. The natural sea sponge texture is evident in the coloration and seen as a patterned look.

Wet burnishing

To burnish means to rub and abrade. The wet burnish cold application technique uses a lightly abrasive pad, like synthetic wool, to apply and distribute the colorant solution across the metal surface. The abrasiveness of the pad removes some coloration just after the colorant solution has been applied. When the colorant-loaded pad is lightly worked across the surface of the metal properly, a uniform coloration will result. With quick-acting reactive processes, wet burnishing is the best cold brush method for achieving uniform results on larger surfaces.

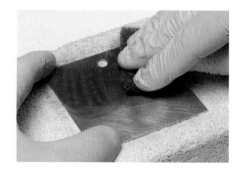

Load the abrasive pad with colorant solution. Move it, with gentle pressure, in small, overlapping circles across the metal. Too coarse an abrasive or too much pressure may result in a coloration that is too light.

The finished result
This uniform coloration on copper was achieved using a very fine synthetic wool pad and a brown patina. Because of the abrasive nature, there may be a slight "tooth" causing a matte appearance.

Spray application: cold

1 Pour a small amount of well-mixed colorant solution into a container suitable for dipping the spatter spray tool in. Dip the spatter spray tool into the solution until saturated and gently tap off the excess. Here, a large bristled toothbrush is loaded with a black patina for steel and will be used for the spatter application.

With spray applications, only the colorant solution comes in contact with the metal surface; the spray tool itself acts only as the means to hold and propel the solution. There are a few great advantages to using a spray application method. First, spraying colorant may be the quickest method for covering large surface areas uniformly. Second, spray applications can yield a droplet effect, mimicking natural oxidation. Third, it is better to layer applications over fragile "chalky" or "loose" colorations via spraying as it won't smear the fragile underlayer.

Factors defining color pattern and consistency from a spray tool include the spray tool type, the orifice size of the sprayer, the proximity of the spray head to the metal surface, and the velocity of the propelled colorant. As with brushing, the spraying technique can be used with both cold and hot coloration processes.

2 Aim the toothbrush at the metal surface area to be spattered. Run your thumb or finger back along the bristles, pulling them back and allowing them to spring forward, throwing the colorant at the metal surface. The spatter pattern is developed by variables such as how loaded the bristles are with solution and the proximity of the bristles to the metal surface. Re-load the bristles and continue spray spattering to create a broader, denser speckled pattern. As with all cold application processes take care not to over apply and allow pools or runs of colorant to form.

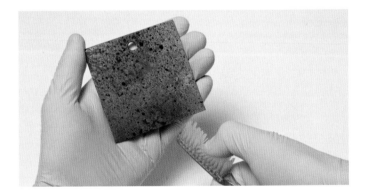

Spatter

The spatter spray technique may be the least controlled of the spray techniques. Any tool that can be used to drip or fling colorant at the metal surface can be used. The coloration pattern developed will depend on the tool used and how the colorant is spattered on the metal.

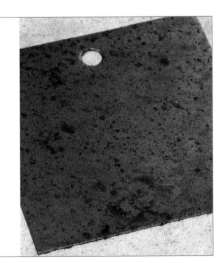

The finished result
The brown-black mottled coloration is the result of the black patina spatter application on bare steel. As with many other application techniques, the beauty of the spray spatter method is its non-uniformity in coverage, revealing the underlying surface color.

Mist

The spray mist technique propels small droplets of colorant solution onto the metal surface via a manual pump mister. The droplet size is determined in part by the size of the mister nozzle and in part by the proximity of the nozzle to the metal surface. Color droplets will be finer and will cover a larger surface area the further away the nozzle is held from the metal. You can always test the droplet size by misting a piece of paper.

Load the colorant solution into the mister bottle. Hold the nozzle the appropriate distance from the metal to yield the desired droplet size. Here, the black patina is loaded in the mister, and held approximately 3 inches (7.5 cm) from the bare steel surface.

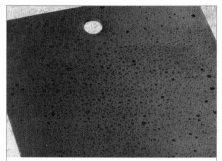

The finished result
Spray misting results in the finest droplets of all the manual spray methods. The droplets can be applied densely enough to appear uniform. Illustrated is a light misting of black patina on bare steel.

Spray

An adjustable nozzle trigger sprayer has the flexibility of spraying from a mist to a stream, using the same spray tool. Trigger sprayers propel a larger volume of solution per stroke and at a higher velocity than spray misters, making them suitable for larger surfaces or when a more elongated oval droplet pattern is desired.

It is advisable to test the spray pattern and nozzle distance on a sheet of paper before spraying on the metal surface.

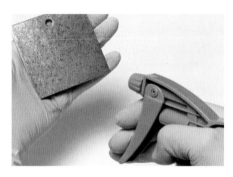

Load the sprayer with colorant. Adjust the nozzle to a medium setting for a "spray" effect, with large droplet size. Here, black patina is used and the nozzle is held 3–4 inches (7.5–10 cm) from the surface.

The finished result
The spray color pattern results in large, ovalized droplets of brown-black across the steel surface. A more uniform coloration would result from a denser application.

Airbrush

The airbrush is the most useful spray tool for creating lighter gradient colorations and uniform coverage. The compressed air serves to atomize the liquid solution to create tiny droplet sizes and control spray velocity.

Most airbrushes have nozzles sized to work with water-based solutions, but some heavily pigmented colorants may clog the nozzle. Experiment with higher air pressures or change to a larger nozzle if clogging is an issue. Due to the fineness of the droplets and relative high velocity of the airbrush, ensure you have adequate ventilation when using it.

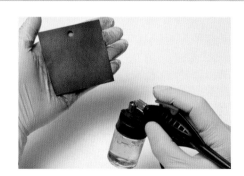

Load the siphon cup with colorant. Depress the trigger in short bursts for intermittent patterns or hold down for uniform coverage. Here black patina is sprayed at 3–4 inches (7.5–10 cm) from the steel surface.

The finished result
The steel tile shows a nice gradient coloration from dark to light. To achieve the gradient, the airbrush movement began slowly on the left side and increased speed as it swept toward the right.

Hot application

A hot application is one where the metal is heated to approximately 180–200°F (80–95°C) and room temperature colorant solution is applied, either by brush or spray methods. Not all reactive colorants can withstand the heat of this process; follow the instructions of the reactive patina recipe. Most non-reactive, water-based "loose" pigments or dyes, however, can. Remember a loose colorant is one with no binder.

The heat is an important part of the process in several ways. First, it opens the pores of the metal to allow the colorant to "bite" into the surface more quickly, making for a more immediately durable colorant layer. Second, heating the metal to the proper temperature allows the colorant vehicle (water in water-based colorants) to evaporate on contact, which helps avoid runs and pooling of the solution and allows the final result to be seen immediately. Third, the elevated temperature of the metal surface aids in the chemical reaction of the reactive-based colorants. Remember that not all colorant solutions work well with, or even can withstand, the temperatures of the hot application process.

Perform hot applications in a well-ventilated area with proper respirator use to protect yourself from the acid gases that will evaporate from the reactive chemicals.

1 Heat the metal surface with an electric heat gun or gas torch until the surface temperature reaches 180–200°F (80–95°C). At this temperature, the liquid solution will evaporate quickly once it touches the metal, but not boil off. A finger-flicked bit of water can help determine the proper temperature before any colorant is applied. Here a wide-nozzle heat gun is held 2–3 inches (5–7.5 cm) from the copper surface to preheat the area.

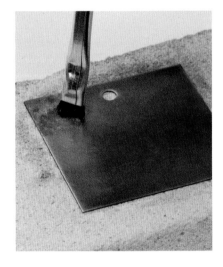

2 Once the metal has reached the proper temperature, apply the colorant solution as a brush or spray application. This example shows the stippling method using a bristle brush loaded with cupric nitrate solution applied to a darkened copper surface.

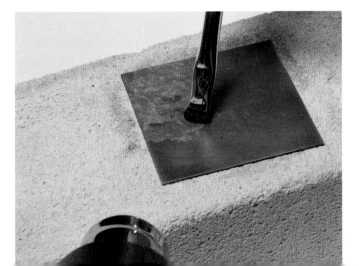

3 Continue the colorant application across the surface of the metal. If the colorant remains liquid on the surface after an application, the metal has cooled too much. Reheat the metal area until the solution just evaporates upon contact, but does not boil off. Here the heat gun remains pointed at the copper surface to keep it within the proper heat range as the colorant is stippled on.

4 Continue the cycle of heating and applying colorant until the surface has been covered. Gradually build up layers of colorant until the desired coloration is met by overlaying the applications, as has been done here.

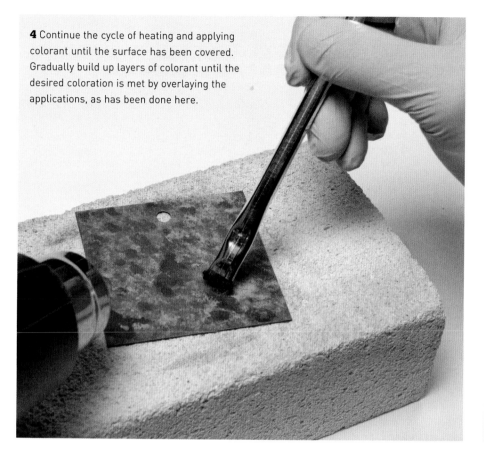

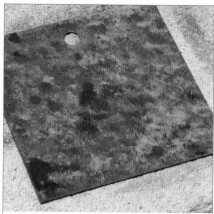

The finished result
The turquoise and green coloration of the hot cupric nitrate application has been created over a copper surface that was first darkened with liver of sulfur. The variation in color comes from the use of heat and layering of the stippled colorant. More heat and more layers developed the coloration in those areas.

PROPER AND IMPROPER HEATING LEVELS

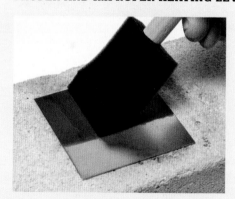

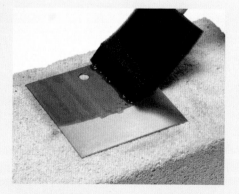

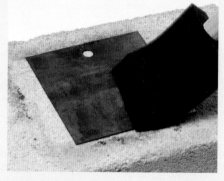

Correct amount of heat
The proper heat range for the hot application is 180–200°F (80–95°C). When the liquid colorant is applied to the metal surface at these temperatures, the liquid evaporates as a trail immediately after application. Proper reheating to maintain the surface temperature between applications is critical.

Not enough heat
When the metal has seen too little heat for the hot process, the colorant solution will stay liquid on the surface. At the very least, the result will act more like a cold application, but pooling, runs, and unevenness are probable. At the most, the chemicals designed to react with heat will not color effectively.

Too much heat
Heating the metal too much (above roughly 212°F/100°C) will result in boiling off the liquid solution, causing dark-colored areas and unevenness. You will see and hear the solution sizzle when it contacts the metal. These markings from the boil-off are more difficult to blend with further applications of colorant or with burnishing.

1 Pour well-mixed colorant solution into a suitably sized bowl. Have your absorbent material cut into the size and quantity of pieces desired to wrap your metal object. Here, a green patina and cheesecloth are being used.

Wrap and bury applications

The wrap and bury application techniques are typically cold-process methods that utilize absorbent, textured materials to create surface texture and patterned colorations. With each technique, a fibrous material is saturated with the colorant solution and put in contact with the metal surface. After some time the metal picks up the color and texture of the material. Wrapping and burying techniques differ only in the way the metal object is encased in the saturated material. With wrapping, the fibrous material (usually cloth) is brought to the metal surface and affixed to it. Burying involves placing the metal object in a container and surrounding the surfaces with a loose, textured material like sawdust.

Any colorant suitable for a cold process application will work for the wrap or bury methods. The metal surface needs to stay encased in the material saturated with colorant solution until the reaction is complete (as with patinas) or the non-reactive colorant has had time to set up on the surface. Removing the material from the surface too early will disrupt the texture quality. Experiment with absorbent materials that have different patterns, textures, and coarseness/grain sizes for varied results.

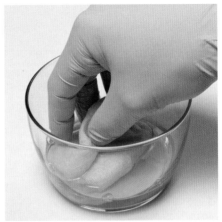

2 Saturate the material in the solution. If using multiple pieces of material, saturate each individually.

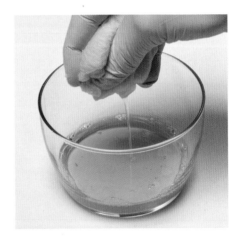

3 Squeeze out the excess solution from the material. The cloth should be completely wetted, but too much solution could overrule the texture of the material during the process or create unwanted color runs.

Wrap

The wrap technique involves saturating absorbent material pieces with the colorant solution. The material is then put against the metal surface and held in position until the desired coloration has been reached. Fabric, cheesecloth, newspaper, etc. all can be used to different effect. The texture of the material and the size and number of pieces used to wrap the object help determine the coloration pattern and texture.

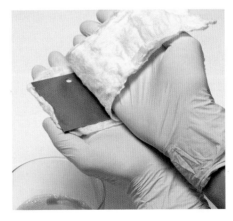

4 Begin wrapping the saturated material around the metal surface. The initial contact of the material against the surface will define the pattern. Be aware of the material edges or seams, as these may cause harsh color lines.

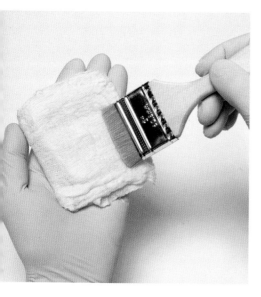

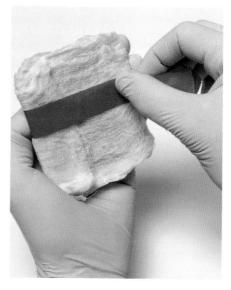

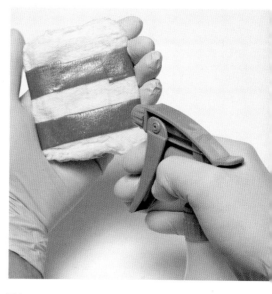

5 Once the material is completely wrapped around the metal surface, lightly brush the outer surface with a dry, soft-bristled brush to ensure there are no air pockets. It is the surface contact between the saturated material and the metal that will develop the color and pattern; any air pockets will show as non-colored areas on your piece.

6 Secure each length or piece of material snugly against the metal surface with tape, rubber bands, or string. Be aware that a tight tape or tie may show as a strong color line on the metal due to increased contact pressure at the bound area.

7 Once secured, re-saturate the absorbent material with more colorant, using a spray application method so as not to disturb the wrap. Again, wet but do not over soak the fabric, as this may lessen the desired effect.

8 If the wrap is to stay on the object for 12 or more hours, loosely wrap it with plastic wrap to prevent the saturated material from drying too quickly. Reactive colorants used with the wrap process may need up to a few days to develop the full coloration. If the material does begin to dry out before the coloration is complete, re-saturate with the colorant using a spray technique.

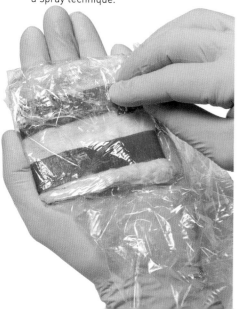

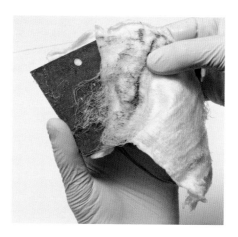

9 After the coloration process is complete (this varies from hours to days, depending on the colorant), remove the plastic wrap and binding and carefully unwrap the material from the metal object. Some loose-fiber cloths (such as cheesecloth) may leave fibers stuck to the dried colorant. Remove the fibers as necessary, but some added texture might be desirable. Allow the surface to sit in open air for 24–72 hours to complete any remaining reaction that is needed.

The finished result
The cheesecloth saturated with a blue-green patina has left a texture imprint on the darkened copper metal surface. The small screen-like pattern is evident across the metal surface. If multiple, smaller pieces were used to cover the surface, the orientation of each piece would be seen in the textured coloration.

Bury

The bury technique involves placing the metal object into an open container and filling the container with colorant-saturated, loose material. The material surrounds the object and presses against the surface. The metal surface takes on the coloration of the solution with the texture of the material particles. Commonly used bury materials include sawdust, dry soil, and shredded paper, but any absorbent material in small particles or shredded pieces will work.

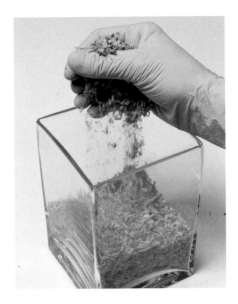

1 Fill a suitable sized container with the absorbent material you have selected. The metal object should be completely buried, so consider this when planning the container size and amount of material needed. Here, a coarse wood shaving "sawdust" is used for the application.

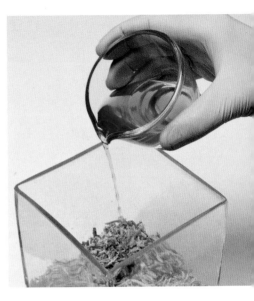

2 Pour a small amount of well-mixed colorant solution into the container, wetting the material. It is easier to add solution to increase wetness, so start out slowly. Here a green patina solution is being used with the coarse wood shavings.

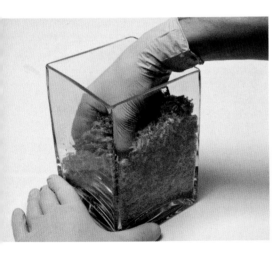

3 Mix the material and solution well: the objective is to evenly wet all the absorbent material in the container. If it is easier, do the filling, pouring, and mixing in smaller batches to ensure uniform wetness.

4 Squeeze a handful of wetted material together to check the moisture content. Properly saturated material will clump and hold its shape after squeezing, but not drip excess liquid. Too little moisture will result in little to no metal coloration. Excessive wetting of the material could overrule the texture quality of the coloration.

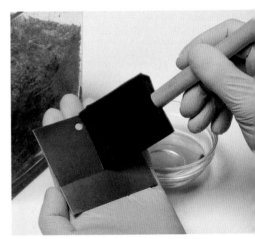

5 Once the absorbent material is sufficiently saturated, lightly wet the metal surface with the colorant solution. With reactive colorations, this initial wetting kick-starts the reaction; wait for visual oxidation to appear on the surface before you bury the object in the container.

6 Bury the object in the saturated material. Decide if the piece is to be completely or partially covered, as this will affect the results. Once buried, try not to reposition the object in the material as this could smear the initial texture coloration.

7 Loosely cover the container with plastic wrap to keep the saturated material from drying too quickly. This will allow the material to stay moist for the duration of the coloration process.

8 When the coloration is complete, unwrap the bury container and carefully remove the object from the material. The amount of time you need to leave your metal buried for is typically listed in the recipe.

9 Using a dry, soft bristle brush, carefully brush off the absorbent material that has dried to the metal surface. Make an aesthetic decision if all the material has to be removed or if the tightly adhered particles can remain for visual effect. Allow the object to sit in open air for 24–72 hours to complete any remaining reaction that is needed.

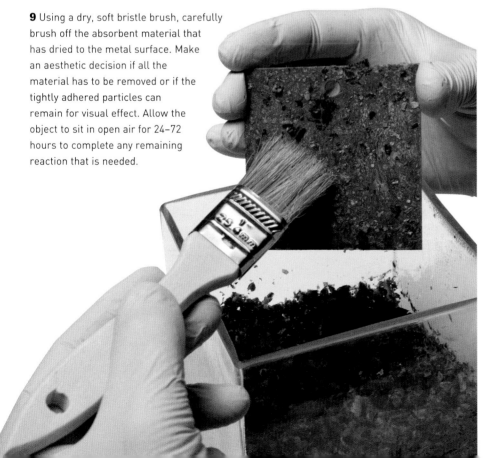

The finished result
The darkened copper surface has a turquoise and green mottled pattern as a result of the bury technique using the coarse wood shavings and blue-green reactive patina. Smaller particle sized material would leave a finer visual texture.

Fume application

Rather than applying liquid solution directly to the metal surface, the fume process relies on airborne reactive fumes enveloping the metal surface, gradually building up the colored oxidation layers over time. Similar to the immersion process, the benefit of fuming is that no application tool that might impart an application pattern is used. Difficult-to-reach surfaces can also be just as easily patinated. As long as the metal surface is completely exposed, there is a better chance for the fumes to react equally on all areas. Fume process applications are relevant for reactive colorations only. The biggest obstacle with this process is that you need a vapor barrier large enough to house the metal object and the solutions.

Always perform fume patinas in a well-ventilated area with proper respirator use to protect yourself from the strong acid vapors when the vapor barrier is not in place.

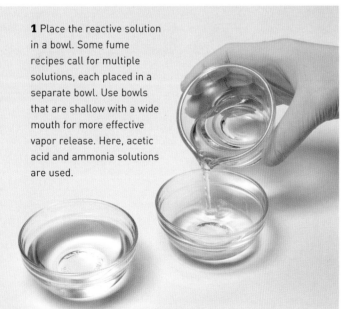

1 Place the reactive solution in a bowl. Some fume recipes call for multiple solutions, each placed in a separate bowl. Use bowls that are shallow with a wide mouth for more effective vapor release. Here, acetic acid and ammonia solutions are used.

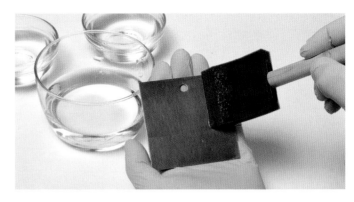

2 Wet the surface of the metal object with distilled water, as shown with the darkened copper tile. The wet metal attracts and holds the reactive vapors against the surface for a better reaction.

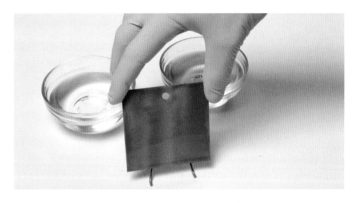

3 Position the metal object in a cluster with the reactive solution bowl(s). Ensure the metal surface is obstruction free, so that the vapors reach all parts uniformly. You may have to design a special stand or holder for this purpose, or rotate the object at an intermediate point in the reactive fuming process.

4 Place an appropriate sized vapor barrier or container over the object and solution bowl(s). The container should be made of a material resistant to the acidic chemical vapors—plastic, glass, or stainless steel. A transparent container is ideal, as this allows you to check the status of the coloration process. Larger pieces can use flexible plastic sheeting as a vapor tent.

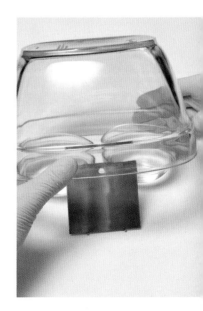

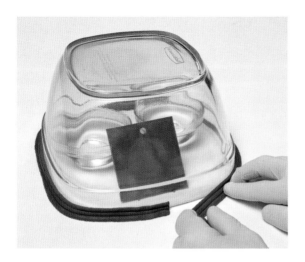

5 A good seal around the rim of the container and the work surface is essential to prevent vapor leakage. Use a sealing caulk or tape that is easily removable.

6 Fume patinas take time; most recipes call for the fume reaction to take place over multiple days. Be patient and keep the fume process undisturbed. Again, having a clear vapor barrier will allow you to check on the coloration development. You decide when the effect is suited to your work.

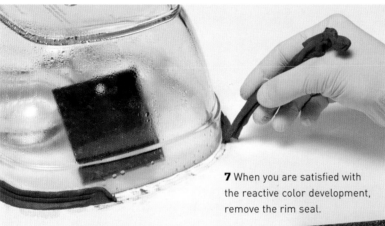

7 When you are satisfied with the reactive color development, remove the rim seal.

The finished result
Depending on the solution strength or length of time the fume patina is allowed to react on the metal surface, the results can vary from a smooth, uniform coverage to a crusty, highly textured surface that indicates a longer reaction time. This tile has been exposed to the reactive solutions for close to 30 days and has the heavily textured surface as a result.

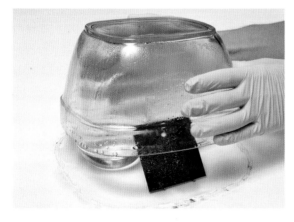

8 Remove the vapor barrier from the cluster and carefully remove your metal object. At this point, re-cover the solution bowl(s) with the vapor barrier in case you decide to fume the object more.

9 The patina will continue reacting and gain durability with time in open air. It is best to allow the object to sit before any handling or clearcoat application begins; a 24–72 hour wait should be sufficient. After this time, re-evaluate if the coloration is satisfactory. If it is not, place the object back under the vapor barrier and reseal the rim for a longer exposure to the reactive colorant.

Masking

The purpose of any masking agent is to keep the applied colorant from reaching the surface underneath, be it the bare metal or an underlying color. Masks come in a variety of forms, but they must be able to withstand both the coloration solution and the application process, and to be removed easily when the application is complete. Some mask materials cannot withstand the temperatures of a hot process or the corrosiveness of a reactive chemical, so it is best to test the mask and process before committing. Some masks may be more conducive to applying to large areas, to creating crisp lines, or to creating organic or irregular shapes.

The most basic of masks are physically held to the surface during the colorant application to block the colorant, but masks such as cardboard may not work well for all processes. The masking agents mentioned here do not constitute an exhaustive list, but all work well for both cold and hot processes, and with both reactive and non-reactive colorants.

Removal of coloration that has seeped into the masked area is done with abrasive cleaning processes, i.e. synthetic wool, power brushing, etc. Choose the method that best matches the underlying surface quality. Unfortunately, if the seeped coloration is on top of an existing coloration (layered), the abrasive cleaning may affect all layers and require a touch-up re-coloration.

Tape mask

Masking tape comes in different widths and has different adhesive qualities meant for more or less delicate surfaces. Choose a tape for delicate surfaces when applying over a fragile coloration. Tape can be left as is, or shapes can be cut from the tape and applied to the metal surface.

1 Regardless of the tape size or shapes, apply the tape to the entire surface that you need masked and firmly press down the edges so that the liquid colorant does not seep in.

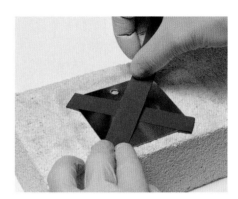

2 After the surface has been masked with the tape, apply the colorant using your preferred method. Here a brown patina is brush wiped on bare steel. Allow the colorant to react or "set" before disturbing the mask. Removal of the mask too early will compromise the integrity of the mask boundary.

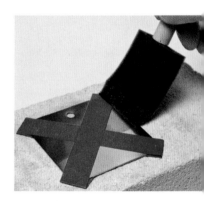

3 Once the coloration has reacted or set, carefully remove the tape mask from the metal surface. Remember that the surrounding coloration may be somewhat chalky and fragile so take care when handling.

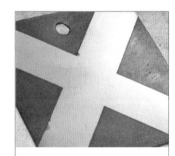

The finished result
A tape mask should leave crisp boundary lines between the coloration and the masked portion. Remove any coloration that has seeped into the masked area with an appropriate abrasive method. Use an acetone wipe to remove any adhesive residue from the tape.

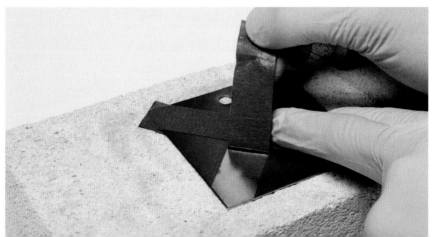

Crayon mask

An oil-based crayon can be a great masking agent. First, it is oil based so it resists the water-based colorant. Second, it has a color so the masked areas are highly visible. Third, the crayon allows you to draw the masked area freehand, which opens up possibilities for creating interesting patterns and fine lines. Crayons may not be the best mask method for use on top of fragile "chalky" colorations because of the rather inherent rubbing on the surface during the application and removal.

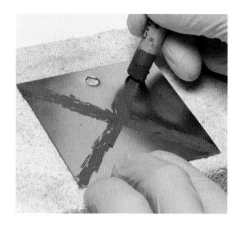

1 Apply the crayon to the metal surface, covering all areas you want masked from the colorant. Color in all areas well, as any bare spots will see the colorant solution. Apply the colorant using your preferred method. If brushing, make sure not to contaminate a large amount of solution with the oily residue picked up by the brush.

2 Allow the colorant to react or set. Remove the crayon mask using an acetone wipe with a cloth or cotton swab. Be mindful that your cleaning action does not smear the coloration if it is chalky and fragile. Clean until no more colored mask is seen on the metal surface or the acetone cloth/swab. Remove any coloration that has seeped into the masked area with an appropriate abrasive method. Note the more organic boundary between the brown patina and the masked bare steel from the crayon mask.

Liquid latex mask

Natural latex rubber cement and other latex removable coatings (such as liquid frisket and peel away spray booth coatings) can act as a masking agent and are convenient to apply and remove, and the mask quality (crisp versus organic) can be easily controlled with the application method. Some liquid latex coatings can be roll or spray applied for larger masked surfaces. Apply a thin coating of the latex and follow the manufacturer's recommendations for set times before applying the colorant solution. Latex masks typically remove with little to no residue left on the surface. A gentle acetone wipe will ensure the surface is free of latex residue.

1 Apply the liquid latex as a thin layer to the metal surface. Here rubber cement is being brushed over bare steel. Allow the latex mask to set so it is durable. Apply the colorant to the surface using your preferred method. If brushing, be gentle when applying over the mask so as not to accidentally peel up the edges.

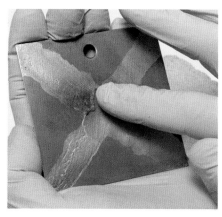

2 Allow the colorant to react or set. Carefully remove the liquid latex mask using your finger or a tool to "roll" or peel it from the surface. Be mindful of the surrounding coloration during the removal process if it is chalky and fragile. Remove any coloration that has seeped into the masked area with an appropriate abrasive method. Here a rather wide, organic mask is used for the brown patina over bare steel.

Burnishing

To burnish means to rub or abrade the surface. When working with reactive or non-reactive "loose" colorants that have no direct binder to adhere them to the metal surface, the coloration can be easily adjusted with burnishing techniques after the colorant solution has been applied and even after it has reacted or set. Burnishing a dry coloration is known as dry burnishing, while abrasively working the wet solution on the metal surface is called wet burnishing.

The burnishing technique (often referred to as brushing back) can be used to abrasively remove the coloration to highlight edges or texture, to increase the color value by lightly removing only some of the coloration, or to blend and unify areas of coloration. Synthetic wool is a typical burnish tool due to its inert nature and availability in a wide range of coarsenesses. Choose the coarseness that best meets the coloration removal needs and leaves the desired surface quality.

Highlighting texture

Colorations have a tendency to unify a surface, more so if they are dark and opaque. Rolled or hammered texture may become too subdued with these colorations. To draw the viewer's eye to the texture, the dry burnishing technique can be used to effectively remove the coloration from the high spots of the texture. This highlighting of the texture makes it visually "pop" from the surrounding surface.

1 Begin by coloring the textured metal surface to the darkest (lowest value) you want to see. Allow the patina to fully react or the non-reactive colorant to set. Here, a cross-hatch patterned texture was created with a hammer on the steel surface, then a hot process, brown patina applied.

2 Lightly dry burnish the high spots or peaks of the texture with an abrasive such as very fine synthetic wool or emery cloth. Continue abrading and removing the coloration until you have enough contrast between the high and low spots. If you remove too much coloration, repeat the colorant application process over the needed areas and dry burnish to match.

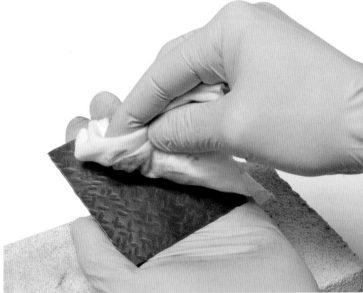

3 When satisfied with the burnishing, remove the abraded residue from the burnishing process with dry, compressed air or an acetone wipe. Use a low-pressure compressed air to blow off the residue on colorations that are fragile and would smear if wiped. Here an acetone wipe is used on the stable patina.

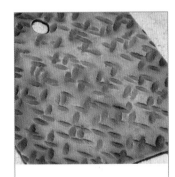

The finished result
Notice how the eye is visually drawn to the textured metal because of the highlighting effect of the dry burnish. Edges and other non-textured details of your object can be highlighted in this manner as well.

Lightening color/increasing value

If the coloration results are too dark, a dry burnish can be used to remove some color, effectively increasing the value to a lighter coloration. Some cold process reactive colorants may not reveal the fully saturated coloration for a few days, until after the full reaction has been completed. It may be difficult to know how much colorant to apply for the desired coloration value, and easier to adjust after you see the results.

Evening out color

Many reactive colorant application techniques leave tool marks. Building up layers of colorant can help with uniform coloration, but sometimes the layers darken the coloration too much. Wet burnishing with the colorant will be the most effective way to apply, or adjust, reactive colorants to achieve uniform colorations. A dry burnish technique can also be used to even out colorations, but the color value will increase.

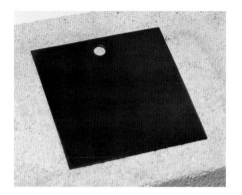

1 Apply the colorant and allow it to fully react, or set. Illustrated is a hot process brown patina applied uniformly over bare steel. The result is a dark, brown coloration.

1 The steel sample has had a brush application of a brown patina applied. Notice the brush paths typical when covering a surface larger than the brush head.

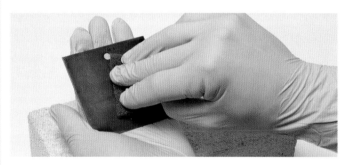

2 Lightly dry burnish the surface with an abrasive such as very fine synthetic wool or emery cloth. Use a light, circular motion, or a "picking" motion (like lightly grabbing the color with the abrasive pad) for uniform results. Continue abrading and removing the coloration until you have the value you desire. If you remove too much coloration, repeat the colorant application process over the needed areas and dry burnish to in order to match. Use compressed air or an acetone wipe to remove the abraded residue.

The finished result
The dry burnished surface yields a lighter coloration than the one originally developed. Very light circular motion was used with the abrasive pad to maintain the uniformity of coloration while increasing the value.

2 With liquid colorant still on the surface of the metal, take a very fine synthetic wool pad and lightly abrade the surface in small, overlapping circles. This effectively works the solution uniformly across the surface and removes the application marks. An alternative is to saturate the synthetic wool pad with the liquid colorant and similarly work across the surface. Both are equally acceptable wet burnish techniques. Blot out the remaining colorant with a dry cloth and inspect the results. Add more colorant to re-darken, or continue the wet burnishing as necessary.

The finished result
The result is a much more uniformly colored surface than the original brush wiped surface. The resulting coloration value is the same after the wet burnish. This is the main difference between the wet and dry burnish methods.

Layering

Often a desired coloration is the result of multiple applications of colorant. Layered colors can yield better saturation and give visual and tactile depth compared to a coloration completed in one step. Layering with translucent colors will alter the feel of an underlying coloration. Burnishing layers of colorations can add a modeled appearance to the surface. A dark under layer coloration allows the applied over layer colorant to visually "pop" or contrast. Non-reactive colorants applied to the surface of a reactive patina or chemical plating can be used to enhance the coloration. Lastly, a gradual build-up of final coloration via layering usually makes for a more durable overall finish, especially with cold process, reactive colorants. Heavily applied cold patinas tend to have poor adhesion and flake off.

LAYERING HINTS AND TIPS

Factors to keep in mind when layering:

- First, reactive colorants need to come in contact with the metal surface in order to develop. When working with both reactive and non-reactive colorants, apply the reactive first.
- Second, applying wet colorant on wet colorant is not layering, rather mixing solution on the metal surface. Layering is defined by applying an overlay of colorant to a "dry" coloration—one that has fully reacted or is set.
- Third, pay attention to colorant opacity, solution strength, and application method and quantity. Darker, more opaque layered colorants will overrule or completely hide the underlying coloration if applied uniformly over the top. Use an application method that creates negative space with the coloration, burnish to remove some top coloration, or mask certain areas.
- Lastly, think about application methods. The application of each layer will affect the visual of the overall coloration (these are variables that can be changed for different effects). However, it is best not to use an application method like brushing on top of a fragile, chalky coloration that disturbs the quality of that coloration. In most cases, these fragile colorations are best layered with spray methods.

Cold/Cold

Cold/Cold refers to both the first and second layers being cold application processes. The first layer must be dry before applying the second layer. Do not use an application tool for the second layer that could smear the first.

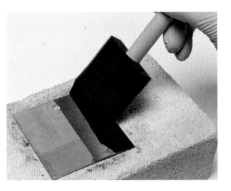

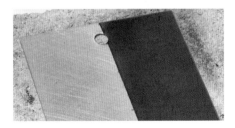

1 Clean the metal surface. Apply the first layer over the bare metal with your chosen method. Here, the copper was first wet burnished with phosphoric acid to clean and etch the surface. The left half was masked with tape and the right half cold immersed into a strong solution of liver of sulfur.

2 Once fully reacted and dry, apply the second layer of cold process colorant over the first, using any application method that yields the coverage and pattern desired. Allow this second layer of colorant to fully react and dry. Shown here is a cold light green patina solution being brush wiped over the entire copper surface, both bare and patinated sides.

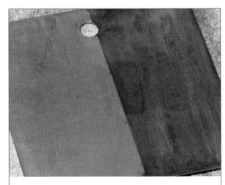

The finished result
A single layer of light green patina coloration remains translucent enough to allow the under layer to influence the overall coloration. Notice how the light green is far less visible over the higher value of the bare copper on the left side compared to the light green layered over the brown coloration on the right side. The light green coloration "pops" off the darker under color.

Cold/Hot

Cold/Hot refers to first and second layer colorant application processes – the first layer is a cold application process with the second layer being a hot application process. Remember that the first layer must be fully reacted and/or dry before applying the second colorant layer. The first layered colorant must be able to take the heat of the second layer process without affecting the coloration quality.

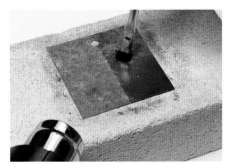

Clean the metal surface and apply the cold process colorant. Allow the colorant to react and dry. Apply the second colorant as a hot process layer. Here copper was prepared as before, remaining bare on the left and having a liver of sulfur coloration on the right. A hot process cupric nitrate patina is stippled on.

The finished result
Notice the difference between the under layer of bare copper on the left side compared to the darker brown coloration from the first layer on the right side. The darker under color allows the stippling to be seen more as individual markings.

Hot/Cold

Hot/Cold refers to first and second layer colorant application processes – the first layer is a hot application process with the second layer being a cold application process. A hot process gives a full reaction more immediately than some cold processes, so allow just enough time for the metal surface to cool before applying the second cold process layer colorant.

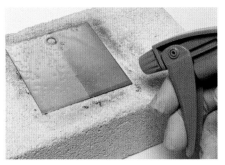

Clean the metal. Apply the hot process colorant and allow to cool. Apply the cold process colorant and allow it to react and dry. Here, a hot ferric nitrate patina was brush applied to the right half of the copper, and the left half remained bare. The second layer is a cold process spray application of a light blue patina.

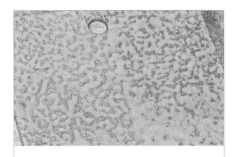

The finished result
Although a bit more subtle, the negative spaces between the opaque, light blue speckled pattern on the right half reveal a lower value coloration compared to the left half.

Hot/Hot

Hot/Hot refers to both the first and second colorant layers being hot application processes. Hot process colorations are complete and durable more immediately. With both layers receiving hot application processes, the second layer can be applied directly after the first coloration looks satisfactory to you.

Clean the metal. Apply the first layer as a hot process application. Apply the second hot process colorant layer. Illustrated is a copper surface with the right half brush wiped with hot ferric nitrate patina. The left half remains bare. The second layer is spattered with a hot white bismuth patina.

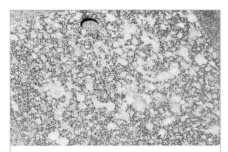

The finished result
There is a subtle difference with how the left half bare copper and the right half golden brown patina under layers interact with the white, speckled pattern of the over layer.

Patination directory

The following pages illustrate metal coloration examples across nine different metals. Included are reactive and non-reactive colorations. Colorant formulas for each example are identified by number, followed by instructions for their application.

The list of colorant formulas can be found on pages 242–249. Cleaning and application processes are discussed in depth on pages 72–105.

Steel

Steel:
INTRODUCTION

Carbon steel is a broad category of ferrous metal alloys comprised of iron, carbon (less than 2%), plus other alloying elements. More than other metal alloys, carbon steels have been engineered for specific physical properties to match desired applications. By adjusting the carbon content and introducing other elements, steel makers can readily affect the strength, hardness, toughness, and ductility of the alloy. Low carbon steel is the most common of the carbon steels, having a carbon content of no greater than 0.30%. Low carbon steels have a great balance of hardness, strength, and plasticity, i.e. the ability to deform permanently without failure, all of which are great attributes to the metalsmith.

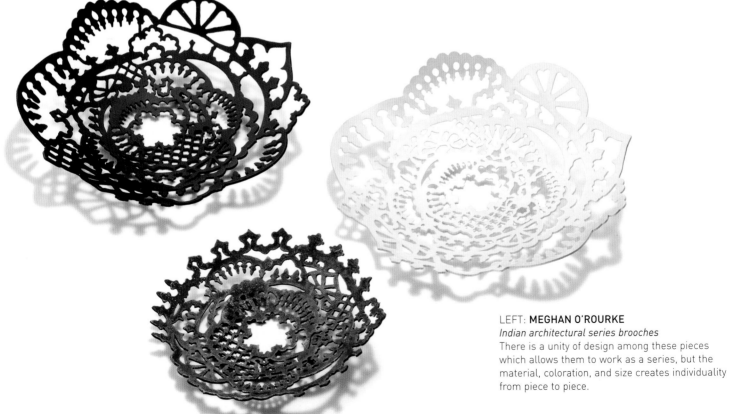

LEFT: **MEGHAN O'ROURKE**
Indian architectural series brooches
There is a unity of design among these pieces which allows them to work as a series, but the material, coloration, and size creates individuality from piece to piece.

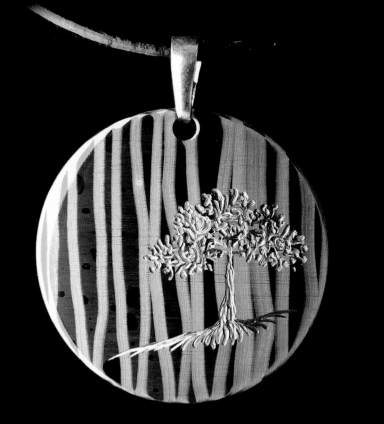

LEFT: **GISELLE DUVAL & TIM ANDREW**
Tree of life
This pendant uses a combination of heat temper coloring and color removal to create visual layers and depth. It is a fine example of using finishing techniques alone to convey the feel of the piece.

Although steel has been dated from as early as 6,000 years ago, modern steel making became much more efficient and economical in the mid-19th century. Steel mass-production literally revolutionized the world, allowing for more durable railroads, taller skyscrapers, and automobile manufacture. Modern steel making involves two stages: smelting naturally occurring iron ore to yield high carbon "pig iron", and melting pig iron to reduce and control the carbon content and add other favorable alloying elements. Thanks to its relative low cost and many available alloys, steel is one of the most used materials, and the most used metal, in the world. Steel is also one of the most recycled materials. Recycled steel maintains all of the properties of virgin steel, with a large energy (and cost) saving versus mining and processing ore for new steel.

Properties

UNS G10100 is a low-carbon steel having between 0.08 and 0.13% carbon content, with manganese being the primary alloying element. G10100 steel can be purchased relatively inexpensively, both as cold-rolled and hot-rolled products. Many shapes and sizes are available including: sheet, plate, wire, solid bar stock, and tubing. Freshly abraded cold-rolled G10100 steel has a silvery gray color, while hot-rolled G10100 steel has a bluish black oxidized surface, resulting from the hot forming process at the steel mill. Freshly abraded hot-rolled steel has the same silvery gray as cold-rolled products, as the heat coloration is surface oxidation only.

ABOVE: **SARAH HOLDEN**
Smile
There is a nice contrast of metals and colors within this work; the cold, blackened steel is stark against the warmth of the copper rim. The color difference also allows the viewer to investigate the cold connections between the two metals.

RIGHT: MEGHAN O'ROURKE
Taj Garden brooches
These intricately cut and pierced steel brooches have been darkened using heat tempering. On two pieces, gentler heating has been used to attain a lighter color which pulls the viewer's eye to the center of the piece.

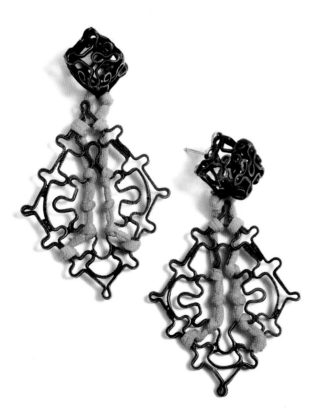

G10100 cold-rolled steel possesses good strength, is both malleable and ductile, and can be readily cold or hot worked. Like most metals, cold working low carbon steel will work-harden the metal. An annealing operation can be performed by heating the metal uniformly to between 1600 and 1800°F (870 and 980°C), followed by a slow furnace cool to relieve the residual stresses, softening the steel again. Unfortunately, this is not very practical for most outside of industrial settings. For this reason, hot working G10100 steel is preferred on pieces with multiple forming steps on the same metal section. Hot working low-carbon steel should be performed within the 200–900°F (95–480°C) range, with temperatures of 1800–2300°F (980°–1260°C) required for hot

LEFT: SARAH HOLDEN
FE1
Using materials and colors as a study in contrasts, these blackened steel earrings are intertwined with brightly colored nylon. The steel is visually cold and mechanical while the nylon is bright, warm, and playful.

forging. Heating and cooling rates do not appreciably affect the physical properties of low-carbon steel, and as such is more user-friendly than higher carbon steels where heat greatly affects strength, hardness, and ductility, and often requires secondary tempering and re-hardening processes.

Low carbon steel can be soldered, brazed, or welded by conventional means. From a coloration point of view, it is important to understand that differing hot joinery methods may or may not have a color match at the joint, but only welding yields a color and metal compositional match. This is important when using reactive colorants and wanting a uniform coloration throughout. Low-carbon steel is moderately heavy, having a specific gravity almost 8 times that of water. The melting temperature range for G10100 steel is between 2498 and 2552°F (1370 and 1400°C).

Low-carbon steel has a very low resistance to oxidation, by nature, heat, or with reactive colorants, and has a good range of oxidation colors. Blacks, browns, yellows, oranges, reds, violets, and blues are all possible, however, the most common oxidation is the familiar orange-brown of "rust". To keep the steel surface (colored or not) from going to rust, a good sealer must be used.

Advantages of G10100 steel

The main advantages of low-carbon steel for the metal artist are the relative low material cost and availability of pre-made shapes and sizes. Low carbon steel has good strength, ductility, and malleability, and can be both cold and hot worked. It is a very forgiving metal with many aspects of the fabrication process. Low-carbon steel can be joined by soldering, brazing, and welding.

Disadvantages of G10100 steel

Disadvantages include the need to work with hot metal for the metal to remain soft, the industrial aesthetic associated with the material, the limited chemical patina colorations available, and the tendency to oxidize as "rust". A proper sealer is usually needed.

ABOVE: **J.L. COLLIER**
Felix Helix ring
Blackened steel, natural brass, and copper are used for the design elements composing this ring. Using color to differentiate components within an object is a wonderful way to have the viewer focus on parts as well as the whole.

NOTES ON SAMPLES USED IN THIS BOOK

In this book, cold-rolled, low-carbon steel UNS G10100 sheet was used for all the samples. G10100 is considered commercial quality steel with an iron content of 99.18–99.62%, a carbon content of 0.080–0.13%, and a manganese content of 0.30–0.60%. Hot-rolled G10100 or carbon steel alloys of differing composition may yield variances in reactive colorations.

1	2
3	4

1. Translucent Light Golden Brown.

Power flap disc surface. Acetone wipe clean. Heat uniformly over hotplate, burner, or in kiln. Remove from heat when desired color developed. Immediately water quench to cool and freeze the color. Dab dry. Acetone wipe. Apply gloss liquid clearcoat immediately.

2. Golden Yellow. 2

Power brush surface. Phosphoric acid clean. Cold foam brush wipe #2 to desired value. Wet burnish to blend. Water rinse immediately. Dab dry. Repeat coloration process as necessary to obtain desired color quality. Acetone wipe. Apply paste wax clearcoat immediately.

3. Light Rust. 59

Power synthetic wool disc surface. Phosphoric acid clean. Cold foam brush wipe #59. Allow to react for 24 hours. Cold spray mist #59. Allow to complete reaction in open air for minimum 3 days. Apply matte liquid clearcoat.

4. Copper Plate. 4, 3

Power brush surface. Phosphoric acid clean. Cold foam brush wipe #4. Cold foam brush wipe #3 over wet #4 until desired plating uniformity. Water rinse immediately. Dab dry. Acetone wipe. Apply matte liquid clearcoat immediately.

See pages 242–249 for the listing of colorant formulas

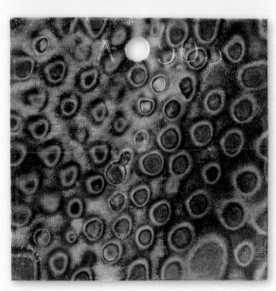

5	6
7	8

5. Aged Copper Plate. 4, 3, 5
Power brush surface. Phosphoric acid clean. Cold foam brush wipe #4. Cold foam brush wipe #3 over wet #4 until desired plating uniformity. Water rinse immediately. Dab dry. Acetone wipe. Hot foam brush wipe #5 until desired value. Dry burnish to blend. Apply matte liquid clearcoat immediately.

6. Translucent Blue-Violet.
Power flap disc surface. Acetone wipe clean. Heat uniformly over hotplate, burner, or in kiln. Remove from heat when desired color developed. Immediately water quench to cool and freeze the color. Dab dry. Acetone wipe. Apply gloss liquid clearcoat immediately.

7. Translucent Red-Violet.
Power flap disc surface. Acetone wipe clean. Heat uniformly over hotplate, burner, or in kiln. Remove from heat when desired color developed. Immediately water quench to cool and freeze the color. Dab dry. Acetone wipe. Apply gloss liquid clearcoat immediately.

8. Translucent Multi-Color Spots Over Steel.
Power flap disc surface. Acetone wipe clean. Develop spot colorations by stippling with flame of air/fuel or oxy/fuel torch. Quench with water saturated cloth to stop the spread of colors. Repeat torch coloring until desired color and pattern developed. Water quench to cool. Dab dry. Acetone wipe. Apply gloss liquid clearcoat immediately.

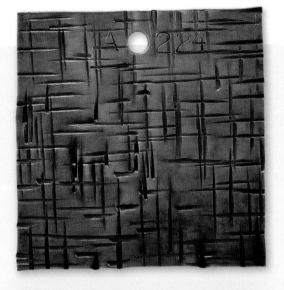

| 9 | 10 |
| 11 | 12 |

9. Golden Yellow Over Mahogany Texture. 2

Hammer texture surface. Phosphoric acid clean. Hot foam brush wipe #2 until desired value. Water rinse immediately. Dab dry. Dry burnish to highlight texture. Acetone wipe. Cold foam brush wipe #2 until desired value. Water rinse immediately. Dab dry. Acetone wipe. Apply satin liquid clearcoat immediately.

10. Heavy Rust. 59

Media blast surface. Acetone wipe clean. Cold foam brush wipe #59. Allow to react for 24 hours. Cold spray mist #59. Allow to react for 24 hours. Repeat cold spray mist applications with 24 hours between each as necessary to obtain desired color quality. Allow to complete reaction in open air for minimum 3 days. Apply matte liquid clearcoat.

11. Green Stipple Over Brown. 4, 3, 7

Power brush surface. Phosphoric acid clean. Cold foam brush wipe #4. Cold foam brush wipe #3 over wet #4 until desired plating uniformity. Water rinse immediately. Dab dry. Acetone wipe. Hot bristle brush stipple #7 until desired color and pattern. Water rinse immediately. Dab dry. Acetone wipe. Apply paste wax clearcoat immediately.

12. Tan Stipple Over Brown. 9, 7

Power brush surface. Phosphoric acid clean. Cold foam brush wipe #9 to desired value. Water rinse immediately. Dab dry. Acetone wipe. Hot bristle brush stipple #7 until desired color and pattern. Water rinse immediately. Dab dry. Acetone wipe. Apply matte liquid clearcoat immediately.

See pages 242–249 for the listing of colorant formulas

13	14
15	16

13. Orange Speckled Texture Over Black. 28, 9

Hand scour. Phosphoric acid clean. Saturate wood shavings with #28. Bury in shavings for 3–5 days. Unbury and remove excess material from surface. Allow to complete reaction in open air for minimum 3 days. Remove any unwanted particles. Cold foam brush wipe #9 until desired value. Water rinse immediately. Dab dry. Acetone wipe. Apply matte liquid clearcoat immediately.

14. Orange Speckled Texture Over Steel. 28

Hand scour surface. Phosphoric acid clean. Saturate wood shavings with #28. Bury in moist shavings for 3–5 days. Unbury and carefully remove excess material from surface. Allow to complete reaction in open air for minimum 3 days. Carefully remove any unwanted particles from surface. Apply matte liquid clearcoat.

15. White Stipple Over Brown. 9, 7, 14

Power brush surface. Phosphoric acid clean. Cold foam brush wipe #9 to desired value. Water rinse immediately. Dab dry. Acetone wipe. Hot bristle brush stipple #7 until desired color and pattern. Water rinse immediately. Dab dry. Acetone wipe. Hot sponge #14 until desired pattern. Apply matte liquid clearcoat immediately.

16. Green Stipple Over Rich Black. 9, 7

Power brush surface. Phosphoric acid clean. Cold foam brush wipe #9 to desired value. Water rinse immediately. Dab dry. Acetone wipe. Hot bristle brush stipple #7 until desired color and pattern. Water rinse immediately. Dab dry. Acetone wipe. Apply paste wax clearcoat immediately.

17	18
19	20

17. Translucent Green With Dark Green Texture. 8, 15

Hammer texture surface. Phosphoric acid clean. Cold foam brush wipe #8 until desired value. Water rinse immediately. Dab dry. Dry burnish to highlight texture. Acetone wipe. Hot foam brush wipe #15. Dry burnish to blend. Apply matte liquid clearcoat immediately.

18. Dark and Pale Blue Over Blue. 8, 16, 14

Media blast surface. Acetone wipe clean. Cold foam brush wipe #8 until desired value. Water rinse immediately. Dab dry. Dry burnish to lighten. Acetone wipe. Hot foam brush wipe #16. Dry burnish to blend. Hot foam brush stipple #14 in desired pattern. Hot foam brush stipple #16 in desired pattern. Dry burnish to blend. Apply matte liquid clearcoat immediately.

19. Translucent Multi-Color Over Steel.

Power flap disc surface. Acetone wipe clean. Draw consistent vertical line of color with flame of air/fuel or oxy/fuel torch. Quench with water saturated cloth to stop the spread of colors. Repeat torch coloring until desired color and pattern developed. Water quench to cool. Dab dry. Acetone wipe. Apply gloss liquid clearcoat immediately.

20. Multi-Color Swirl. 8

Power brush surface. Phosphoric acid clean. Cold bristle brush wipe #8 in desired pattern. Immediately water rinse to freeze the colors. Repeat application and rinse as necessary to develop desired colors and pattern. Dab dry. Acetone wipe. Apply satin liquid clearcoat immediately.

See pages 242–249 for the listing of colorant formulas

21	22
23	24

21. Translucent Pale Blue.
Power flap disc surface. Acetone wipe clean. Heat uniformly over hotplate, burner, or in kiln. Remove from heat when desired color developed. Immediately water quench to cool and freeze the color. Dab dry. Acetone wipe. Apply gloss liquid clearcoat immediately.

22. Translucent Violet Over Masked Steel. 13
Power brush surface. Acetone wipe clean. Apply tape mask to desired area. Media blast surface. Acetone wipe clean. Hot foam brush wipe #13 until desired value. Dry burnish to blend. Remove tape mask. Apply matte liquid clearcoat immediately.

23. Translucent Blue
Power flap disc surface. Acetone wipe clean. Heat uniformly over hotplate, burner, or in kiln. Remove from heat when desired color developed. Immediately water quench to cool and freeze the color. Dab dry. Acetone wipe. Apply gloss liquid clearcoat immediately.

24. Mahogany Brown. 2
Power brush surface. Phosphoric acid clean. Hot foam brush wipe #2 to desired value. Wet burnish to blend. Water rinse immediately. Dab dry. Repeat coloration process as necessary to obtain desired color quality. Acetone wipe. Apply paste wax clearcoat immediately.

25 | 26

25. Translucent Red With dark Red Texture. 8, 10
Hammer texture surface. Phosphoric acid clean. Cold foam brush wipe #8 until desired value. Water rinse immediately. Dab dry. Dry burnish to highlight texture. Acetone wipe. Hot foam brush wipe #10 until desired value. Dry burnish to blend. Apply satin liquid clearcoat immediately.

26. Translucent Violet Over Golden Yellow. 2, 13
Power flap disc surface uniformly in vertical lines followed by horizontal bands. Phosphoric acid clean. Cold foam brush wipe #2 to desired value. Water rinse immediately. Dab dry. Acetone wipe. Hot foam brush wipe #13 until desired value. Dry burnish to blend. Apply satin liquid clearcoat immediately.

27. Heavy Brown and Midnight Blue Over Masked Steel. 61, 56, 62, 63
Power flap disc surface. Acetone wipe clean. Apply tape mask. Cold foam brush #61 until desired value. Water rinse immediately. Dab dry. Acetone wipe. Cold foam brush wipe #56 to wet surface. Fume for 24 hours with #56, #62, and #63 in separate bowls. Uncover and allow to react in open air for minimum 3 days. Remove tape mask. Apply matte liquid clearcoat.

28. Antiqued Copper Plate. 4, 3, 5, 18
Power brush surface. Phosphoric acid clean. Cold foam brush wipe #4. Cold foam brush wipe #3 over wet #4 until desired plating uniformity. Water rinse immediately. Dab dry. Acetone wipe. Hot foam brush wipe #5 until desired value. Dry burnish to blend. Hot foam brush stipple #18. Dry burnish to blend. Repeat #5 and #18 applications as necessary. Apply matte liquid clearcoat immediately.

See pages 242–249 for the listing of colorant formulas

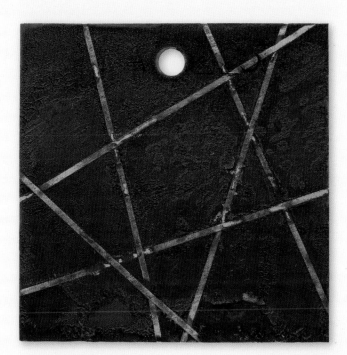

29. Chocolate Brown. 9, 5
Power brush surface. Phosphoric acid clean. Cold foam brush wipe #9 to desired value. Wet burnish to blend. Water rinse immediately. Dab dry. Dry burnish to lighten. Acetone wipe. Hot foam brush wipe #5 until desired value. Dry burnish to blend. Apply satin liquid clearcoat immediately.

30 | 31

30. Rich Reddish Brown. 9, 10, 11
Power brush surface. Phosphoric acid clean. Cold foam brush wipe #9 until desired value. Water rinse immediately. Dab dry. Dry burnish to lighten. Acetone wipe. Hot foam brush wipe #10. Hot foam brush wipe #11. Repeat hot foam brush wipe #10. Dry burnish to blend. Apply satin liquid clearcoat immediately.

31. Slate Black. 8
Power brush surface. Phosphoric acid clean. Cold foam brush wipe #8 to desired value. Wet burnish to blend. Water rinse immediately. Dab dry. Repeat coloration process as necessary to obtain desired color quality. Acetone wipe. Apply matte liquid clearcoat immediately.

32. Slate Black with Rich Black Texture. 8
Hammer texture surface. Phosphoric acid clean. Cold foam brush wipe #8 to desired value. Water rinse immediately. Dab dry. Dry burnish to highlight texture. Acetone wipe. Apply satin liquid clearcoat immediately.

33. Black Over Masked Steel. 61
Power brush surface. Phosphoric acid clean. Apply tape mask. Cold immerse in #61 until desired value. Water rinse immediately. Dab dry. Remove tape mask. Acetone wipe. Apply matte liquid clearcoat immediately.

See pages 242–249 for the listing of colorant formulas

34. Rich Black. 9
Power brush surface. Phosphoric acid clean. Cold foam brush wipe #9 to desired value. Wet burnish to blend. Water rinse immediately. Dab dry. Repeat coloration process as necessary to obtain desired color quality. Acetone wipe. Apply paste wax clearcoat immediately.

Stainless steel

Stainless steel:

INTRODUCTION

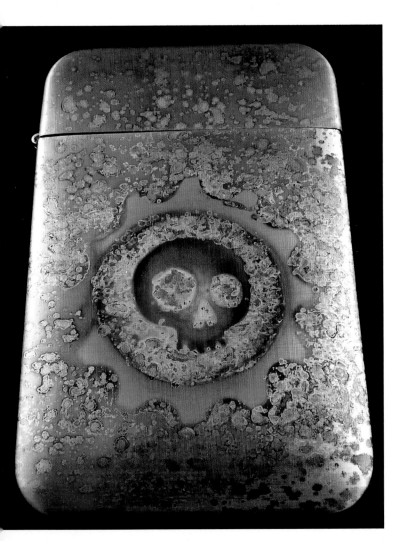

Stainless steel is a specific carbon steel alloy that was developed for its resistance to oxidation. There are a variety of stainless steels, falling into three categories: austenitic, ferritic, and martensitic, each having a specific composition and resulting physical properties. Austenitic stainless steels are by far the most common, alloying chromium and nickel elements (the former for corrosion resistance, the latter for compound stability). The austenitic stainless steels are typically non-magnetic (even though they are ferrous metals), very corrosion resistant, and possess good toughness (combination of strength and plasticity) and ductility. Having favorable fabrication characteristics similar to plain low-carbon steel, coupled with its corrosion resistance and ability to maintain a high luster make it an attractive metal for artists and craftspeople.

Although the oxidation resistance of iron-chromium alloys was recognized in the early 19th century, it wasn't until the advent of a carbon-free chromium process developed later that century which allowed modern stainless steel production to become feasible in the early 20th century. Today, stainless steel alloys are inexpensive enough to be used widely in

LEFT: **GISELLE DUVAL & TIM ANDREW**
Skull and gear case
Using different coloration application methods on a single piece can help bring about textures and visual interest. A type of persona is created with this functional object in part because of the representational shapes and in part because of the interrupted coloration indicating decay or erosion.

consumer, food service, and architectural industries, among others. Austenitic stainless steels cost approximately twice that of plain low-carbon steel. Stainless steel is 100% recyclable, although the recycled content has some loss of desirable properties and is thus blended with virgin stainless steel for new products.

Properties

UNS S30400 stainless steel is the most common of all the stainless steels. It is a special low-carbon steel alloy, with a carbon content no greater than 0.08%. The other primary alloying elements are chromium (18.0–20.0%) and nickel (8.0–10.0%). S30400 stainless steel is widely available as sheet, plate, bar stock, pipe, and tubing. The freshly abraded color of S30400 is a bright, silvery gray.

S30400 stainless possesses an excellent combination of strength and workability. Austenitic S30400 can be easily cold worked, but must be annealed to relieve cold-work-related stresses. The stress relieving annealing temperature ranges between 1850 and 2050°F (1010 and 1120°C), followed by a quick quench cooling. Too high a temperature, or too slow a cooling rate can impact the corrosion resistance of the metal. S30400 can also be readily hot worked, or forged at temperatures between 2100 and 2300°F (1150 and 1260°C), but again, quick cooling is key to maintaining all the beneficial rust-resistant properties.

Stainless S30400 can be soldered, brazed, or welded by conventional means. As with other metals, it is important to understand that differing hot joinery methods may or may not have a color match at the joint, but only welding yields a color and metal compositional match. This is important when using reactive colorants. The weight of S30400 stainless is just slightly higher than that of regular low-carbon steel, or approximately 8 times that of water. S30400 stainless has a melting temperature range of 2550–2651°F (1400–1455°C).

Although stainless steel is formulated to resist natural oxidation, reactive colors of black, brown, yellow, orange, red, violet, and blue are accessible, most through heat temper coloring processes. Black is the most common chemically induced oxidation color.

Advantages of S30400 stainless steel

The main advantages of S30400 stainless steel are its relative

ABOVE: **GISELLE DUVAL & TIM ANDREW**
Summer love earrings
Heat temper colorations change in hue or value as the metal surface temperature increases. Various color effects can be achieved by temper coloring to a higher temperature, abrading select areas back to the bare metal, then temper coloring again to a lower temperature, as was done with these earrings.

low cost and wide availability. Stainless can also be polished and maintains a high luster. Stainless steel S30400 is typically non-magnetic, has great strength and workability properties.

Disadvantages of S30400 stainless steel

The drawbacks to S30400 are its limited chemically reactive colorations and the care required to maintain its corrosion resistance properties when using heat during the forming, joining, and coloring processes.

NOTES ON SAMPLES USED IN THIS BOOK

In this book, austenitic stainless steel alloy UNS S30400, commonly called 18-8 stainless (referring to its main alloyed elements), sheet was used for all the samples. S30400 is comprised primarily of 66.35–74.0% iron, 18.0–20.0% chromium, and 8.0–10.5% nickel. Stainless steel alloys of differing composition may yield variances in reactive colorations.

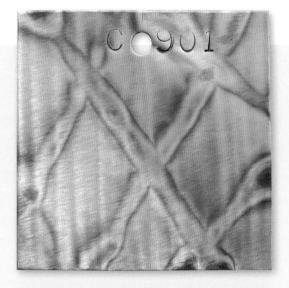

1. Translucent Multi-Color Bands Over Stainless.

Power flap disc surface. Acetone wipe clean. Draw consistent line of color with flame of air/fuel or oxy/fuel torch. Quench with water saturated cloth to stop the spread of colors. Repeat until desired color and pattern developed. Water quench to cool. Dab dry. Acetone wipe. Apply gloss liquid clearcoat.

2. Translucent Orange-Brown.

Power flap disc surface. Acetone wipe clean. Heat uniformly over hotplate, burner, or in kiln. Remove from heat when desired color developed. Immediately water quench to cool and freeze the color. Dab dry. Acetone wipe. Apply gloss liquid clearcoat.

3. Translucent Light Brown

Polish surface. Acetone wipe clean. Heat uniformly over hotplate, burner, or in kiln. Remove from heat when desired color developed. Immediately water quench to cool and freeze the color. Dab dry. Acetone wipe. Apply gloss liquid clearcoat.

4. Translucent Multi-Color Bands Over Golden Brown.

Media blast surface uniformly. Power flap disc vertical bands. Acetone wipe clean. Heat surface with flame of air/fuel or oxy/fuel torch until desired colors develop. Immediately water quench to cool and freeze the color. Dab dry. Acetone wipe. Apply gloss liquid clearcoat.

See pages 242–249 for the listing of colorant formulas

5	6
7	8

5. Yellow Stipple Over Black. 57, 17

Power brush surface. Phosphoric acid clean. Cold foam brush wipe #57 until desired value. Water rinse. Dab dry. Dry burnish to lighten. Acetone wipe. Hot bristle brush stipple #17 until desired value and pattern. Apply matte liquid clearcoat.

6. Translucent Orange Pattern Over Black. 57, 11

Power brush surface. Phosphoric acid clean. Cold foam brush wipe #57 until desired value. Water rinse. Dab dry. Dry burnish to lighten. Acetone wipe. Hot spray stream #11 until desired pattern and value. Apply matte liquid clearcoat.

7. Black Imprint Over Translucent Orange. 11, 57

Media blast surface. Phosphoric acid clean. Hot foam brush wipe #11 until desired value. Dry burnish to blend. Saturate dried leaf with #57. Press or wrap against surface. Allow 2–3 minutes for color to develop. Remove saturated leaf. Water rinse. Dab dry. Dry burnish to blend. Apply matte liquid clearcoat.

8. Reddish Gray With Texture. 57, 10

Hammer texture surface. Media blast surface. Cold immerse in #57 until desired value. Water rinse. Dab dry. Dry burnish to highlight texture. Hot foam brush wipe #10 until desired value. Dry burnish to blend. Apply matte liquid clearcoat.

9 | 10

9. Green Stipple with Silver-Gray Striations. 15
Polish surface. Acetone wipe clean. Hot sponge #15 until desired value and pattern. Abrade with synthetic wool pad to remove select color in desired pattern. Apply satin liquid clearcoat.

10. Blue Speckle Over Masked Slate Black. 16, 57
Media blast surface. Phosphoric acid clean. Apply liquid latex mask over desired area. Hot spray mist #16 until desired value and coverage. Apply matte liquid clearcoat to affix loose color. Remove latex mask. Cold immerse in #57 until desired value. Water rinse. Dab dry. Apply matte liquid clearcoat.

11. Slate Black with Texture. 57
Hammer texture surface. Media blast surface. Phosphoric acid clean. Cold immerse in #57 until desired value. Water rinse. Dab dry. Dry burnish highlight texture. Acetone wipe. Apply matte liquid clearcoat.

12. Slate Black. 57
Media blast surface. Phosphoric acid clean. Cold immerse in #57 until desired value. Water rinse. Dab dry. Dry burnish to lighten. Acetone wipe. Apply matte liquid clearcoat.

See pages 242–249 for the listing of colorant formulas

13. Black Speckle Over Stainless. 18

Polish surface. Phosphoric acid clean. Hot spray mist #18 until desired value and pattern. Apply satin liquid clearcoat.

Aluminum

Aluminum:
INTRODUCTION

ABOVE: **JON M. RYAN**
Blue Mountain ring
Coloration can be used to enhance the given feeling of the form. The sky blue used here has a cool, almost barren sense which echoes the mountainous subject of the ring.

Pure, elemental aluminum is the most prevalent metal found in the earth's crust. Aluminum is a non-ferrous (containing no iron) metal that is lightweight, and in pure form is very soft and possesses low strength. Aluminum is often alloyed with other elements to increase the hardness and strength to fit broader industrial applications. Aluminum alloys have a high strength-to-weight ratio while maintaining very good ductility and malleability, all of which can be favorable to the metalsmith.

Aluminum was successfully isolated as a metal in the early-19th century, but it wasn't until late in the century that an economical means of extracting aluminum from ore was developed. Prior to this, aluminum was considered more valuable than gold. Today, almost all the metallic aluminum production begins with the mineral bauxite, which is only found in select areas of the world. A combination smelting and electrolysis process is used to extract the metal from the bauxite, a process that consumes much electricity. Recycled aluminum has the same properties as virgin aluminum, with only a fraction of the needed process energy; for this reason, recycling has become an important part of the aluminum industry. Aluminum and its alloys are the most widely used non-ferrous metals, second overall only to iron and steel. Even with its difficult production, aluminum is relatively inexpensive and is used in many items from consumer goods to the construction and transportation industries. The costs of basic aluminum alloys are approximately the same as low-carbon steel.

RIGHT: **ANNA TALBOT**
Red and Brown riding hood
The warm colors of the patinated gilding metal and anodized aluminum visually come to the foreground while the cool colors fall to the back. Here, color is used to create depth of scene within a relatively shallow space.

BELOW: **PEGGY ENG**
Ripple
This work is made of individual slivers of aluminum that are fused together, and then given an undulating form with the ends trailing off. The anodized dyed blue coloration helps with the sense of air or water movement.

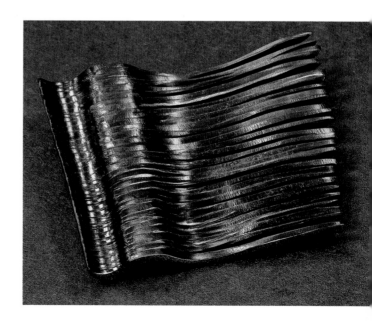

Properties

Aluminum alloy UNS A93003 introduces manganese (1.0–1.5%) primarily for strength reasons. Aluminum alloys are widely available as sheet, plate, solid bar stock of various shapes, and tubing, however A93003 is primarily a sheet product. The freshly abraded color of aluminum alloy A93003 is whitish silver.

A93003 aluminum is ductile and malleable, but has lower strength than most metals mentioned in this book (sterling silver being the lowest strength). Aluminum alloy A93003 can be readily worked both cold and hot, and like most metals, it work hardens when cold worked. A93003 aluminum can be

RIGHT: **JOANNE COX**
Tendrill cuff
The coloring of metal can do much more than simply add a feeling of antiquity. Think of the metal surface as a "blank canvas" for colors, textures, and imagery to be placed on. Here, an image transfer technique with dye was used to create the composition.

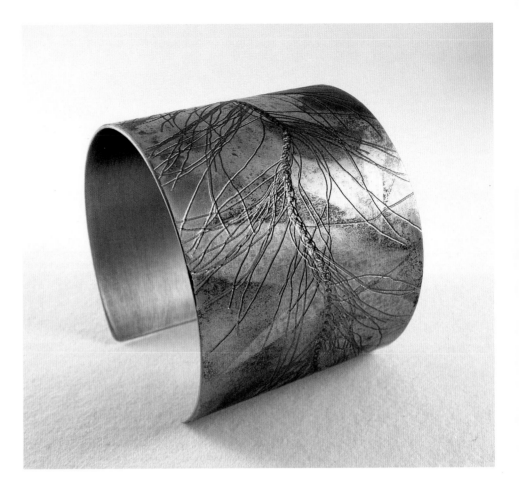

ABOVE: **PEGGY ENG**
Large disk with pearl
The rich, dark dye coloration given to the aluminum is interrupted by the shiny line bisecting the middle, leading the viewer's eye toward the pearl. This is a nice example of using color value to showcase a specific part of the form or piece.

annealed by uniformly heating the metal to approximately 775°F (410°C), followed by air-cooling. Basic aluminum alloys can also be hot worked and forged, both at temperatures between 500 and 950°F (260 and 510°C).

Aluminum alloys can be soldered, brazed, or welded by conventional means, but it is important to remove all aluminum oxide from the joint area prior to hot joining. This is done with mechanical and chemical cleaning and use of fluxes. From a coloration point of view, it is important to understand that differing hot joinery methods may or may not have a color match at the joint, but only welding yields a color and metal compositional match. This is important when using reactive colorants. The weight of aluminum is relatively low, with a specific gravity of 2.73 (water sg = 1.00). A93003 aluminum has a melting temperature range of 1190–1210°F (645–655°C).

Although aluminum and its alloys oxidize readily, naturally occurring aluminum oxide is a transparent layer that resists further oxidation (most true with pure aluminum). This clear oxide layer is what makes hot joinery and the finishing of aluminum more difficult. The tough aluminum oxide layer needs to be removed for proper adhesion, and can dull a finish. Aluminum and its alloys are very restricted in reactive colorations, all falling in the black family.

Advantages of A93003 aluminum

The main advantages of aluminum alloy A93003 are its relative low cost with ease of accessibility, its light weight (3–5 times lighter than the other metals mentioned in this book), and its cold workability with proper annealing. A93003 can be readily hot joined.

Disadvantages of A93003 aluminum

The disadvantage of A93003 aluminum is that it is primarily available as a sheet product only. Other aluminum alloys are available in various shapes, but may be more expensive. Aluminum and its alloys are limited in true oxidation colors, with black being the only available. Forming aluminum A93003 requires much closer attention to avoid stress cracking while cold working. Frequent annealing is required. Lastly, the clear aluminum oxide makes hot joining the metal just a bit more challenging compared to other metals.

ABOVE: **JON M. RYAN**
Untitled
The addition of unnatural color can help take found objects, in this case 1 yen coins, slightly out of context and create visual interest by forcing the viewer's mind to work just a bit to identify the ready-made piece(s). Using a consistent coloration from object to object unifies the individual components to form a singular work.

NOTES ON SAMPLES USED IN THIS BOOK

In this book, aluminum alloy UNS A93003 (commonly called 3003 aluminum) sheet was used for all the samples. A93003 is comprised primarily of 96.7–99.0% aluminum, 1.0–1.50% manganese, and 0.050–0.20% copper. Aluminum alloys of differing composition may yield variances in reactive colorations.

1	2
3	4

1. Stippled Yellow and Brown. 17

Power synthetic wool disc surface. Phosphoric acid clean. Hot bristle brush stipple #17 until desired color and pattern. Apply matte liquid clearcoat.

2. Translucent Yellow Striations In Black. 58, 17

Hand scour surface. Phosphoric acid clean. Cold foam brush wipe #58 to desired value. Water rinse. Dab dry. Abrade with synthetic wool pad in vertical direction to remove select color. Acetone wipe. Hot foam brush wipe #17 until desired value. Dry burnish to blend. Apply satin liquid clearcoat.

3. Black Over Masked Golden Yellow Stipple. 17, 58

Hand scour surface. Phosphoric acid clean. Hot foam brush stipple #17 until desired pattern and value. Allow to cool. Apply liquid latex mask over desired area. Cold foam brush wipe #58 until desired value. Water rinse. Dab dry. Remove latex mask. Acetone wipe. Apply satin liquid clearcoat.

4. Multi-Color Bands Over Black and Aluminum. 58, 17, 11

Power flap disc surface. Phosphoric acid clean. Apply liquid latex mask to desired area. Cold foam brush wipe #58 to desired value. Water rinse. Dab dry. Remove latex mask. Dry burnish to lighten. Acetone wipe. Hot foam brush wipe #17 over desired area until desired value. Dry burnish to blend. Apply matte liquid clearcoat.

See pages 242–249 for the listing of colorant formulas

5	6
7	8

5. Translucent Brown. 5
Power synthetic wool disc surface. Phosphoric acid clean. Hot foam brush wipe #5 until desired value. Dry burnish to lighten and blend. Apply matte liquid clearcoat.

6. Translucent Brown With Dark Brown Texture. 58, 5
Hammer texture surface. Phosphoric acid clean. Cold foam brush wipe #58 to desired value. Water rinse. Dab dry. Dry burnish to highlight texture. Acetone wipe. Hot foam brush wipe #5 until desired value. Dry burnish to blend. Apply matte liquid clearcoat.

7. Stippled Orange Over Translucent Brown. 5, 11
Power synthetic wool disc surface. Phosphoric acid clean. Hot foam brush wipe #5 until desired value. Dry burnish to lighten and blend. Hot sponge #11 until desired pattern and value. Apply matte liquid clearcoat.

8. Translucent Red. 10
Power flap disc surface. Phosphoric acid clean. Hot foam brush wipe #10 until desired value. Dry burnish to blend. Apply satin liquid clearcoat.

| 9 | 10 |
| 11 | 12 |

9. Green Stipple Over Black. 12, 6

Hand scour surface. Phosphoric acid clean. Cold immerse in #12 until desired value. Water rinse. Dab dry. Hot bristle brush stipple #6 until desired color and pattern. Apply paste wax clearcoat.

10. Translucent Green Bands. 15

Power flap disc surface. Phosphoric acid clean. Hot foam brush wipe #15 until desired value. Dry burnish to blend. Tape mask desired areas. Hot foam brush wipe #15 until desired value. Remove tape mask. Apply satin liquid clearcoat.

11. Translucent Green Speckle Over Burnished Black. 58, 15

Hand scour surface. Phosphoric acid clean. Cold foam brush wipe #58 to desired value. Dab dry. Dry burnish to lighten. Acetone wipe. Hot spray splatter #15 until desired value and pattern. Apply matte liquid clearcoat.

12. Black Pattern Over Translucent Violet. 13, 58

Media blast surface. Phosphoric acid clean. Hot spray mist #13 until desired value and coverage. Dry burnish to blend. Saturate textured cloth with #58. Press or wrap onto surface. Allow 2–3 minutes for the color to develop. Carefully remove cloth. Water rinse. Dab dry. Apply matte liquid clearcoat.

See pages 242–249 for the listing of colorant formulas

13	14
15	16

13. Translucent Violet Speckle. 13
Power flap disc surface. Phosphoric acid clean. Hot spray mist #13 until desired value and coverage. Apply satin liquid clearcoat.

14. Blue Pattern Over Translucent Blue. 16
Power flap disc surface. Phosphoric acid clean. Hot foam brush wipe #16 until desired value. Dry burnish to blend. Hot foam brush stipple #16 until desired pattern and value. Apply satin liquid clearcoat.

15. Black Stipple Over Translucent Blue. 16, 58
Hand scour surface. Phosphoric acid clean. Hot foam brush wipe #16 until desired value. Dry burnish to blend. Cold bristle brush stipple #58 until desired pattern and value. Water rinse. Dab dry. Apply matte liquid clearcoat

16. Silvery Gray With Black Texture. 58
Hammer texture surface. Phosphoric acid clean. Cold foam brush wipe #58 to desired value. Water rinse. Dab dry. Dry burnish to highlight texture. Acetone wipe. Apply matte liquid clearcoat.

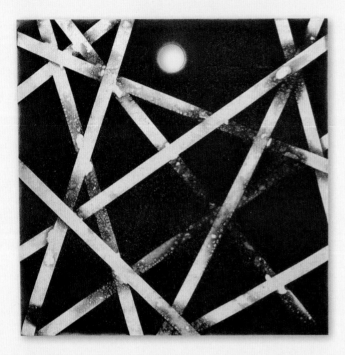

17 | 18

17. Black Over Masked Aluminum. 12

Hand scour surface. Phosphoric acid clean. Apply tape mask to desired area. Cold immerse in #12 until desired value. Water rinse. Dab dry. Remove tape mask. Acetone wipe. Apply matte liquid clearcoat.

18. Grayish Black Over Texture. 12

Power sanding disc surface. Phosphoric acid clean. Cold immerse in #12 until desired value. Water rinse. Dab dry. Dry burnish to highlight texture. Acetone wipe. Apply satin liquid clearcoat.

19.Translucent Black Ringlets Over Aluminum. 18

Power synthetic wool disc surface. Phosphoric acid clean. Hot spray #18 until desired pattern and value. Apply matte liquid clearcoat.

20. Jet Black. 12

Hand scour surface. Phosphoric acid clean. Cold foam brush wipe #12 to desired value. Water rinse. Dab dry. Acetone wipe. Apply matte liquid clearcoat.

See pages 242–249 for the listing of colorant formulas

21. Grayish Black. 12
Hand scour surface. Phosphoric
acid clean. Cold foam brush wipe
#12 to desired value. Wet burnish
to blend and lighten. Water rinse.
Dab dry. Acetone wipe. Apply
satin liquid clearcoat.

Copper

Copper:
INTRODUCTION

BELOW: **JUDY PARADY**
Three medallions
Metal colorations can help create an entire series or line of work from the same basic form. The addition of colorations, settings, and incised lines make each of these pieces unique within a family.

Copper is a non-ferrous elemental metal that has been used for thousands of years. It, along with the copper-based alloys (brass and bronze, namely), played an important role in the development of civilizations. Pure copper is a very soft metal with excellent malleability and ductility. Its workability, raw metal and oxidation colors, stability of oxidation states, and high luster ability have long made copper an attractive metal for ornamentation.

Copper use has been traced back at least 10,000 years to the Middle East region. Prior to copper, it is believed only gold and meteoric iron metals were utilized. The most probable initial copper process was cold forming of native copper. The discovery and refinement of heat sources facilitated processes such as annealing, smelting from ore, and casting (using the lost wax technique). Copper instruments included weaponry, tools, coins, and jewelry. Today, a multi-step smelting, heating, and electrorefining process is used to extract copper from ores, the most common being a sulfide named chalcopyrite. Today's copper

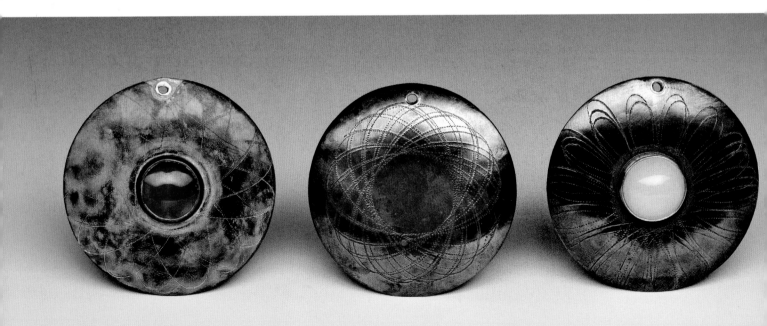

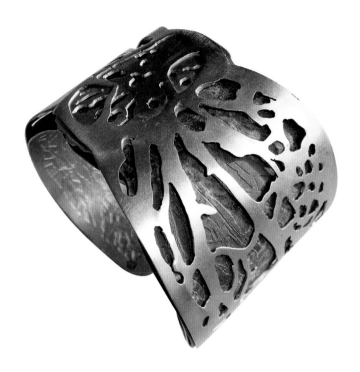

RIGHT: **JANE DE BAECKE**
Organic cuff 3
Allowing the viewer to look through the top layer into an under layer via negative cutouts is a wonderful way to create visual interest. The color and surface difference between the brightened, smooth outer brass and the inner patinated, etched copper heightens this interest.

is primarily used for decorative and ornamental building materials and as a base for many metal alloys. Because of its more difficult extraction process, copper costs nearly seven times that of low-carbon steel. Pure copper has a 100% recyclability rate, and thus recycling is a big part of the copper industry. Copper is the third highest recycled metal, behind iron and aluminum. It is estimated that 80% of all the copper extracted from the earth's crust is still in use today.

Properties

Copper UNS C11000 is considered "pure" copper, and has a chemical composition of 99.90% copper and 0.04% oxygen. It is often referred to as "electrolytic tough pitch", or ETP copper. C11000 copper is commonly available as sheet, plate, bar, rod, strip, and wire products. Freshly abraded C11000 copper is a reddish orange color, and is one of only four elemental metals having a color other than silver or gray.

UNS C11000 copper is considered a tough metal, having both good strength and excellent ductility. Its favorable ductility and malleability make this an excellent choice for forming. C11000 possesses excellent cold and hot forming characteristics. Cold forming requires proper annealing to a temperature between 700 and 1200°F (370 and 650°C) and should be followed by an air cool to alleviate work hardening stresses. Hot working or forging can be performed at temperatures between 1400 and 1600°F (760 and 870°C).

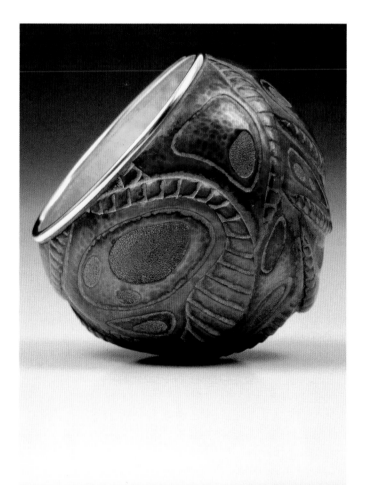

RIGHT: **DAVID HUANG**
Luminous Relic 960-2
Natural oxidation tends to be more advanced in recessed areas. Mimic this feel by applying color to a textured surface and burnish to keep it in the low-lying areas. Here, the green colorant was applied to the copper form and burnished, with an antiquing solution layered on top.

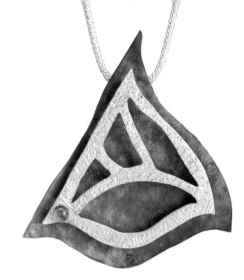

RIGHT: **JULIA RAI**
Wave
The multi-colors developed on the sheet copper through heat temper oxidation serve as a beautiful backdrop to the fine silver outer layer. Creating the darker colored backdrop ensures the silver is visually prominent.

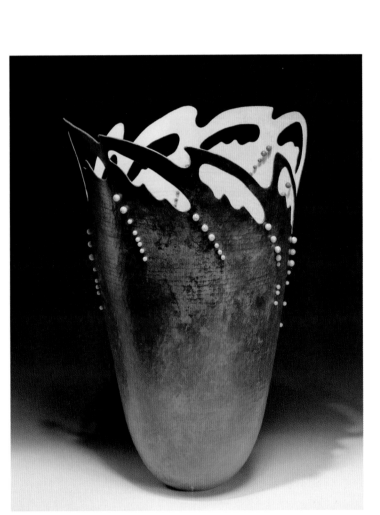

ABOVE: **CAROL WARNER**
Fireworks #2
The coloration on this hand-hammered copper vessel is beautiful and mimics natural oxidation, but more than this it uses color to define the interior and exterior spaces. The warm golden yellow of the interior invites the viewer to gaze inside.

Copper C11000 can be readily hot joined with soldering, brazing, or welding, although oxygen-free copper (UNS C10100) has more favorable welding characteristics. As with other metals, it is important to understand that differing hot joinery methods may or may not have a color match at the joint, but only welding yields a color and metal compositional match. This is important when using reactive colorants. A disadvantage to copper is its weight, roughly 9 times that of water (specific gravity of 8.89). With the metals discussed in this book, only sterling silver is heavier. The melting point of C11000 copper is between 1949 and 1981°F (1065 and 1080°C).

Pure copper oxidizes readily under normal atmospheric conditions to a brown or black copper oxide. This oxidation acts as a great barrier to further degradation of the underlying metal. Copper has oxidation colors of black, brown, yellow, orange, red, violet, blue, and green, making it the most readily colored metal with reactive processes.

Advantages of C11000 copper

One main advantage to pure copper is that it has long since been considered a metal of beauty, both in the raw state and with its many available reactive oxidation colors. Copper can be brought to a high luster quite easily, but requires a clearcoat to keep it from dulling and tarnishing. Other advantages include the excellent cold and hot forming characteristics and ease of hot joinery. Copper C11000 is readily found as sheet, plate, rod, and wire products.

Disadvantages of C11000 copper

The main disadvantage to pure copper is the raw material cost of nearly 7 times that of low-carbon steel. UNS C11000 copper is also relatively heavy and a very soft metal.

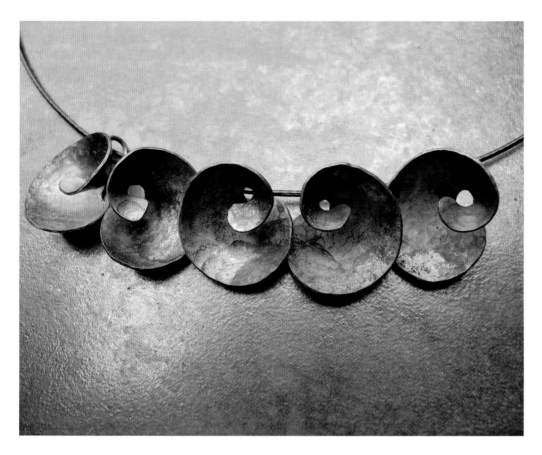

LEFT: **ANN BRUFORD**
Multi-wave necklace
A dark, oxidized underlayer allows the top layered greens and blues from the heat temper coloration to visually "pop" from the copper surface.

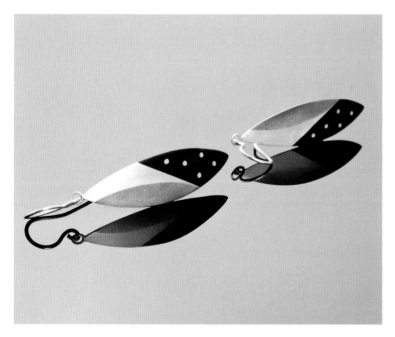

LEFT: **LEONIE BENNETT**

Tryst: earrings I
One method to visually differentiate parts of an object is to use multiple metal compositions that react differently to a reactive colorant. Here is a fine example of a coloration result with a darker color at the alloy where there is a higher copper content.

NOTES ON SAMPLES USED IN THIS BOOK

In this book, copper UNS C11000, commonly called electrolytic tough pitch (ETP) copper, sheet was used for all the samples. The composition of UNS C11000 is comprised of a minimum 99.90% copper plus a maximum of 0.04% oxygen. Pure copper of differing composition may yield variances in reactive colorations.

1	2
3	4

1. Aged Copper. 21
Hand scour surface. Phosphoric acid clean. Cold foam brush wipe #21 until desired value. Water rinse. Dab dry. Dry burnish to lighten and blend. Acetone wipe. Apply paste wax clearcoat.

2. Orange-Brown With Brown Speckle. 54
Media blast surface. Phosphoric acid clean. Hot immerse at just below boiling in #54 for 30 minutes. Stir solution every 5 minutes. Water rinse. Dab dry. Acetone wipe. Apply paste wax clearcoat.

3. Red-Orange Speckle Over Copper. 44
Power synthetic wool disc surface. Phosphoric acid clean. Hot immerse at just below boiling in #44 for 2½ minutes. Water rinse. Dab dry. Apply paste wax clearcoat.

4. Translucent Orange. 49
Power synthetic wool disc surface. Phosphoric acid clean. Hot immerse at just below boiling in #49 for 30 minutes. Stir solution every 5 minutes. Water rinse. Dab dry. Apply paste wax clearcoat.

See pages 242–249 for the listing of colorant formulas

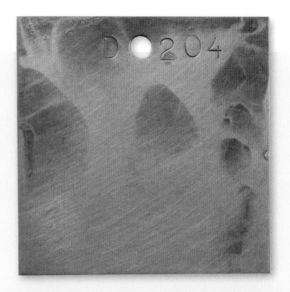

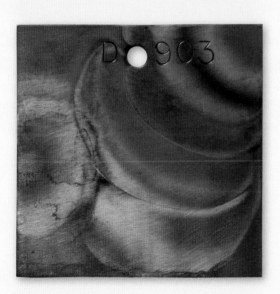

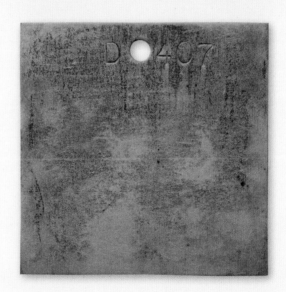

| 5 | 6 |
| 7 | 8 |

5. Light Orange-Brown. 56
Media blast surface. Phosphoric acid clean. Hot immerse at just below boiling in #56 for 30 minutes. Water rinse. Dab dry. Acetone wipe. Apply paste wax clearcoat.

6. Red-Violet With Pale Golden Brown Pattern. 19
Hand scour surface. Hot pickle bath clean. Cold immerse dip in #19 with no dwell time. Water rinse. Dab dry. Acetone wipe. Apply paste wax clearcoat.

7. Translucent Multi-Color Pattern.
Polish surface. Phosphoric acid clean. Develop spot colorations by stippling with flame of air/fuel or oxy/fuel torch. Quench with water saturated cloth to stop the spread of colors. Repeat until desired color and pattern developed. Water quench to cool. Dab dry. Acetone wipe. Apply gloss liquid clearcoat.

8. Violet Speckle Over Copper. 35
Media blast surface. Phosphoric acid clean. Cold immerse in #35 for 5 days. Stir every 24 hours. Water rinse. Dab dry. Acetone wipe. Apply satin liquid clearcoat.

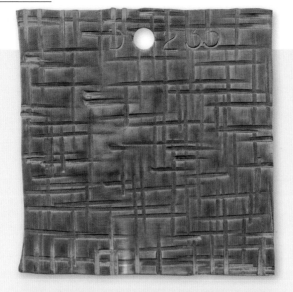

9	10
11	12

9. Aged Copper With Yellow-Brown Texture. 40, 17

Hammer texture surface. Phosphoric acid clean. Cold foam brush wipe #40 until desired value. Water rinse. Dab dry. Hot foam brush wipe #17 until desired value. Dry burnish to blend and highlight texture. Apply matte liquid clearcoat.

10. Brown Pattern Over Orange-Brown. 53

Media blast surface. Phosphoric acid clean. Hot immerse at just below boiling in #53 for 30 minutes. Stir solution every 5 minutes. Water rinse. Dab dry. Acetone wipe. Apply paste wax clearcoat.

11. Brown Stipple Over Copper. 23

Power flap disc surface. Phosphoric acid clean. Hot bristle brush stipple #23 until desired value and pattern. Apply paste wax clearcoat.

12. Red-Orange. 27

Hand scour surface. Phosphoric acid clean. Boiling immersion in cupric sulfate portion of #29 for 15 minutes. Remove and immediately immerse in hot water (140°F/60°C) to keep surface hot. Add ammonium chloride portion of #29 to boiling solution. Return object to boiling solution for 10 minutes. Hot water rinse. Dab dry. Acetone wipe. Apply matte liquid clearcoat.

See pages 242–249 for the listing of colorant formulas

13. Aged Copper With Black Texture. 38

Hammer texture surface. Phosphoric acid clean. Cold immerse in #38 until desired value. Water rinse. Dab dry. Dry burnish to highlight texture. Acetone wipe. Apply matte liquid clearcoat.

14. Orange-Brown With Black. 55

Media blast surface. Phosphoric acid clean. Hot immerse at just below boiling in #55 for 30 minutes. Stir solution every 5 minutes. Water rinse. Dab dry. Acetone wipe. Apply clear wax.

15. Brown Stipple. 21, 23

Hand scour surface. Phosphoric acid clean. Cold foam brush wipe #21 until desired value. Water rinse. Dab dry. Dry burnish to lighten and blend. Acetone wipe. Hot bristle brush stipple #23 until desired value and pattern. Apply matte liquid clearcoat.

16. Red-Orange Speckle. 44

Power synthetic wool disc surface. Phosphoric acid clean. Hot immerse at just below boiling in #44 for 5 minutes. Water rinse. Dab dry. Apply paste wax clearcoat.

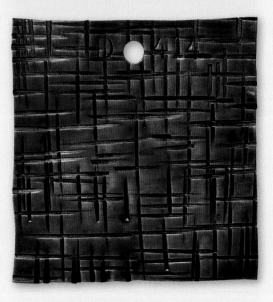

17	18
19	20

17. Translucent Light Reddish Brown.

Polish surface. Phosphoric acid clean. Heat uniformly over hotplate, burner, or in kiln. Remove from heat when desired color developed. Immediately water quench to cool and freeze the color. Dab dry. Acetone wipe. Apply gloss liquid clearcoat.

18. Grayish Brown. 45

Media blast surface. Phosphoric acid clean. Cold immerse in #45 for 2 minutes. Water rinse. Dab dry. Acetone wipe. Apply matte liquid clearcoat.

19. Translucent Metallic Red With Black Texture. 37, 10

Hammer texture surface. Phosphoric acid clean. Cold foam brush wipe #37 until desired value. Water rinse. Dab dry. Dry burnish to highlight texture. Acetone wipe. Hot foam brush wipe #10 until desired value. Apply satin liquid clearcoat.

20. Reddish Brown Pattern. 21, 24

Hand scour surface. Phosphoric acid clean. Cold foam brush wipe #21 until desired value. Water rinse. Dab dry. Dry burnish blend. Acetone wipe. Hot spray #24 with surface at or above 212°F (100°C). Repeat spray application until desired color and pattern. Apply paste wax clearcoat.

See pages 242–249 for the listing of colorant formulas

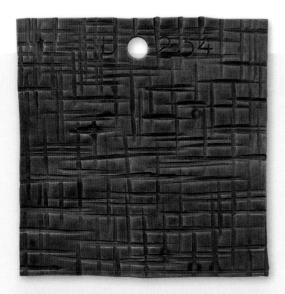

21	22
23	24

21. Orange-Brown With Dark Brown Texture. 40, 11
Hammer texture surface. Phosphoric acid clean. Cold foam brush wipe #40 until desired value. Water rinse. Dab dry. Hot foam brush wipe #11 until desired value. Dry burnish to blend. Apply matte liquid clearcoat.

22. Liver Brown. 20
Hand scour surface. Hot pickle bath clean. Cold immerse in #20 for 10 seconds. Water rinse. Dab dry. Acetone wipe. Apply paste wax clearcoat.

23. Dark Red-Orange. 44
Power synthetic wool disc surface. Phosphoric acid clean. Hot immerse at just below boiling in #44 for 10 minutes. Stir solution at 5 minutes. Water rinse. Dab dry. Apply paste wax clearcoat.

24. Brown With Dark Brown Texture. 40
Hammer texture surface. Phosphoric acid clean. Cold foam brush wipe #40 until desired value. Water rinse. Dab dry. Acetone wipe. Apply matte liquid clearcoat.

25	26
27	28

25. Pale Blue-Green Stipple With Pink and Brown. 59
Hand scour surface. Phosphoric acid clean. Hot sponge heated #59 (180–190°F/82–88°C) until desired color and pattern. Apply paste wax clearcoat.

26. Pale Blue With Tan. 46
Hand scour surface. Phosphoric acid clean. Cold foam brush wipe #46. Allow to react for 24 hours. Cold spray airbrush #46. Allow to react for 24 hours. Repeat cold spray airbrush application 3 times with 24 hours between each. Allow to complete reaction in open air for minimum 3 days. Apply matte liquid clearcoat.

27. Pale Teal Over Light Brown. 45, 46
Hand scour surface. Phosphoric acid clean. Cold immerse in #45 for 1 minute. Water rinse. Dab dry. Acetone wipe. Cold foam brush wipe #46. Allow to react for 24 hours. Cold spray airbrush #46. Allow to react for 24 hours. Repeat cold spray airbrush application 3 times with 24 hours between each. Allow to complete reaction in open air for minimum 3 days. Apply matte liquid clearcoat.

28. Teal. 34
Hand scour surface. Phosphoric acid clean. Cold foam brush wipe #34. Allow to react for 24 hours. Cold spray airbrush #34. Allow to react for 24 hours. Repeat cold spray airbrush application 3 times with 24 hours between each. Allow to complete reaction in open air for minimum 3 days. Apply matte liquid clearcoat.

See pages 242–249 for the listing of colorant formulas

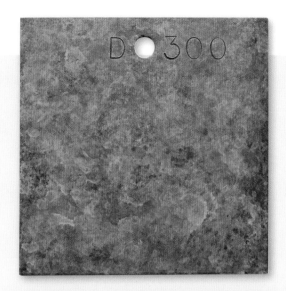

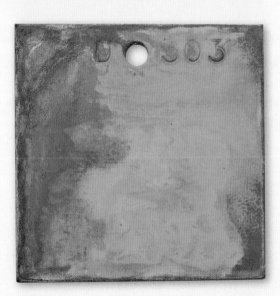

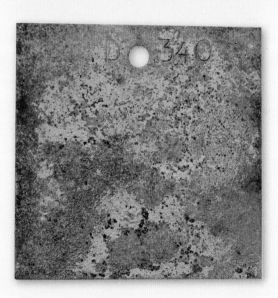

29	30
31	32

29. Pale Green Over Masked Aged Copper. 45, 46

Media blast surface. Phosphoric acid clean. Cold immerse in #45 for 2 minutes. Water rinse. Dab dry. Acetone wipe. Apply tape mask. Cold foam brush wipe #46. Allow to react for 24 hours. Cold spray mist #46. Allow to react for 24 hours. Repeat cold spray mist application 3 times at 24 hour intervals. Remove mask. Allow to complete reaction in open air for minimum 3 days. Apply matte liquid clearcoat.

30. Blue-Green Stipple Over Brown. 21, 6

Hand scour surface. Phosphoric acid clean. Cold foam brush wipe #21 until desired value. Water rinse. Dab dry. Dry burnish to blend. Acetone wipe. Hot bristle brush stipple #6 until desired color and pattern. Apply matte liquid clearcoat.

31. Pale Blue-Green With Grayish Brown. 26

Hand scour surface. Phosphoric acid clean. Cold foam brush wipe #26. Allow to react for 24 hours. Cold spray airbrush #26. Allow to react for 24 hours. Repeat cold spray airbrush application 3 times with 24 hours between each. Allow to complete reaction in open air for minimum 3 days. Apply matte liquid clearcoat.

32. Blue-Green and Black Speckle. 35, 22

Hand scour surface. Phosphoric acid clean. Hot spray mist #35 until desired color and pattern. Hot spray mist #22 until desired value and pattern. Water rinse. Dab dry. Acetone wipe. Apply paste wax clearcoat.

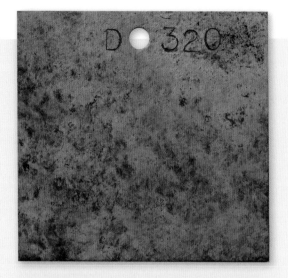

| 33 | 34 |
| 35 | 36 |

33. Heavy Blue-Green Stipple. 35

Hand scour surface. Phosphoric acid clean. Hot bristle brush stipple #35 until desired color and pattern. Apply paste wax clearcoat.

34. Blue-Green and Golden Brown Stipple Over Brown. 21, 6, 23

Hand scour surface. Phosphoric acid clean. Cold foam brush wipe #21 until desired value. Water rinse. Dab dry. Dry burnish to blend. Acetone wipe. Hot bristle brush stipple #6 until desired color and pattern. Hot bristle brush stipple #23 until desired value and pattern. Apply paste wax clearcoat.

35. Greenish Blue. 32

Hand scour surface. Phosphoric acid clean. Cold foam brush wipe #32. Allow to react for 24 hours. Cold spray airbrush #32. Allow to react for 24 hours. Repeat cold spray airbrush application 3 times with 24 hours between each. Allow to complete reaction in open air for minimum 3 days. Apply matte liquid clearcoat.

36. Light Blue-Green Over Light Brown. 45, 52

Power synthetic wool disc surface. Phosphoric acid clean. Cold immerse in #45 for 1 minute. Water rinse. Dab dry. Acetone wipe. Cold foam brush wipe #52. Allow to react for 24 hours. Cold spray airbrush #52. Allow to react for 24 hours. Repeat cold spray airbrush application 3 times at 24 hour intervals. Allow to complete reaction in open air for minimum 3 days. Apply matte liquid clearcoat.

See pages 242–249 for the listing of colorant formulas

37	38
39	40

37. Pale Blue-Green With Tan. 48

Hand scour surface. Phosphoric acid clean. Cold foam brush wipe #48. Allow to react for 24 hours. Cold spray airbrush #48. Allow to react for 24 hours. Repeat cold spray airbrush application 3 times with 24 hours between each. Allow to complete reaction in open air for minimum 3 days. Apply matte liquid clearcoat.

38. Light Blue and Green Over Masked Light Brown. 41, 59

Media blast. Phosphoric acid clean. Cold foam brush wipe #41. Water rinse. Dab dry. Apply liquid latex mask. Cold foam brush wipe #59. Allow to react for 24 hours. Cold spray mist #59. Allow to react for 24 hours. Repeat cold spray mist 3 times at 24 hour intervals. Allow to complete reaction in open air for minimum 3 days. Apply matte liquid clearcoat to affix coloration. Remove latex. Apply matte liquid clearcoat.

39. Blue-Green and Brown Speckled Texture Over Copper. 56, 28

Hand scour surface. Phosphoric acid clean. Cold foam brush wipe #56 to wet surface. Saturate wood shavings with #28. Bury in shavings for 24 hours. Unbury and remove excess material from surface. Allow to complete reaction in open air for minimum 3 days. Carefully remove any unwanted particles from surface. Apply matte liquid clearcoat.

40. Aged Copper With Green-Blue Texture. 25

Hammer texture surface. Media blast surface. Phosphoric acid clean. Cold foam brush wipe #25. Allow to react for 24 hours. Cold spray mist #25. Allow to react for 24 hours. Repeat cold spray mist application 3 times with 24 hours between each. Allow to complete reaction in open air for minimum 3 days. Dry burnish to highlight texture. Apply matte liquid clearcoat.

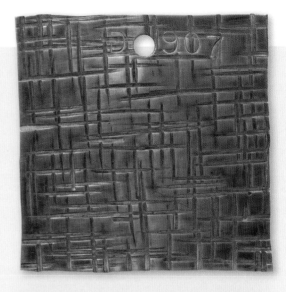

41	42
43	44

41. Blue-Green and Olive With Texture. 38, 60

Hammer texture. Media blast surface. Phosphoric acid clean. Cold foam brush wipe #38. Water rinse. Dab dry. Dry burnish to highlight texture. Cold foam brush wipe #60. Allow to react for 24 hours. Cold spray mist #60. Allow to react for 24 hours. Repeat cold spray mist application 3 times at 24 hour intervals. Allow to complete reaction in open air for minimum 3 days. Apply matte liquid clearcoat.

42. Aged Copper With Pastel Black Texture. 37, 14

Hammer texture surface. Phosphoric acid clean. Cold foam brush wipe #37 until desired value. Water rinse. Dab dry. Dry burnish to highlight texture. Acetone wipe. Hot foam brush wipe #14 until desired value. Dry burnish to highlight texture. Apply satin liquid clearcoat.

43. Sky Blue Over Olive Green. 45, 48

Hand scour surface. Phosphoric acid clean. Cold immerse in #45 for 1 minute. Water rinse. Dab dry. Acetone wipe. Cold foam brush wipe #48. Allow to react for 24 hours. Cold spray airbrush #48. Allow to react for 24 hours. Repeat cold spray airbrush application 3 times at 24 hour intervals. Allow to complete reaction in open air for minimum 3 days. Apply matte liquid clearcoat.

44. Bluish Green With Brown. 1

Hand scour surface. Phosphoric acid clean. Cold foam brush wipe #1. Allow to react for 24 hours. Cold spray airbrush #1. Allow to react for 24 hours. Repeat cold spray airbrush application 3 times with 24 hours between each. Allow to complete reaction in open air for minimum 3 days. Apply matte liquid clearcoat.

See pages 242–249 for the listing of colorant formulas

45	46
47	48

45. Pale Blue-Green. 33
Hand scour surface. Phosphoric acid clean. Cold foam brush wipe #33. Allow to react for 24 hours. Cold spray airbrush #33. Allow to react for 24 hours. Repeat cold spray airbrush application 3 times with 24 hours between each. Allow to complete reaction in open air for minimum 3 days. Apply matte liquid clearcoat.

46. Pale Blue-Green With Sky Blue. 28
Hand scour surface. Phosphoric acid clean. Cold foam brush wipe #28. Allow to react for 24 hours. Cold spray airbrush #28. Allow to react for 24 hours. Repeat cold spray airbrush application 3 times with 24 hours between each. Allow to complete reaction in open air for minimum 3 days. Apply matte liquid clearcoat.

47. Light Blue and Pale Green. 59
Power synthetic wool disc surface. Phosphoric acid clean. Cold foam brush wipe #59. Allow to react for 24 hours. Cold spray mist #59. Allow to react for 24 hours. Repeat cold spray mist application 3 times with 24 hours between each. Allow to complete reaction in open air for minimum 3 days. Apply matte liquid clearcoat.

48. Bluish Green With Imprint. 28
Media blast surface. Phosphoric acid clean. Affix dried leaves to surface with liquid latex. Cold foam brush wipe #28 over leaves and surface. Allow to react for 24 hours. Cold spray mist #28. Allow to react for 24 hours. Repeat cold spray mist application 3 times at 24 hour intervals. Remove leaves. Allow to complete reaction in open air for minimum 3 days. Apply matte liquid clearcoat.

49	50
51	52

49. Blue-Green Over Dark Brown With Texture. 38, 32
Hammer texture. Media blast surface. Phosphoric acid clean. Cold foam brush wipe #38. Water rinse. Dab dry. Dry burnish to highlight texture. Cold foam brush wipe #32. Allow to react for 24 hours. Cold spray mist #32. Allow to react for 24 hours. Repeat cold spray mist application 3 times at 24 hour intervals. Allow to complete reaction in open air for minimum 3 days. Apply matte liquid clearcoat.

50. Heavy Greenish Blue. 25
Hand scour surface. Phosphoric acid clean. Cold foam brush wipe #25. Allow to react for 24 hours. Cold spray airbrush #25. Allow to react for 24 hours. Repeat cold spray airbrush application 3 times with 24 hours between each. Allow to complete reaction in open air for minimum 3 days. Apply satin liquid clearcoat.

51. Vibrant Blue-Green. 60
Power synthetic wool disc surface. Phosphoric acid clean. Cold foam brush wipe #60. Allow to react for 24 hours. Cold spray mist #60. Allow to react for 24 hours. Repeat cold spray mist application 3 times with 24 hours between each. Allow to complete reaction in open air for minimum 3 days. Apply matte liquid clearcoat.

52. Blue-Green and Brown Pattern Over Copper. 28
Hand scour surface. Phosphoric acid clean. Saturate textured cloth with #28. Wrap surface with cloth. Allow to react for 24 hours. Unwrap and allow to complete reaction in open air for 3 days. Apply matte liquid clearcoat.

See pages 242–249 for the listing of colorant formulas

53	54
55	56

53. Light Blue Pattern Over Golden Brown. 45, 52
Media blast surface. Phosphoric acid clean. Cold immerse in #45 for 2 minutes. Water rinse. Dab dry. Acetone wipe. Cold foam brush wipe #52. Saturate textured cloth with #52. Wrap surface with cloth. Allow to react for 24 hours. Unwrap and allow to complete reaction in open air for minimum 3 days. Apply matte liquid clearcoat.

54. Blue-Green Pattern Over Dark Brown. 22, 28
Hand scour surface. Phosphoric acid clean. Cold foam brush wipe #22 until desired value. Water rinse. Dab dry. Dry burnish to blend. Acetone wipe. Saturate textured cloth with #28. Wrap surface with cloth. Allow to react for 24 hours. Unwrap and allow to complete reaction in open air for 3 days. Apply matte liquid clearcoat.

55. Dark Blue-Green. 29
Hand scour surface. Phosphoric acid clean. Cold foam brush wipe #29. Allow to react for 24 hours. Cold spray airbrush #29. Allow to react for 24 hours. Repeat cold spray airbrush application 3 times with 24 hours between each. Allow to complete reaction in open air for minimum 3 days. Apply matte liquid clearcoat.

56. Dark Brown With Blue-Green Texture. 35
Hammer texture surface. Media blast surface. Phosphoric acid clean. Cold foam brush wipe #35. Allow to react for 24 hours. Cold spray mist #35. Allow to react for 24 hours. Repeat cold spray mist application with 24 hours between each until desired color develops in texture. Allow to complete reaction in open air for minimum 3 days. Apply matte liquid clearcoat.

57. Blue-Green With Dark Brown. 36
Hand scour surface. Phosphoric acid clean. Cold foam brush wipe #36. Allow to react for 24 hours. Cold spray airbrush #36. Allow to react for 24 hours. Repeat cold spray airbrush application 3 times with 24 hours between each. Allow to complete reaction in open air for minimum 3 days. Apply matte liquid clearcoat.

58. Blue-Green With Midnight Blue. 56, 30, 31
Hand scour surface. Phosphoric acid clean. Cold foam brush wipe #56 to wet surface. Fume for 7 days with #30 and #31 in separate bowls. Uncover and allow to react in open air for minimum 3 days. Apply matte liquid clearcoat.

59. Dark Brown With Blue-Green Speckle. 35
Hand scour surface. Phosphoric acid clean. Cold foam brush wipe #35. Allow to react for 24 hours. Cold spray airbrush #35. Allow to react for 24 hours. Repeat cold spray airbrush application 3 times with 24 hours between each. Allow to complete reaction in open air for minimum 3 days. Apply matte liquid clearcoat.

60. Sky Blue, Orange and Green Speckled Texture With Dark Brown. 28
Hand scour surface. Phosphoric acid clean. Cold foam brush wipe #28 to wet surface. Saturate wood shavings with #28. Bury in moist shavings for 24 hours. Unbury and remove excess material from surface. Allow to complete reaction in open air for minimum 3 days. Carefully remove any unwanted particles from surface. Apply matte liquid clearcoat.

See pages 242–249 for the listing of colorant formulas

61	62
63	64

61. Pale Blue With Gray-Brown. 47

Hand scour surface. Phosphoric acid clean. Cold foam brush wipe #47. Allow to react for 24 hours. Cold spray airbrush #47. Allow to react for 24 hours. Repeat cold spray airbrush application 3 times with 24 hours between each. Allow to complete reaction in open air for minimum 3 days. Apply matte liquid clearcoat.

62. Pale Blue-Gray Over Khaki. 45, 47

Hand scour surface. Phosphoric acid clean. Cold immerse in #45 for 1 minute. Water rinse. Dab dry. Acetone wipe. Cold foam brush wipe #47. Allow to react for 24 hours. Cold spray airbrush #47. Allow to react for 24 hours. Repeat cold spray airbrush application 3 times with 24 hours between each. Allow to complete reaction in open air for minimum 3 days. Apply matte liquid clearcoat.

63. Black Over Masked Copper. 22

Hand scour surface. Apply tape mask to desired area. Media blast surface. Acetone wipe clean. Cold foam brush wipe #22 until desired value. Water rinse. Dab dry. Remove tape mask. Acetone wipe. Apply satin liquid clearcoat.

64. Midnight Blue Over Masked Copper. 42, 56, 62, 63

Power flap disc surface. Acetone wipe clean. Apply tape mask to desired area. Cold foam brush #42 until desired value. Water rinse. Dab dry. Cold foam brush wipe #56 to wet surface. Fume for 24 hours with #56, #62, and #63 in separate bowls. Uncover and allow to react in open air for minimum 3 days. Remove tape mask. Apply matte liquid clearcoat.

65 | 66

65. Violet and Brown Speckled Texture Over Light Brown. 22, 35

Power synthetic wool disc surface. Phosphoric acid clean. Cold foam brush wipe #22. Water rinse. Dab dry. Acetone wipe. Dry burnish to blend. Saturate wood shavings with #35. Bury in moist shavings for 48 hours. Unbury and remove excess material from surface. Allow to complete reaction in open air for minimum 3 days. Remove any unwanted particles from surface. Apply matte liquid clearcoat.

66. Translucent Multi-Color Rosettes.

Power flap disc surface. Acetone wipe clean. Develop spot colorations by stippling with flame of air/fuel or oxy/fuel torch. Quench with water saturated cloth to stop the spread of colors. Repeat until desired color and pattern developed. Water quench to cool. Dab dry. Acetone wipe. Apply gloss liquid clearcoat.

67. Pale Green Over Brick Red. 44, 46

Hand scour. Phosphoric acid clean. Hot immerse at just below boiling in #44 for 30 minutes. Stir solution every 5 minutes. Water rinse. Dab dry. Cold foam brush wipe #46. Allow to react for 24 hours. Cold spray airbrush #46. Allow to react for 24 hours. Repeat cold spray airbrush 3 times at 24 hour intervals. Allow to complete reaction in open air for minimum 3 days. Apply matte liquid clearcoat.

68. Translucent Brown. 40

Power flap disc surface. Phosphoric acid clean. Cold immerse in #40 for 1 minute. Water rinse. Dab dry. Buff to remove loose patina. Apply paste wax clearcoat.

See pages 242–249 for the listing of colorant formulas

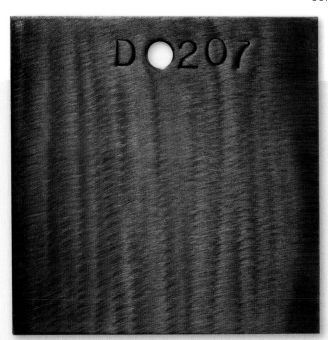

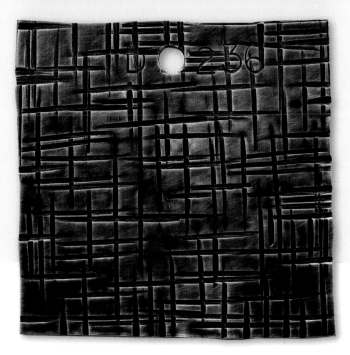

69. Antiqued Copper With Black Texture. 37, 40

Hammer texture surface. Phosphoric acid clean. Cold foam brush wipe #37 until desired value. Water rinse. Dab dry. Dry burnish to highlight texture. Cold foam brush wipe #40 until desired value. Water rinse. Dab dry. Dry burnish to blend. Acetone wipe. Apply satin liquid clearcoat.

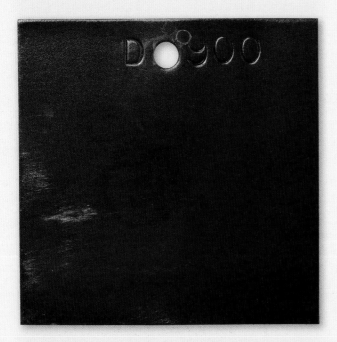

70 | 71

70. Translucent Reddish Brown.
Polish surface. Phosphoric acid
clean. Heat uniformly over
hotplate, burner, or in kiln.
Remove from heat when desired
color developed. Immediately
water quench to cool and freeze
the color. Dab dry. Acetone wipe.
Apply gloss liquid clearcoat.

**71. Sky Blue Over Dark Brick
Red. 44, 48**
Hand scour. Phosphoric acid clean.
Hot immerse at just below boiling
in #44 for 30 minutes. Stir solution
every 5 minutes. Water rinse. Dab
dry. Cold foam brush wipe #48.
Allow to react for 24 hours. Cold
spray airbrush #48. Allow to react
for 24 hours. Repeat cold spray
airbrush application 3 times at 24
hour intervals. Allow to complete
reaction in open air for minimum 3
days. Apply matte liquid clearcoat.

**72. Pale Blue Over Deep Red.
44, 47**
Hand scour. Phosphoric acid clean.
Hot immerse at just below boiling
in #44 for 30 minutes. Stir solution
every 5 minutes. Water rinse. Dab
dry. Cold foam brush wipe #47.
Allow to react for 24 hours. Cold
spray airbrush #47. Allow to react
for 24 hours. Repeat cold spray
airbrush application 3 times at 24
hour intervals. Allow to complete
reaction in open air for minimum 3
days. Apply matte liquid clearcoat.

73. Dark Brick Red. 44
Power synthetic wool disc
surface. Phosphoric acid clean.
Hot immerse at just below
boiling in #44 for 30 minutes. Stir
solution every 5 minutes. Water
rinse. Dab dry. Apply paste wax
clearcoat.

See pages 242–249 for the listing of colorant formulas

72	73
	74

74. Metallic Violet With Pastel Violet Texture. 40, 13, 14
Hammer texture surface. Phosphoric acid clean. Cold foam brush wipe #40. Water rinse. Dab dry. Dry burnish to highlight texture. Acetone wipe. Hot foam brush wipe #13 until desired value. Dry burnish to blend. Hot foam brush wipe #14. Dry burnish to highlight texture. Repeat hot applications of #13 and #14 alternately with dry burnishing. Apply satin liquid clearcoat.

75 | 76

75. Dark Reddish Brown. 51
Power synthetic wool disc surface. Phosphoric acid clean. Hot immerse at just below boiling in #51 for 30 minutes. Water rinse. Dab dry. Acetone wipe. Apply paste wax clearcoat.

76. Violet Over Masked Grayish Brown. 35
Media blast surface. Phosphoric acid clean. Tape mask desired area. Hot immerse at just below boiling in #35 for 10 minutes. Remove from solution and carefully remove tape mask. Continue hot immersion for 10 minutes longer. Rinse with hot water immerse at 140°F (60°C). Dab dry. Apply paste wax clearcoat.

77. Brownish Black. 39
Power flap disc surface. Phosphoric acid clean. Cold immerse in #39 for 1 minute. Water rinse. Dab dry. Buff to remove loose patina. Acetone wipe. Apply paste wax clearcoat.

78. Dark Liver Brown. 21
Hand scour surface. Hot pickle bath clean. Cold immerse in #21 for 10 seconds. Water rinse. Dab dry. Acetone wipe. Apply paste wax clearcoat.

See pages 242–249 for the listing of colorant formulas

79. Black Speckle Over Slate Black. 38, 18

Hand scour surface. Phosphoric acid clean. Cold immerse in #38 until desired value. Water rinse. Dab dry. Dry burnish to lighten. Acetone wipe. Hot spray #18 to desired pattern and value. Apply matte liquid clearcoat.

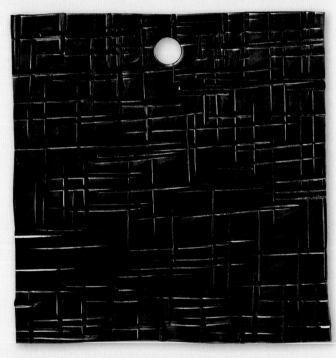

80 | 81

80. Slate Black. 38
Power flap disc surface. Phosphoric acid clean. Cold immerse in #38 for 1 minute. Water rinse. Dab dry. Buff to remove loose patina. Acetone wipe. Apply paste wax clearcoat.

81. Metallic Black With Texture. 22
Hammer texture surface. Phosphoric acid clean. Cold foam brush wipe #22 until desired value. Water rinse. Dab dry. Acetone wipe. Apply satin liquid clearcoat.

82. Black Pattern Over Slate Black. 38, 22
Hand scour surface. Phosphoric acid clean. Cold immerse in #38 until desired value. Water rinse. Dab dry. Dry burnish to lighten. Saturate textured cloth with #22. Press or wrap onto surface. Allow 2–3 minutes for color to develop. Carefully remove cloth. Water rinse. Dab dry. Acetone wipe. Apply matte liquid clearcoat.

83. Jet Black. 37
Power flap disc surface. Phosphoric acid clean. Cold immerse in #37 for 1 minute. Water rinse. Dab dry. Buff to remove loose patina. Acetone wipe. Apply paste wax clearcoat.

See pages 242–249 for the listing of colorant formulas

84. Bluish Black. 22

Hand scour surface. Hot pickle
bath clean. Cold immerse in #22
for 10 seconds. Water rinse. Dab
dry. Acetone wipe. Apply paste
wax clearcoat.

Brass 230 & 260

Brass:

INTRODUCTION

ABOVE: **DANIEL WADDINGTON**
The Atlas Diamond
The coloration process can be used to create visual depth on the metal surface. With this pendant, the color pattern and texture from the application process plus the abrasive removal of color to define the diamond "facets" aid in visually creating dimension from a flat form.

True brass is a metal alloy consisting primarily of copper and zinc. A brass is considered an alpha brass if the zinc content is kept below 35%. Alpha brasses are face centered cubic crystalline structured, possessing good malleability and cold working properties. By adjusting the zinc content, a range of brasses can be created with varying properties to meet specific needs. In addition to good cold workability, true brasses have desirable raw metal colors of golden brown to golden yellow colors. Brasses can also be brought to a high luster.

Copper-zinc alloyed brasses predate written history, but it is thought that most brass use prior to the Roman period was accidental in how it was developed. Deliberate brass production began with the Romans using a cementation process of heating copper and ores containing zinc (smithsonite ore, or calamine). In this process the vaporized zinc permeates the copper, but the exact zinc content is

LEFT: **SHARLA PIDD**
Desert hoops
The opaque, light aquamarine reactive coloration immediately provides a sense of antiquity to these brass ring forms, which offsets the hanging transparent crystals very nicely. The choice of coloration also helps soften the feel of this piece.

RIGHT: **SARAH KARST**
Snake charmer
A multi-layered, reactive coloration over textured brass allows the color to sit and build in the recesses. Care must be taken so the layered opaque patina does not overwhelm the metal texture, especially if it is fairly shallow.

difficult to control. In the 16th century, metallic zinc was successfully extracted from ore, which led to the discovery of a new brass making process called speltering. The speltering process allowed for direct alloying of copper and metallic zinc and resulted in a more exact control of the alloyed percentages. By the 19th century inexpensive zinc distillation processes made speltering much more economical, and is still used today. Because of the relatively large percentage of zinc present in these copper alloys, true brasses are typically less expensive than pure copper, at roughly 5 times that of low carbon steel. Brass is readily available as sheet, plate, rod, tubing, and wire products. It is estimated that 90% of brass is recycled, driven primarily by the higher costs of virgin copper and brass production.

Properties

In this book, two distinct brasses are illustrated: UNS C23000 with a nominal composition of 85% copper and 15% zinc, and UNS C26000 with a nominal composition of 70% copper and 30% zinc. UNS C23000 brass has many common names: red brass, rich-low, jeweler's brass/bronze, Merlin's Gold, and NuGold. It is found primarily as sheet, pipe, and wire products. Many metalsmiths choose C23000 for its raw metal color that closely resembles gold when polished. UNS C23000 brass has a brownish yellow color when freshly abraded. Brass C26000 is commonly called yellow brass or cartridge brass, a name given for its use as ammunition cartridges. C26000 brass is much more abundant in use, and can be purchased in sheet, plate, bar, tube and wire form. UNS 26000 brass has a golden yellow color when the surface is freshly abraded.

ABOVE: **AMANDA MCCALLUM**
Ring stack
Contrast can help draw the viewer's eye to a specific feature or detail of a piece. This series of rings makes use of two dissimilar metals, silver and brass, and a burnished patina coloration to showcase the design details.

RIGHT: **CAREN HARTLEY**
Translations no. 3
Both surface quality and color
are used to define the interior
and exterior of this cast brass
piece, and help the viewer
recreate the broken vessel
form. The dark coloration of
the textured outer surface is in
stark contrast to the smooth,
highly polished interior.

ABOVE: **MISHELE FREEMAN**
Ocean of noise cuff
This simple curved brass form becomes a special, one-of-
a-kind piece with the addition of a reactive coloration.
Here, layers of dark brown and light blue cold patinas
create complex patterns and depth.

Both C23000 and C26000 brasses have good strength,
ductility, and malleability characteristics making for desirable
metals for industry, architecture, and metal art. Cold working
either brass is very favorable, albeit with proper annealing to
reduce the work hardening internal stresses which can lead
to cracking. Annealing temperature for both is between 800–
1400°F (425–760°C), followed by an air cool. Care must be
taken not to overheat brass as the zinc will boil off before the
melting temperature of the alloyed copper. Hot working either
brass C23000 or C26000 is fair to good at best, with the proper
working temperature of 1350–1650°F (730–900°C) required.

UNS C23000 and C26000 can both easily be soldered and
brazed by conventional means. Welding either alloy is rated
as good, with care necessary so as to not boil off the zinc
content by overheating the metal during the process. As with
other metals, it is important to understand that differing hot
joinery methods may or may not have a color match at the
joint, but only welding yields a color and metal compositional
match. This is important when using reactive colorants.
Brasses C23000 and C26000 have specific gravities of 8.75
and 8.53, respectively, with water sg = 1.00. The melting
temperatures range between 1810 and 1877°F (990 and
1030°C) for brass C23000 and 1680–1750°F (915–955°C) for
brass C26000.

Both brasses will oxidize easily, but due to the zinc
content not as readily as pure copper. Reactive coloration
ranges are similar to copper though, with black, brown,
yellow, orange, red, violet, blue, and green possible. The
higher zinc content of C26000 brass makes some colors more
difficult to achieve.

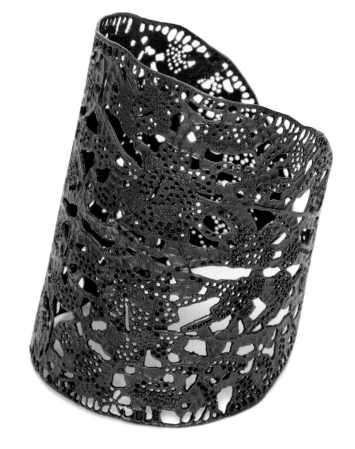

Advantages of C23000 and C26000 brass

The advantages to both C23000 and C26000 brass are similar. Both have a desirable raw material aesthetic and can be brought to a high luster with polishing. Both can easily be cold formed as long as proper annealing is used. Both are easily soldered and brazed, with decent weldability. C23000 and C26000 are readily available as sheet product.

Disadvantages of C23000 and C26000 brass

The main drawbacks to either C23000 or C26000 are the higher raw material price (roughly 5 times that of steel) and the greater difficulty in using hot processes that approach the point at which the alloyed zinc vaporizes. Brass C23000 bar shapes are not as prevalent as alloy C26000 bar stock.

ABOVE: **MARIA TSIMPISKAKI**

Cyprus bracelet
Applying colorations to a metal surface changes the feel of the piece completely. Imagine the feel of this object if left as bare brass metal; even with the dark color, this piece is still delicate and airy thanks to the intricate negative spaces.

NOTES ON SAMPLES USED IN THIS BOOK

In this book, brass UNS C23000 (commonly called red brass, rich-low, jeweler's brass/bronze, Merlin's Gold, and NuGold) and brass UNS C26000 (commonly called yellow or cartridge brass), sheet was used for all the samples. C23000 is comprised nominally of 85% copper and 15% zinc, while UNS C26000 is made up of 70% copper and 30% zinc. Brasses of differing compositions may yield variances in reactive colorations.

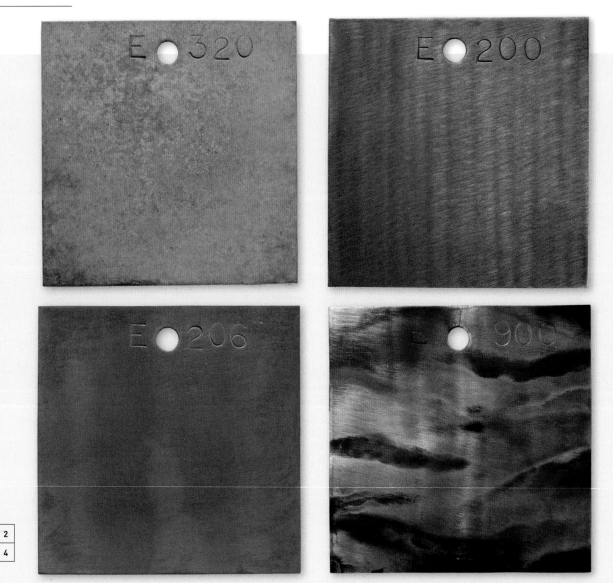

1. Pale Green and Tan Stipple Over Dark Brown. 59

Hand scour surface. Phosphoric acid clean. Hot sponge heated #59 180–190ºF (82–88ºC) until desired color and pattern develop. Apply paste wax clearcoat.

2. Translucent Brown. 40

Power flap disc surface. Phosphoric acid clean. Cold immerse in #39 for 1 minute. Water rinse. Dab dry. Buff to remove loose patina. Acetone wipe. Apply paste wax clearcoat.

3. Light Golden Brown. 49

Power synthetic wool disc surface. Phosphoric acid clean. Hot immerse in #49 at just below boiling for 30 minutes. Stir solution every 5 minutes. Water rinse. Dab dry. Apply paste wax clearcoat.

4. Translucent Multi-colored Pattern.

Power flap disc surface. Acetone wipe clean. Develop colorations and pattern with horizontal flame movement of air/fuel or oxy/fuel torch. Quench with water saturated cloth to stop the spread of colors. Repeat until desired color and pattern developed. Water quench to cool. Dab dry. Acetone wipe. Apply gloss liquid clearcoat.

See pages 242–249 for the listing of colorant formulas

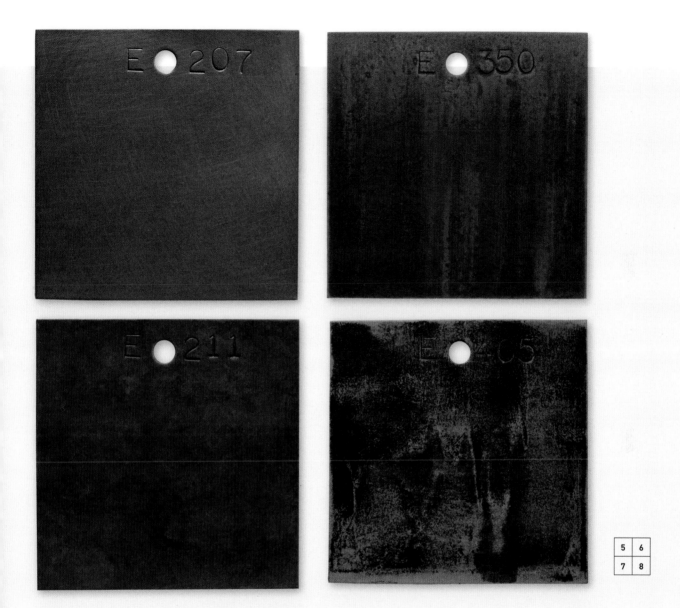

5. Golden Brown. 19
Hand scour surface. Hot pickle bath clean. Cold immerse in #19 for 10 seconds. Water rinse. Dab dry. Acetone wipe. Apply paste wax clearcoat.

6. Dark Blue-Violet With Aged Brass. 46
Media blast surface. Phosphoric acid clean. Cold foam brush wipe #46. Allow to react for 24 hours. Cold spray mist #46. Allow to react for 24 hours. Repeat cold spray mist application 3 times with 24 hours between each. Allow to complete reaction in open air for minimum 3 days. Apply matte liquid clearcoat.

7. Dark Brown Stipple Over Golden Brown. 21, 23
Hand scour surface. Phosphoric acid clean. Cold foam brush wipe #21 until desired value. Wet burnish to blend. Water rinse. Dab dry. Acetone wipe. Hot bristle brush stipple #23 until desired value and pattern. Apply matte liquid clearcoat.

8. Violet Speckle. 35
Media blast surface. Phosphoric acid clean. Cold immerse in #35 for 5 days. Stir solution every 24 hours. Water rinse. Dab dry. Acetone wipe. Apply satin liquid clearcoat.

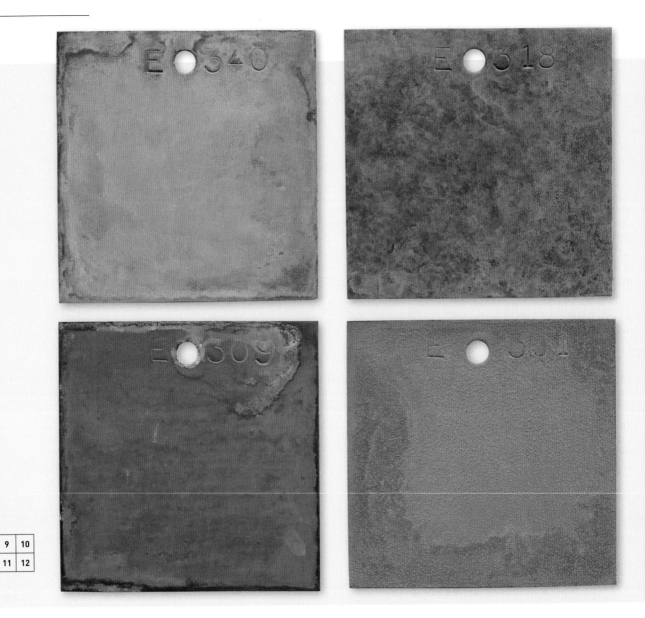

9. Light Blue-Green. 59
Power synthetic wool disc surface. Phosphoric acid clean. Cold foam brush wipe #59. Allow to react for 24 hours. Cold spray mist #59. Allow to react for 24 hours. Repeat cold spray mist application 3 times with 24 hours between each. Allow to complete reaction in open air for minimum 3 days. Apply matte liquid clearcoat.

10. Blue-Green and Golden Brown Stipple Over Brown. 21, 6, 23
Hand scour surface. Phosphoric acid clean. Cold foam brush wipe #21 until desired value. Water rinse. Dab dry. Dry burnish to blend. Acetone wipe. Hot bristle brush stipple #6 until desired color and pattern. Hot bristle brush stipple #23 until desired value and pattern. Apply matte liquid clearcoat.

11. Sky Blue Over Olive Green. 45, 48
Hand scour surface. Phosphoric acid clean. Cold immerse in #45 for 1 minute. Water rinse. Dab dry. Acetone wipe. Cold foam brush wipe #48. Allow to react for 24 hours. Cold spray airbrush #48. Allow to react for 24 hours. Repeat cold spray airbrush application 3 times with 24 hours between each. Allow to complete reaction in open air for minimum 3 days. Apply matte liquid clearcoat.

12. Teal. 34
Hand scour surface. Phosphoric acid clean. Cold foam brush wipe #34. Allow to react for 24 hours. Cold spray airbrush #34. Allow to react for 24 hours. Repeat cold spray airbrush application 3 times with 24 hours between each. Allow to complete reaction in open air for minimum 3 days. Apply matte liquid clearcoat.

See pages 242–249 for the listing of colorant formulas

| 13 | 14 |
| 15 | 16 |

13. Pale Bluish Green Over Masked Dark Tan. 45, 46
Media blast. Phosphoric acid clean. Cold immerse in #45 for 2 minutes. Water rinse. Dab dry. Acetone wipe. Apply tape mask. Cold foam brush wipe #46. Allow to react for 24 hours. Cold spray mist #46. Allow to react for 24 hours. Repeat cold spray mist application 3 times at 24 hour intervals. Remove tape mask. Allow to complete reaction in open air for minimum 3 days. Apply matte liquid clearcoat.

14. Light Blue-Green Over Light Brown. 45, 52
Power synthetic wool disc surface. Phosphoric acid clean. Cold immerse in #45 for 5 minutes. Water rinse. Dab dry. Acetone wipe. Cold foam brush wipe #52. Allow to react for 24 hours. Cold spray airbrush #52. Allow to react for 24 hours. Repeat cold spray airbrush application 3 times at 24 hour intervals. Allow to complete reaction in open air for minimum 3 days. Apply matte liquid clearcoat.

15. Pale Teal Pattern. 26
Media blast surface. Phosphoric acid clean. Apply dry, textured open weave cloth over surface. Cold foam brush wipe #26 over cloth. Allow 24 hours to react. Repeat foam brush wipe application 4 times with 24 hours between each. Remove cloth from surface. Allow to complete reaction in open air for minimum 3 days. Apply matte liquid clearcoat.

16. Pale and Sky Blue Speckled Texture Over Dark Brown. 22, 28
Hand scour surface. Phosphoric acid clean. Cold foam brush wipe #22. Wet burnish to blend and lighten. Water rinse. Dab dry. Acetone wipe. Saturate wood shavings with #28. Bury in shavings for 24 hours. Unbury and remove excess material. Allow to complete reaction in open air for minimum 3 days. Remove any unwanted particles from surface. Apply matte liquid clearcoat.

17	18
19	20

17. Blue-Green and Olive With Texture. 38, 60
Hammer texture surface. Media blast. Phosphoric acid clean. Cold foam brush wipe #38. Water rinse. Dab dry. Dry burnish to highlight texture. Cold foam brush wipe #60. Allow to react for 24 hours. Cold spray mist #60. Allow to react for 24 hours. Repeat cold spray mist 3 times at 24 hour intervals. Allow to complete reaction in open air for minimum 3 days. Apply matte liquid clearcoat.

18. Blue-Green With Dark Brown. 28
Power synthetic wool disc surface. Phosphoric acid clean. Cold foam brush wipe #28. Allow to react for 24 hours. Cold spray mist #28. Allow to react for 24 hours. Repeat cold spray mist application 3 times with 24 hours between each. Allow to complete reaction in open air for minimum 3 days. Apply matte liquid clearcoat.

19. Heavy Blue Green. 33
Hand scour surface. Phosphoric acid clean. Cold foam brush wipe #33. Allow to react for 24 hours. Cold spray airbrush #33. Allow to react for 24 hours. Repeat cold spray airbrush application 3 times with 24 hours between each. Allow to complete reaction in open air for minimum 3 days. Apply matte liquid clearcoat.

20. Vibrant Blue-Green. 60
Power synthetic wool disc surface. Phosphoric acid clean. Cold foam brush wipe #60. Allow to react for 24 hours. Cold spray mist #60. Allow to react for 24 hours. Repeat cold spray mist application 3 times with 24 hours between each. Allow to complete reaction in open air for minimum 3 days. Apply matte liquid clearcoat.

See pages 242–249 for the listing of colorant formulas

| 21 | 22 |
| 23 | 24 |

21. Sky Blue With Violet. 25
Hand scour surface. Phosphoric acid clean. Cold foam brush wipe #25. Allow to react for 24 hours. Cold spray airbrush #25. Allow to react for 24 hours. Repeat cold spray airbrush application 3 times with 24 hours between each. Allow to complete reaction in open air for minimum 3 days. Apply matte liquid clearcoat.

22. Sky Blue Pattern Over Dark Brown. 45, 52
Media blast surface. Phosphoric acid clean. Cold immerse in #45 for 2 minutes. Water rinse. Dab dry. Acetone wipe. Cold foam brush wipe #52. Saturate textured cloth with #52. Wrap surface with cloth. Allow to react for 24 hours. Unwrap and allow to complete reaction in open air for minimum 3 days. Apply matte liquid clearcoat.

23. Aged Brass With Green-Blue Texture. 25
Hammer texture surface. Media blast surface. Phosphoric acid clean. Cold foam brush wipe #25. Allow to react for 24 hours. Cold spray mist #25. Allow to react for 24 hours. Repeat cold spray mist application 3 times with 24 hours between each. Allow to complete reaction in open air for minimum 3 days. Dry burnish to highlight texture. Apply matte liquid clearcoat.

24. Pale Blue Green With Dark Brown. 36
Hand scour surface. Phosphoric acid clean. Cold foam brush wipe #36. Allow to react for 24 hours. Cold spray airbrush #36. Allow to react for 24 hours. Repeat cold spray airbrush application 3 times with 24 hours between each. Allow to complete reaction in open air for minimum 3 days. Apply matte liquid clearcoat.

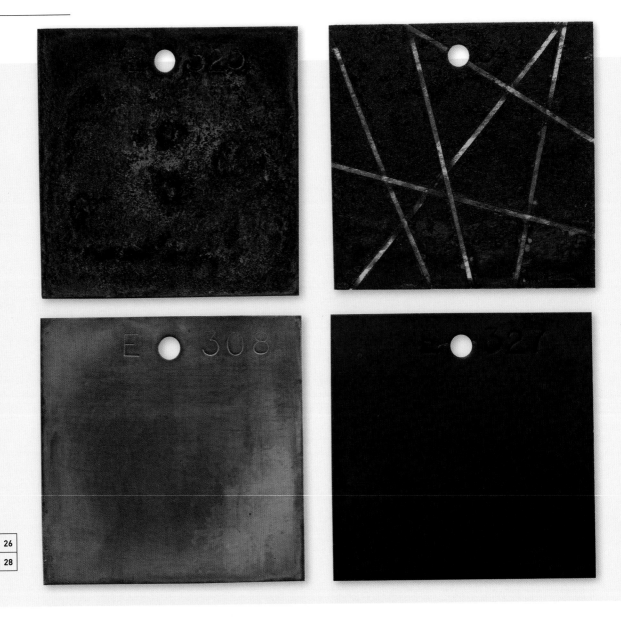

25	26
27	28

25. Dark Blue-Green With Dark Brown. 29
Hand scour surface. Phosphoric acid clean. Cold foam brush wipe #29. Allow to react for 24 hours. Cold spray mist #29. Allow to react for 24 hours. Repeat cold spray mist application 3 times with 24 hours between each. Allow to complete reaction in open air for minimum 3 days. Apply matte liquid clearcoat.

26. Heavy Midnight Blue Over Masked Brass. 42, 56, 62, 63
Power flap disc surface. Acetone wipe clean. Apply tape mask to desired area. Cold foam brush #42 until desired value. Water rinse. Dab dry. Cold foam brush wipe #56 to wet surface. Fume for 24 hours with #56, #62, and #63 in separate bowls. Uncover and allow to react in open air for minimum 3 days. Remove tape mask. Apply matte liquid clearcoat.

27. Pale Blue and Green Over Grayish Brown. 45, 47
Hand scour surface. Phosphoric acid clean. Cold immerse in #45 for 1 minute. Water rinse. Dab dry. Acetone wipe. Cold foam brush wipe #47. Allow to react for 24 hours. Cold spray airbrush #47. Allow to react for 24 hours. Repeat cold spray airbrush application 3 times with 24 hours between each. Allow to complete reaction in open air for minimum 3 days. Apply matte liquid clearcoat.

28. Midnight Blue. 56, 30, 31
Hand scour surface. Phosphoric acid clean. Fume for 7 days with #56, #30, and #31 in separate bowls. Uncover and allow to react in open air for minimum 3 days. Apply matte liquid clearcoat.

See pages 242–249 for the listing of colorant formulas

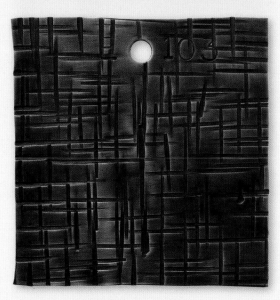

29	30
31	32

29. Deep Brick Red. 51
Power synthetic wool disc surface. Phosphoric acid clean. Hot immerse in #51 at just below boiling for 30 minutes. Water rinse. Dab dry. Apply paste wax clearcoat.

30. Grayish Brown. 45
Media blast surface. Phosphoric acid clean. Cold immerse in #45 for 2 minutes. Water rinse. Dab dry. Acetone wipe. Apply matte liquid clearcoat.

31. Red-Violet Over Masked Grayish Violet. 35
Media blast surface. Phosphoric acid clean. Tape mask desired area. Hot immerse at just below boiling in #35 for 10 minutes. Remove from solution and carefully remove tape mask. Continue hot immersion for 10 minutes longer. Rinse with hot water immerse at 140ºF (60ºC). Dab dry. Apply paste wax clearcoat.

32. Aged Brass With Black Texture. 37
Hammer texture surface. Media blast surface. Phosphoric acid clean. Cold foam brush wipe #37 until desired value. Water rinse. Dab dry. Dry burnish to highlight texture. Acetone wipe. Apply paste wax clearcoat.

33 | 34

33. Pale Blue Over Brick Red. 44, 47

Hand scour surface. Phosphoric acid clean. Hot immerse in #44 at just below boiling for 30 minutes. Stir solution every 5 minutes. Water rinse. Dab dry. Cold foam brush wipe #47. Allow to react for 24 hours. Cold spray airbrush #47. Allow to react for 24 hours. Repeat cold spray airbrush 3 times at 24 hour intervals. Allow to complete reaction in open air for minimum 3 days. Apply matte liquid clearcoat.

34. Sky Blue Over Dark Brick Red. 44, 48

Hand scour surface. Phosphoric acid clean. Hot immerse in #44 at just below boiling for 30 minutes. Stir solution every 5 minutes. Water rinse. Dab dry. Cold foam brush wipe #48. Allow to react for 24 hours. Cold spray airbrush #48. Allow to react for 24 hours. Repeat cold spray airbrush 3 times at 24 hour intervals. Allow to complete reaction in open air for minimum 3 days. Apply matte liquid clearcoat.

35. Brownish Black. 39

Power flap disc surface. Phosphoric acid clean. Cold immerse in #39 for 1 minute. Water rinse. Dab dry. Buff to remove loose patina. Acetone wipe. Apply paste wax clearcoat.

36. Pale Green Over Grayish Brown. 47

Hand scour surface. Phosphoric acid clean. Cold foam brush wipe #47. Allow to react for 24 hours. Cold spray airbrush #47. Allow to react for 24 hours. Repeat cold spray airbrush application 3 times with 24 hours between each. Allow to complete reaction in open air for minimum 3 days. Apply matte liquid clearcoat.

See pages 242–249 for the listing of colorant formulas

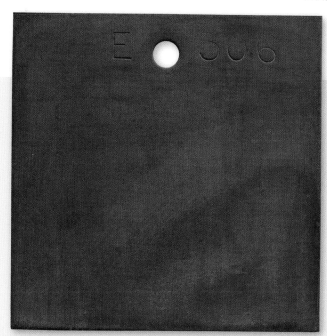

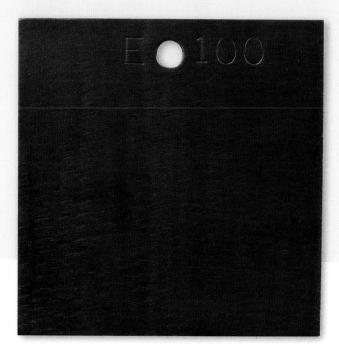

37. Jet Black. 37
Power flap disc surface.
Phosphoric acid clean. Cold
immerse in #37 for 1 minute.
Water rinse. Dab dry. Buff to
remove loose patina. Acetone
wipe. Apply paste wax clearcoat.

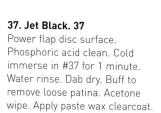

1	2
3	4

1. Aged Brass With Brown. 54

Media blast surface. Phosphoric acid clean. Hot immerse in #54 at just below boiling for 30 minutes. Stir solution every 5 minutes. Water rinse. Dab dry. Acetone wipe. Apply paste wax clearcoat.

2. Translucent Golden Brown. 21

Hand scour surface. Phosphoric acid clean. Cold foam brush wipe #21until desired value. Water rinse. Dab dry. Dry burnish to blend. Acetone wipe. Apply paste wax clearcoat.

3. Aged Brass With Black Texture. 40

Hammer texture surface. Phosphoric acid clean. Cold foam brush wipe #40 until desired value. Water rinse. Dab dry. Dry burnish to highlight texture. Acetone wipe. Apply paste wax clearcoat.

4. Pale Green With Golden Brown. 46

Hand scour surface. Phosphoric acid clean. Cold foam brush wipe #46. Allow to react for 24 hours. Cold spray airbrush #46. Allow to react for 24 hours. Repeat cold spray airbrush application 3 times with 24 hours between each. Allow to complete reaction in open air for minimum 3 days. Apply matte liquid clearcoat.

See pages 242–249 for the listing of colorant formulas

| 5 | 6 |
| 7 | 8 |

5. Yellowish Brown. 49
Power synthetic wool disc surface. Phosphoric acid clean. Hot immerse in #49 at just below boiling for 30 minutes. Stir solution every 5 minutes. Water rinse. Dab dry. Apply paste wax clearcoat.

6. Reddish Brown Stipple. 21, 24
Hand scour surface. Phosphoric acid clean. Cold foam brush wipe #21 until desired darkness. Water rinse. Dab dry. Dry burnish to lighten and blend. Acetone wipe. Hot spray #24 with surface at or above 212°F (100°C). Repeat spray application until desired color and pattern. Apply paste wax clearcoat.

7. Brown Stipple Over Golden Brown. 21, 23
Hand scour surface. Phosphoric acid clean. Cold foam brush wipe #21until desired value. Water rinse. Dab dry. Dry burnish to blend. Acetone wipe. Hot bristle brush stipple #23 until desired value and pattern. Apply matte liquid clearcoat.

8. Translucent Brown. 40
Power flap disc surface. Phosphoric acid clean. Cold immerse in #40 for 1 minute. Water rinse. Dab dry. Buff to remove loose patina. Acetone wipe. Apply paste wax clearcoat.

9	10
11	12

9. Translucent Light Brown. 42
Power flap disc surface.
Phosphoric acid clean. Cold
immerse in #42 for 1 minute.
Water rinse. Dab dry. Buff to
remove loose patina. Acetone
wipe. Apply paste wax clearcoat.

**10. Red-Violet Speckled Texture
Over Aged Brass. 22, 35**
Power synthetic wool disc surface.
Phosphoric acid clean. Cold foam
brush wipe #22. Water rinse. Dab
dry. Dry burnish to blend. Acetone
wipe. Saturate wood shavings with
#35. Bury in moist shavings for 48
hours. Unbury and remove excess
material from surface. Allow to
complete reaction in open air for
minimum 3 days. Remove any
unwanted particles from surface.
Apply matte liquid clearcoat.

**11. Antiqued Brass With
Texture. 37**
Hammer texture surface. Media
blast surface. Phosphoric acid
clean. Cold foam brush wipe #37
until desired value. Water rinse.
Dab dry. Dry burnish to highlight
texture. Acetone wipe. Apply
paste wax clearcoat.

**12. Aged Brass With Blue-Green
Texture. 38, 60**
Hammer texture surface. Media
blast. Phosphoric acid clean. Cold
foam brush wipe #38. Water rinse.
Dab dry. Dry burnish to highlight
texture. Cold foam brush wipe #60.
Allow to react for 24 hours. Cold
spray mist #60. Allow to react for
24 hours. Repeat cold spray mist 3
times at 24 hour intervals. Allow to
complete reaction in open air for
minimum 3 days. Dry burnish.
Apply matte liquid clearcoat.

See pages 242–249 for the listing of colorant formulas

13	14
15	16

13. Golden Brown and Blue-Green Stipple. 21, 6, 23

Hand scour surface. Phosphoric acid clean. Cold foam brush wipe #21until desired value. Water rinse. Dab dry. Dry burnish to blend. Acetone wipe. Hot bristle brush stipple #6 until desired color and pattern. Hot bristle brush stipple #23 until desired value and pattern. Apply matte liquid clearcoat.

14. Blue-Green With Black Speckle. 35, 22

Hand scour surface. Phosphoric acid clean. Hot spray mist #35 until desired color and pattern. Hot spray mist #22 until desired value and pattern. Water rinse. Dab dry. Acetone wipe. Apply paste wax clearcoat.

15. Green Over Olive. 45, 48

Hand scour surface. Phosphoric acid clean. Cold immerse in #45 for 1 minute. Water rinse. Dab dry. Acetone wipe. Cold foam brush wipe #48. Allow to react for 24 hours. Cold spray airbrush #48. Allow to react for 24 hours. Repeat cold spray airbrush application 3 times with 24 hours between each. Allow to complete reaction in open air for minimum 3 days. Apply matte liquid clearcoat.

16. Bluish Green Over Masked Reddish Brown. 45, 46

Media blast surface. Phosphoric acid clean. Cold immerse in #45 for 2 minutes. Water rinse. Dab dry. Acetone wipe. Apply tape mask. Cold foam brush wipe #46. Allow to react for 24 hours. Cold spray airbrush #46. Allow to react for 24 hours. Repeat cold spray airbrush 3 times at 24 hour intervals. Remove tape mask. Allow to complete reaction in open air for minimum 3 days. Apply matte liquid clearcoat.

17	18
19	20

17. Blue-Green Stipple Over Brown. 21, 6
Hand scour surface. Phosphoric acid clean. Cold foam brush wipe #21until desired value. Water rinse. Dab dry. Dry burnish to blend. Acetone wipe. Hot bristle brush stipple #6 until desired color and pattern. Apply matte liquid clearcoat.

18. Grayish Blue and Green. 45, 47
Hand scour surface. Phosphoric acid clean. Cold immerse in #45 for 1 minute. Water rinse. Dab dry. Acetone wipe. Cold foam brush wipe #47. Allow to react for 24 hours. Cold spray airbrush #47. Allow to react for 24 hours. Repeat cold spray airbrush application 3 times at 24 hour intervals. Allow to complete reaction in open air for minimum 3 days. Apply matte liquid clearcoat.

19. Teal Stipple Over Brown. 35
Hand scour surface. Phosphoric acid clean. Hot bristle brush stipple #35 until desired color and pattern. Apply paste wax clearcoat.

20. Green and Light Blue With Red. 59
Power synthetic wool disc surface. Phosphoric acid clean. Cold foam brush wipe #59. Allow to react for 24 hours. Cold spray mist #59. Allow to react for 24 hours. Repeat cold spray mist application 3 times with 24 hours between each. Allow to complete reaction in open air for minimum 3 days. Apply matte liquid clearcoat.

See pages 242–249 for the listing of colorant formulas

21	22
23	24

21. Light Blue-Green Pattern. 26

Media blast surface. Phosphoric acid clean. Apply textured open weave cloth over surface. Cold foam brush wipe #26 over cloth and surface. Allow 24 hours to react. Repeat foam brush wipe application 4 times with 24 hours between each. Remove cloth from surface. Allow to complete reaction in open air for minimum 3 days. Apply matte liquid clearcoat.

22. Vibrant Blue-Green Over Brown. 45, 52

Power synthetic wool disc surface. Phosphoric acid clean. Cold immerse in #45 for 5 minutes. Water rinse. Dab dry. Acetone wipe. Cold foam brush wipe #52. Allow to react for 24 hours. Cold spray airbrush #52. Allow to react for 24 hours. Repeat cold spray airbrush application 3 times at 24 hour intervals. Allow to complete reaction in open air for minimum 3 days. Apply matte liquid clearcoat.

23. Light Teal. 32

Hand scour surface. Phosphoric acid clean. Cold foam brush wipe #32. Allow to react for 24 hours. Cold spray airbrush #32. Allow to react for 24 hours. Repeat cold spray airbrush application 3 times with 24 hours between each. Allow to complete reaction in open air for minimum 3 days. Apply matte liquid clearcoat.

24. Pale Blue With Dark Brown. 35

Hand scour surface. Phosphoric acid clean. Cold foam brush wipe #35. Allow to react for 24 hours. Cold spray airbrush #35. Allow to react for 24 hours. Repeat cold spray airbrush application 3 times with 24 hours between each. Allow to complete reaction in open air for minimum 3 days. Apply matte liquid clearcoat.

25	26
27	28

25. Blue-Green With Pink. 26
Hand scour surface. Phosphoric acid clean. Cold foam brush wipe #26. Allow to react for 24 hours. Cold spray airbrush #26. Allow to react for 24 hours. Repeat cold spray airbrush application 3 times with 24 hours between each. Allow to complete reaction in open air for minimum 3 days. Apply matte liquid clearcoat.

26. Light Blue-Green With Pink. 34
Hand scour surface. Phosphoric acid clean. Cold foam brush wipe #34. Allow to react for 24 hours. Cold spray airbrush #34. Allow to react for 24 hours. Repeat cold spray airbrush application 3 times with 24 hours between each. Allow to complete reaction in open air for minimum 3 days. Apply matte liquid clearcoat.

27. Blue-Green Pattern Over Brown. 22, 28
Hand scour surface. Phosphoric acid clean. Cold foam brush wipe #22 until desired value. Water rinse. Dab dry. Dry burnish to blend. Acetone wipe. Saturate textured cloth with #28. Wrap surface with cloth. Allow to react for 24 hours. Unwrap and allow to complete reaction in open air for 3 days. Apply matte liquid clearcoat.

28. Blue-Green Speckled Texture Over Brass. 28
Hand scour surface. Phosphoric acid clean. Cold foam brush wipe #28 to wet surface. Saturate wood shavings with #28. Bury in moist shavings for 24 hours. Unbury and carefully remove excess material from surface. Allow to complete reaction in open air for minimum 3 days. Carefully remove any unwanted particles from surface. Apply matte liquid clearcoat.

See pages 242–249 for the listing of colorant formulas

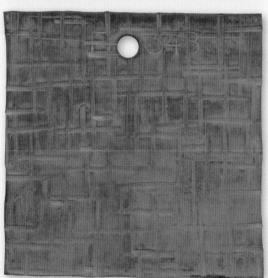

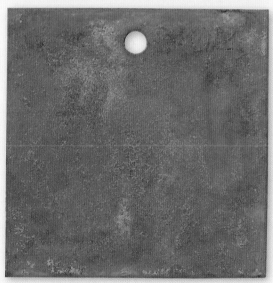

29	30
31	32

29. Light Blue With Pinkish Brown. 33
Hand scour surface. Phosphoric acid clean. Cold foam brush wipe #33. Allow to react for 24 hours. Cold spray airbrush #33. Allow to react for 24 hours. Repeat cold spray airbrush application 3 times with 24 hours between each. Allow to complete reaction in open air for minimum 3 days. Apply matte liquid clearcoat.

30. Sky Blue Pattern Over Brown. 45, 52
Media blast surface. Phosphoric acid clean. Cold immerse in #45 for 2 minutes. Water rinse. Dab dry. Acetone wipe. Cold foam brush wipe #52. Saturate textured cloth with #52. Wrap surface with cloth. Allow to react for 24 hours. Unwrap and allow to complete reaction in open air for 3 days. Apply matte liquid clearcoat.

31. Powder Blue Over Brown With Texture. 38, 32
Hammer texture surface. Media blast surface. Phosphoric acid clean. Cold foam brush wipe #38. Water rinse. Dab dry. Dry burnish to highlight texture. Cold foam brush wipe #32. Allow to react for 24 hours. Cold spray mist #32. Allow to react for 24 hours. Repeat cold spray mist application 3 times at 24 hour intervals. Allow to complete reaction in open air for minimum 3 days. Apply matte liquid clearcoat.

32. Vibrant Light Blue. 25
Hand scour surface. Phosphoric acid clean. Cold foam brush wipe #25. Allow to react for 24 hours. Cold spray airbrush #25. Allow to react for 24 hours. Repeat cold spray airbrush application 3 times with 24 hours between each. Allow to complete reaction in open air for minimum 3 days. Apply satin liquid clearcoat.

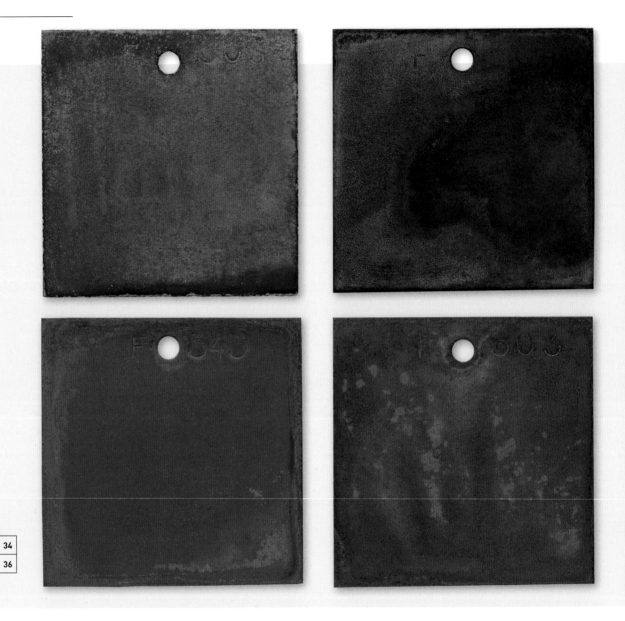

33. Sky Blue. 28
Hand scour surface. Phosphoric acid clean. Cold foam brush wipe #28. Allow to react for 24 hours. Cold spray airbrush #28. Allow to react for 24 hours. Repeat cold spray airbrush application 3 times with 24 hours between each. Allow to complete reaction in open air for minimum 3 days. Apply matte liquid clearcoat.

34. Dark Blue-Green. 29
Hand scour surface. Phosphoric acid clean. Cold foam brush wipe #29. Allow to react for 24 hours. Cold spray airbrush #29. Allow to react for 24 hours. Repeat cold spray airbrush application 3 times with 24 hours between each. Allow to complete reaction in open air for minimum 3 days. Apply matte liquid clearcoat.

35. Vibrant Green-Blue. 60
Power synthetic wool disc surface. Phosphoric acid clean. Cold foam brush wipe #60. Allow to react for 24 hours. Cold spray mist #60. Allow to react for 24 hours. Repeat cold spray mist application 3 times with 24 hours between each. Allow to complete reaction in open air for minimum 3 days. Apply matte liquid clearcoat.

36. Vibrant Blue-Green. 1
Hand scour surface. Phosphoric acid clean. Cold foam brush wipe #1. Allow to react for 24 hours. Cold spray airbrush #1. Allow to react for 24 hours. Repeat cold spray airbrush application 3 times with 24 hours between each. Allow to complete reaction in open air for minimum 3 days. Apply matte liquid clearcoat.

See pages 242–249 for the listing of colorant formulas

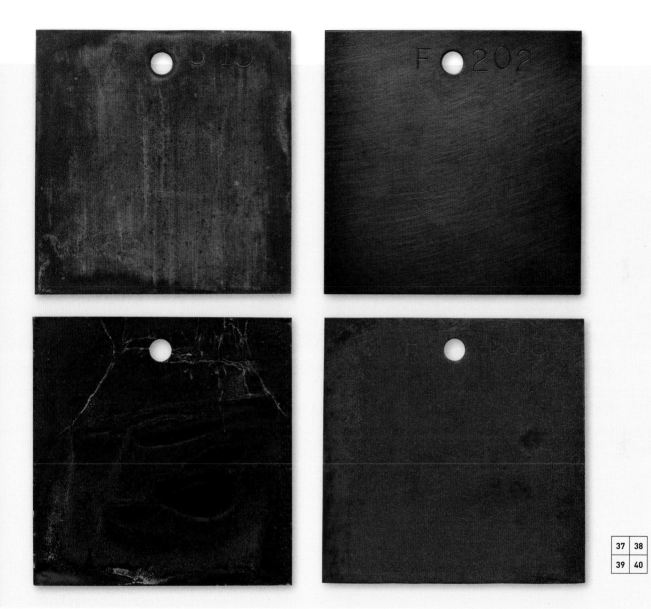

37	38
39	40

37. Blue-Green With Brown. 36
Hand scour surface. Phosphoric acid clean. Cold foam brush wipe #36. Allow to react for 24 hours. Cold spray airbrush #36. Allow to react for 24 hours. Repeat cold spray airbrush application 3 times with 24 hours between each. Allow to complete reaction in open air for minimum 3 days. Apply matte liquid clearcoat.

38. Translucent Slate Black. 21
Hand scour surface. Hot pickle bath clean. Cold immerse in #21 for 10 seconds. Water rinse. Dab dry. Acetone wipe. Apply paste wax clearcoat.

39. Dark Blue With Midnight Blue. 56, 30, 31
Hand scour surface. Phosphoric acid clean. Cold foam brush wipe #56 to wet surface. Fume for 7 days with #30 and #31 in separate bowls. Uncover and allow to react in open air for minimum 3 days. Apply matte liquid clearcoat.

40. Red-Orange Sparkle. 27
Hand scour surface. Phosphoric acid clean. Boiling immersion in cupric sulfate portion of #29 for 15 minutes. Remove and immediately immerse in hot water (140°F/60°C) to keep surface hot. Add ammonium chloride portion of #29 to boiling solution. Return object to boiling solution for 10 minutes. Hot water rinse. Dab dry. Acetone wipe. Apply satin liquid clearcoat.

41 | 42

41. Dark Brick Red. 44
Power synthetic wool disc surface. Phosphoric acid clean. Hot immerse in #44 at just below boiling for 30 minutes. Stir solution every 5 minutes. Water rinse. Dab dry. Apply paste wax clearcoat.

42. Aged Brass with Metallic Pastel Red Texture. 37, 10, 14
Hammer texture surface. Phosphoric acid clean. Cold foam brush wipe #37 until desired value. Water rinse. Dab dry. Dry burnish to blend. Hot foam brush wipe #10 until desired value. Dry burnish to blend. Hot foam brush wipe #14 until desired value. Dry burnish to blend. Repeat hot applications of #10 and #14 alternately with dry burnishing until desired coloration. Apply satin liquid clearcoat.

43. Pale Blue Over Dark Brick Red. 44, 46
Hand scour surface. Phosphoric acid clean. Hot immerse in #44 at just below boiling for 30 minutes. Stir solution every 5 minutes. Water rinse. Dab dry. Cold foam brush wipe #46. Allow to react for 24 hours. Cold spray airbrush #46. Allow to react for 24 hours. Repeat cold spray airbrush 3 times at 24 hour intervals. Allow to complete reaction in open air for minimum 3 days. Apply matte liquid clearcoat.

44. Dark Brick Red With Golden Yellow Pattern. 19
Hand scour surface. Hot pickle bath clean. Cold immerse in #19 for 10 seconds. Water rinse. Dab dry. Acetone wipe. Apply paste wax clearcoat.

See pages 242–249 for the listing of colorant formulas

45. Pale Blue-Green With Khaki. 47

Hand scour surface. Phosphoric acid clean. Cold foam brush wipe #47. Allow to react for 24 hours. Cold spray airbrush #47. Allow to react for 24 hours. Repeat cold spray airbrush application 3 times with 24 hours between each. Allow to complete reaction in open air for minimum 3 days. Apply matte liquid clearcoat.

| 46 | 47 |

46. Sky Blue Over Dark Brick Red. 44, 48

Hand scour surface. Phosphoric acid clean. Hot immerse in #44 at just below boiling for 30 minutes. Stir solution every 5 minutes. Water rinse. Dab dry. Cold foam brush wipe #48. Allow to react for 24 hours. Cold spray airbrush #48. Allow to react for 24 hours. Repeat cold spray airbrush 3 times at 24 hour intervals. Allow to complete reaction in open air for minimum 3 days. Apply matte liquid clearcoat.

47. Pale Blue Over Brick Red. 44, 47

Hand scour surface. Phosphoric acid clean. Hot immerse in #44 at just below boiling for 30 minutes. Stir solution every 5 minutes. Water rinse. Dab dry. Cold foam brush wipe #47. Allow to react for 24 hours. Cold spray airbrush #47. Allow to react for 24 hours. Repeat cold spray airbrush 3 times at 24 hour intervals. Allow to complete reaction in open air for minimum 3 days. Apply matte liquid clearcoat.

48. Dark Blue-Violet Speckle. 35

Media blast surface. Phosphoric acid clean. Cold immerse in #35 for 5 days. Stir solution every 24 hours. Water rinse. Dab dry. Acetone wipe. Apply satin liquid clearcoat.

49. Jet Black. 37

Power flap disc surface. Phosphoric acid clean. Cold immerse in #37 for 1 minute. Water rinse. Dab dry. Buff to remove loose patina. Acetone wipe. Apply paste wax clearcoat.

See pages 242–249 for the listing of colorant formulas

	49
48	50

50. Brownish Black. 39

Power flap disc surface.
Phosphoric acid clean. Cold
immerse in #39 for 1 minute.
Water rinse. Dab dry. Buff to
remove loose patina. Acetone
wipe. Apply paste wax clearcoat.

Bronze 220 & 655

Bronze:

INTRODUCTION

The term bronze was used historically to indicate copper-tin alloys, but today the word is used to indicate any copper alloy that looks like bronze. In fact, some "bronzes" are actually brasses by definition as they are alloys of copper and zinc. Today's bronzes can be alloys of copper and many elements including tin, zinc, lead, aluminum, and phosphorus among others, all formulated for specific advantageous properties. Bronzes used for art metal are hard, tough (combination of strength and ductility), and can be cold and hot worked. Bronzes also have warm raw metal colors (typically in the brown family) that patinate to rich oxidation colors.

Bronze was a very important metal for the development of civilizations as it supplanted stone and copper for tools and weaponry due to its increased hardness and toughness. The classic Bronze Age is defined as the period dating from 3300–1200BC, it eventually lost out to the Iron Age due to iron being easier to find and process. Copper-tin bronze was the dominant bronze as early as the 3rd millennium BC. Only a few ancient geographic locations had abundance of both copper and tin, so bronze was a metal that relied heavily on trade. Today, bronze uses the smelting processes to combine copper with the desired elements. The cost of bronze varies based on the specific alloy and amount of copper present, but ranges from 4–7 times that of low carbon steel. Bronzes, like brasses can be easily recycled with proper separation into the family of bronze before any melting is performed.

Properties

Bronzes UNS C22000 and UNS C65500 were chosen to illustrate bronze colorations throughout this book. C22000 bronze, also known as commercial bronze or gilding metal, has a nominal composition of 90% copper and 10% zinc. Although technically a brass with zinc being the main alloyed element, C22000 is called bronze because of its more bronze-like raw material color. A freshly abraded C22000 bronze surface has a golden brown color. C22000 is readily available as plate and sheet products. Bronze C65500 is a silicone bronze with a nominal composition of 97% copper and 3% silicone. It has a composition similar to modern bronzes used for castings and silicone bronze welding rod. Silicone bronze C65500 is available as sheet, plate, rod, and pipe. Abraded C65500 surfaces appear reddish brown in color.

Both of these bronzes have good strength, ductility, and malleability, which makes for a tough metal. Both can be cold worked, with use of proper annealing to reduce the work hardening internal stresses. The proper annealing temperature for C22000 bronze is between 800 and 1450°F (425 and 790°C) with an air cool. Annealing temperature range for bronze C65500 is slightly different at between 900 and 1300°F (480 and 705°C), followed by air-cooling. Hot working C22000 bronze is rated at good, with working temperature between 1400 and 1600°F (760–870°C). Care must be taken not to overheat the metal and boil off the alloyed zinc. Bronze C65500 is a great metal for hot working, with working temperatures between 1300–1600°F (705–870°C).

Both C22000 and C65500 bronzes can be hot joined by soldering, brazing, or welding. As with hot working, care must be taken when welding C22000 as to not boil off the zinc content by overheating the metal during the process. As with other metals, it is important to understand that differing hot joinery methods may or may not have a color match at the joint, but only welding yields a color and metal compositional match. This is important when using reactive

ABOVE: **MARIKO SUMIOKA**
Rokusyo no yane earrings
The overlapping patinated bronze tiles look as if they were taken directly from a well-weathered copper-tiled rooftop. The black areas give the sense of a continued aging process.

colorants. Both bronze weights are typical of copper alloys at between 8 ½–9 times that of water. Bronze C22000 has a melting temperature of 1870–1913°F (1020–1045°C), while C65500 melts between 1780 and 1877°F (970 and 1025°C).

As with most copper alloys, bronzes oxidize readily to form reactive colors of black, brown, yellow, orange, red, violet, blue, and green. The actual color quality developed will depend on the composition of the bronze.

Advantages of C22000 and C65500 bronze
The advantages of using bronze as an art metal are many. Bronze has a strong history as being used for art objects. Bronze has good ductility and malleability while possessing higher hardness and strength than pure copper. Both C22000 and C65500 bronzes can be readily cold worked, with proper annealing. Bronze C65500 has excellent hot working characteristics as well. Bronzes in general have warm raw metal colors, in the brown family, that patinate to beautiful, rich colorations across the spectrum. C22000 and C65500 bronze can be soldered, brazed, or welded.

Disadvantages of C22000 and C65500 bronze
The main disadvantages with bronzes are shared with brasses and copper: raw material cost, weight, and available raw material shapes. Both C22000 and C65500 bronze can easily be found as sheet, but other shapes may prove more difficult to get hold of.

NOTES ON SAMPLES USED IN THIS BOOK

In this book, bronze UNS C22000 (commonly called commercial bronze or gilding metal) and bronze UNS C65500 (commonly called silicone bronze or high silicone bronze), sheet was used for all the samples. C22000 is comprised nominally of 90% copper and 10% zinc, while UNS C65500 is made up of 97% copper and 3% silicone. Bronzes of differing compositions may yield variances in reactive colorations.

1. Aged Bronze. 56
Media blast surface. Phosphoric acid clean. Hot immerse in #56 at just below boiling for 30 minutes. Water rinse. Dab dry. Acetone wipe. Apply paste wax clearcoat.

2. Translucent Light Golden Brown. 41
Power flap disc surface. Phosphoric acid clean. Cold immerse in #41 for 1 minute. Water rinse. Dab dry. Buff to remove loose patina. Acetone wipe. Apply paste wax clearcoat.

3. Golden Brown. 49
Power synthetic wool disc surface. Phosphoric acid clean. Hot immerse in #49 at just below boiling for 30 minutes. Stir solution every 5 minutes. Water rinse. Dab dry. Apply paste wax clearcoat.

4. Aged Bronze With Brown. 55
Media blast surface. Phosphoric acid clean. Hot immerse in #55 at just below boiling for 30 minutes. Stir solution every 5 minutes. Water rinse. Dab dry. Acetone wipe. Apply paste wax clearcoat.

See pages 242–249 for the listing of colorant formulas

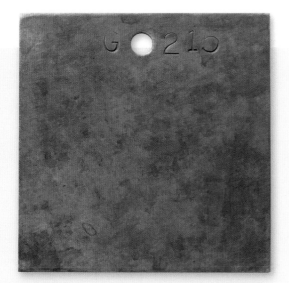

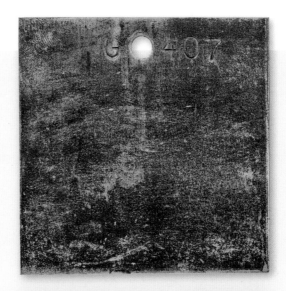

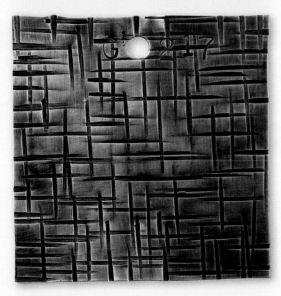

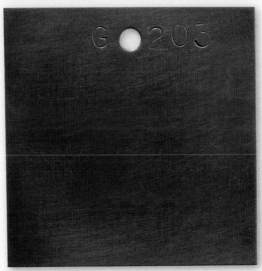

5	6
7	8

5. Brown Stipple Over Golden Yellow. 23
Power flap disc surface. Phosphoric acid clean. Hot bristle brush stipple #23 until desired value and pattern. Apply paste wax clearcoat.

6. Dark Violet Speckle. 35
Media blast surface. Phosphoric acid clean. Cold immerse in #35 for 5 days. Stir solution every 24 hours. Water rinse. Dab dry. Acetone wipe. Apply satin liquid clearcoat.

7. Aged Bronze With Dark Brown Texture. 40
Hammer texture surface. Phosphoric acid clean. Cold foam brush #40 until desired value. Water rinse. Dab dry. Dry burnish to highlight texture. Acetone wipe. Apply paste wax clearcoat.

8. Translucent Brown. 19
Hand scour surface. Hot pickle bath clean. Cold immerse in #19 for 10 seconds. Water rinse. Dab dry. Actone wipe. Apply paste wax clearcoat.

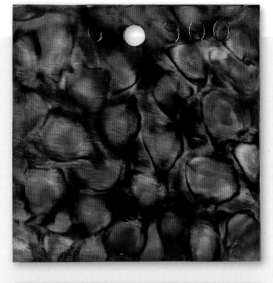

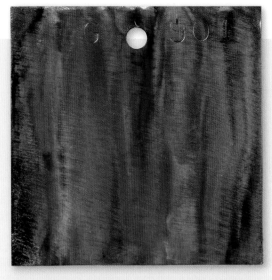

9	10
11	12

9. Translucent Multi-Color Rosettes.

Power flap disc surface. Acetone wipe clean. Develop spot colorations by stippling with flame of air/fuel or oxy/fuel torch. Quench with water saturated cloth to stop the spread of colors. Repeat until desired color and pattern developed. Water quench to cool. Dab dry. Acetone wipe. Apply gloss liquid clearcoat.

10. Translucent Multi-Color Bands.

Power flap disc surface. Acetone wipe clean. Draw vertical lines of color with flame of air/fuel or oxy/fuel torch. Quench with water saturated cloth to stop the spread of colors. Repeat until desired color and pattern developed. Water quench to cool. Dab dry. Acetone wipe. Apply gloss liquid clearcoat.

11. Red-Orange. 27

Hand scour surface. Phosphoric acid clean. Boiling immersion in cupric sulfate portion of #29 for 15 minutes. Remove and immediately immerse in hot water (140ºF/60ºC) to keep surface hot. Add ammonium chloride portion of #29 to boiling solution. Return object to boiling solution for 10 minutes. Hot water rinse. Dab dry. Acetone wipe. Apply matte liquid clearcoat.

12. Pale Blue-Green With Light Brown. 46

Hand scour surface. Phosphoric acid clean. Cold foam brush wipe #46. Allow to react for 24 hours. Cold spray airbrush #46. Allow to react for 24 hours. Repeat cold spray airbrush application 3 times with 24 hours between each. Allow to complete reaction in open air for minimum 3 days. Apply matte liquid clearcoat.

See pages 242–249 for the listing of colorant formulas

| 13 | 14 |
| 15 | 16 |

13. Blue-Green and Sky Blue Speckled Texture Over Bronze. 56, 28

Hand scour surface. Phosphoric acid clean. Cold foam brush wipe #56 to wet surface. Saturate wood shavings with #28. Bury in moist shavings for 24 hours. Unbury and carefully remove excess material from surface. Allow to complete reaction in open air for minimum 3 days. Carefully remove any unwanted particles from surface. Apply matte liquid clearcoat.

14. Blue-Green and Golden Brown Stipple. 21, 6, 23

Hand scour surface. Phosphoric acid clean. Cold foam brush wipe #21 until desired value. Water rinse. Dab dry. Dry burnish to blend. Acetone wipe. Hot bristle brush stipple #6 until desired color and pattern. Hot bristle brush stipple #23 until desired value and pattern. Apply matte liquid clearcoat.

15. Pale Bluish Green Over Masked Reddish Brown. 45, 46

Media blast surface. Phosphoric acid clean. Cold immerse in #45 for 2 minutes. Water rinse. Dab dry. Acetone wipe. Apply tape mask. Cold foam brush wipe #46. Allow to react for 24 hours. Cold spray mist #46. Allow to react for 24 hours. Repeat cold spray mist application 3 times with 24 hours between each. Remove tape mask. Allow to complete reaction in open air for minimum 3 days. Apply matte liquid clearcoat.

16. Teal. 34

Hand scour surface. Phosphoric acid clean. Cold foam brush wipe #34. Allow to react for 24 hours. Cold spray airbrush #34. Allow to react for 24 hours. Repeat cold spray airbrush application 3 times with 24 hours between each. Allow to complete reaction in open air for minimum 3 days. Apply matte liquid clearcoat.

| 17 | 18 |
| 19 | 20 |

17. Pale Green, Blue-Green and Black Speckle. 35, 22
Hand scour surface. Phosphoric acid clean. Hot spray mist #35 until desired color and pattern. Hot spray mist #22 until desired value and pattern. Water rinse. Dab dry. Acetone wipe. Apply paste wax clearcoat.

18. Olive and Blue-Green With Texture. 38, 60
Hammer texture surface. Media blast surface. Phosphoric acid clean. Cold foam brush wipe #38. Water rinse. Dab dry. Dry burnish to highlight texture. Cold foam brush wipe #60. Allow to react for 24 hours. Cold spray mist #60. Allow to react for 24 hours. Repeat cold spray mist 3 times at 24 hour intervals. Allow to complete reaction in open air for minimum 3 days. Apply matte liquid clearcoat.

19. Blue-Green Stipple Over Brown. 21, 6
Hand scour surface. Phosphoric acid clean. Cold foam brush wipe #21 until desired value. Water rinse. Dab dry. Dry burnish to blend. Acetone wipe. Hot bristle brush stipple #6 until desired color and pattern. Apply matte liquid clearcoat.

20. Blue-Green With Light Brown. 48
Hand scour surface. Phosphoric acid clean. Cold foam brush wipe #48. Allow to react for 24 hours. Cold spray airbrush #48. Allow to react for 24 hours. Repeat cold spray airbrush application 3 times with 24 hours between each. Allow to complete reaction in open air for minimum 3 days. Apply matte liquid clearcoat.

See pages 242–249 for the listing of colorant formulas

| 21 | 22 |
| 23 | 24 |

21. Blue-Green and Khaki. 26
Hand scour surface. Phosphoric acid clean. Cold foam brush wipe #26. Allow to react for 24 hours. Cold spray airbrush #26. Allow to react for 24 hours. Repeat cold spray airbrush application 3 times with 24 hours between each. Allow to complete reaction in open air for minimum 3 days. Apply matte liquid clearcoat.

22. Blue-Green With Dark Brown. 35
Hand scour surface. Phosphoric acid clean. Cold foam brush wipe #35. Allow to react for 24 hours. Cold spray airbrush #35. Allow to react for 24 hours. Repeat cold spray airbrush application 3 times with 24 hours between each. Allow to complete reaction in open air for minimum 3 days. Apply matte liquid clearcoat.

23. Light Blue-Green. 32
Hand scour surface. Phosphoric acid clean. Cold foam brush wipe #32. Allow to react for 24 hours. Cold spray airbrush #32. Allow to react for 24 hours. Repeat cold spray airbrush application 3 times with 24 hours between each. Allow to complete reaction in open air for minimum 3 days. Apply matte liquid clearcoat.

24. Vibrant Light Blue-Green. 25
Hand scour surface. Phosphoric acid clean. Cold foam brush wipe #25. Allow to react for 24 hours. Cold spray airbrush #25. Allow to react for 24 hours. Repeat cold spray airbrush application 3 times with 24 hours between each. Allow to complete reaction in open air for minimum 3 days. Apply satin liquid clearcoat.

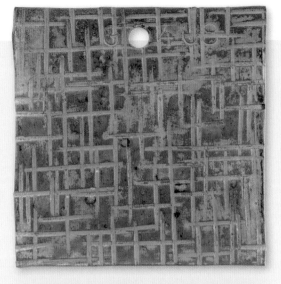

25	26
27	28

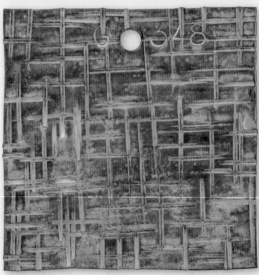

25. Aged Bronze With Vibrant Blue-Green Texture. 25

Hammer texture surface. Media blast surface. Phosphoric acid clean. Cold foam brush wipe #25. Allow to react for 24 hours. Cold spray mist #25. Allow to react for 24 hours. Repeat cold spray mist application 3 times with 24 hours between each. Allow to complete reaction in open air for minimum 3 days. Dry burnish to highlight texture. Apply matte liquid clearcoat.

26. Heavy Blue-Green With Grayish Brown. 33

Hand scour surface. Phosphoric acid clean. Cold foam brush wipe #33. Allow to react for 24 hours. Cold spray airbrush #33. Allow to react for 24 hours. Repeat cold spray airbrush application 3 times with 24 hours between each. Allow to complete reaction in open air for minimum 3 days. Apply matte liquid clearcoat.

27. Vibrant Blue-Green. 60

Power synthetic wool disc surface. Phosphoric acid clean. Cold foam brush wipe #60. Allow to react for 24 hours. Cold spray mist #60. Allow to react for 24 hours. Repeat cold spray mist application 3 times with 24 hours between each. Allow to complete reaction in open air for minimum 3 days. Apply matte liquid clearcoat.

28. Light Blue-Green Over Brown. 38, 32

Hammer texture surface. Media blast surface. Phosphoric acid clean. Cold foam brush wipe #38. Water rinse. Dab dry. Dry burnish to highlight texture. Cold foam brush wipe #32. Allow to react for 24 hours. Cold spray mist #32. Allow to react for 24 hours. Repeat cold spray mist 3 times at 24 hour intervals. Allow to complete reaction in open air for minimum 3 days. Apply matte liquid clearcoat.

See pages 242–249 for the listing of colorant formulas

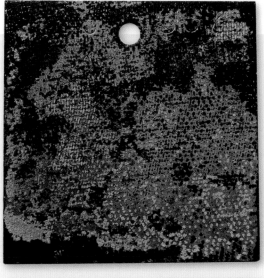

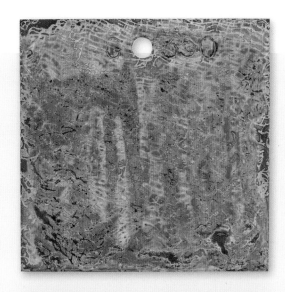

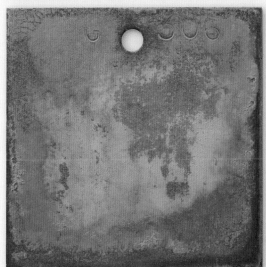

| 29 | 30 |
| 31 | 32 |

29. Sky and Midnight Blue Pattern Over Bronze. 28

Hand scour surface. Phosphoric acid clean. Saturate textured cloth with #28. Wrap surface with cloth. Allow to react for 24 hours. Unwrap and allow to complete reaction in open air for 3 days. Apply matte liquid clearcoat.

30. Sky Blue Pattern Over Brown. 45, 52

Media blast surface. Phosphoric acid clean. Cold immerse in #45 for 2 minutes. Water rinse. Dab dry. Acetone wipe. Cold foam brush wipe #52. Saturate textured cloth with #52. Wrap surface with cloth. Allow to react for 24 hours. Unwrap and allow to complete reaction in open air for 3 days. Apply matte liquid clearcoat.

31. Sky Blue. 28

Hand scour surface. Phosphoric acid clean. Cold foam brush wipe #28. Allow to react for 24 hours. Cold spray airbrush #28. Allow to react for 24 hours. Repeat cold spray airbrush application 3 times with 24 hours between each. Allow to complete reaction in open air for minimum 3 days. Apply matte liquid clearcoat.

32. Dark Sky Blue. 29

Hand scour surface. Phosphoric acid clean. Cold foam brush wipe #29. Allow to react for 24 hours. Cold spray airbrush #29. Allow to react for 24 hours. Repeat cold spray airbrush application 3 times with 24 hours between each. Allow to complete reaction in open air for minimum 3 days. Apply matte liquid clearcoat.

33	34
35	36

33. Dark and Midnight Blue. 56, 30, 31

Hand scour surface. Phosphoric acid clean. Cold foam brush wipe #56 to wet surface. Fume for 7 days with #30 and #31 in separate bowls. Uncover and allow to react in open air for minimum 3 days. Apply matte liquid clearcoat.

34. Grayish Blue and Olive. 45, 47

Hand scour surface. Phosphoric acid clean. Cold immerse in #45 for 1 minute. Water rinse. Dab dry. Acetone wipe. Cold foam brush wipe #47. Allow to react for 24 hours. Cold spray airbrush #47. Allow to react for 24 hours. Repeat cold spray airbrush application 3 times at 24 hour intervals. Allow to complete reaction in open air for minimum 3 days. Apply matte liquid clearcoat.

35. Heavy Blue-Violet Over Masked Bronze. 42, 56, 62, 63

Power flap disc surface. Acetone wipe clean. Apply tape mask to desired area. Cold foam brush #42 until desired value. Water rinse. Dab dry. Cold foam brush wipe #56 to wet surface. Fume for 24 hours with #56, #62, and #63 in separate bowls. Uncover and allow to react in open air for minimum 3 days. Remove tape mask. Apply matte liquid clearcoat.

36. Antiqued Bronze With Texture. 37

Hammer texture surface. Media blast surface. Phosphoric acid clean. Cold foam brush wipe #37 until desired value. Water rinse. Dab dry. Dry burnish to highlight texture. Acetone wipe. Apply paste wax clearcoat.

See pages 242–249 for the listing of colorant formulas

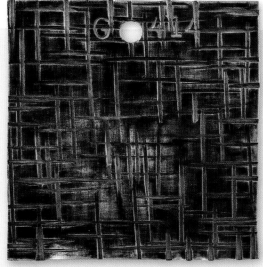

37	38
39	40

37. Dark Violet With Dark Yellow Texture. 37, 13, 17
Hammer texture surface. Phosphoric acid clean. Cold foam brush wipe #37 until desired value. Water rinse. Dab dry. Dry burnish to highlight texture. Hot foam brush wipe #13 until desired value. Dry burnish to blend. Hot foam brush wipe #17. Dry burnish to highlight texture. Repeat hot applications of #13 and #17 alternately with dry burnishing. Apply satin liquid clearcoat.

38. Sky Blue Over Dark Brick Red. 44, 48
Hand scour surface. Phosphoric acid clean. Hot immerse in #44 at just below boiling for 30 minutes. Stir solution every 5 minutes. Water rinse. Dab dry. Cold foam brush wipe #48. Allow to react for 24 hours. Cold spray airbrush #48. Allow to react for 24 hours. Repeat cold spray airbrush 3 times at 24 hour intervals. Allow to complete reaction in open air for minimum 3 days. Apply matte liquid clearcoat.

39. Translucent Brownish Black. 40
Power flap disc surface. Phosphoric acid clean. Cold immerse in #40 for 1 minute. Water rinse. Dab dry. Buff to remove loose patina. Acetone wipe. Apply paste wax clearcoat.

40. Dark Brick Red. 44
Power synthetic wool disc surface. Phosphoric acid clean. Hot immerse in #44 at just below boiling for 30 minutes. Stir solution every 5 minutes. Water rinse. Dab dry. Apply paste wax clearcoat.

41 | 42

41. Pale Blue Over Red-Orange. 44, 46

Hand scour surface. Phosphoric acid clean. Hot immerse in #44 at just below boiling for 30 minutes. Stir solution every 5 minutes. Water rinse. Dab dry. Cold foam brush wipe #46. Allow to react for 24 hours. Cold spray airbrush #46. Allow to react for 24 hours. Repeat cold spray airbrush 3 times at 24 hour intervals. Allow to complete reaction in open air for minimum 3 days. Apply matte liquid clearcoat.

42. Pale Blue Over Brick Red. 44, 47

Hand scour surface. Phosphoric acid clean. Hot immerse in #44 at just below boiling for 30 minutes. Stir solution every 5 minutes. Water rinse. Dab dry. Cold foam brush wipe #47. Allow to react for 24 hours. Cold spray airbrush #47. Allow to react for 24 hours. Repeat cold spray airbrush 3 times at 24 hour intervals. Allow to complete reaction in open air for minimum 3 days. Apply matte liquid clearcoat.

43. Grayish Brown. 45

Media blast surface. Phosphoric acid clean. Cold immerse in #45 for 2 minutes. Water rinse. Dab dry. Acetone wipe. Apply matte liquid clearcoat.

44. Translucent Dark Reddish Brown. 21

Hand scour surface. Hot pickle bath clean. Cold immerse in #21 for 10 seconds. Water rinse. Dab dry. Acetone wipe. Apply paste wax clearcoat.

See pages 242–249 for the listing of colorant formulas

45. Dark Red-Violet Over Masked Grayish Violet. 35

Media blast surface. Phosphoric acid clean. Tape mask desired area. Hot immerse at just below boiling in #35 for 10 minutes. Remove from solution and carefully remove tape mask. Continue hot immersion for 10 minutes longer. Rinse with hot water immerse at 140ºF (60ºC). Dab dry. Apply paste wax clearcoat.

46 | 47

46. Translucent Brown. 20
Hand scour surface. Hot pickle bath clean. Hot foam brush wipe #20 until desired value. Water rinse. Dab dry. Dry burnish to blend. Acetone wipe. Apply paste wax clearcoat.

47. Reddish Brown Pattern. 21, 24
Hand scour surface. Phosphoric acid clean. Cold foam brush wipe #21 until desired value. Water rinse. Dab dry. Dry burnish to blend. Acetone wipe. Hot spray #24 with surface at or above 212ºF (100ºC). Repeat spray application until desired color and pattern. Apply paste wax clearcoat.

48. Brownish Black. 39
Power flap disc surface. Phosphoric acid clean. Cold immerse in #39 for 1 minute. Water rinse. Dab dry. Buff to remove loose patina. Acetone wipe. Apply paste wax clearcoat.

49. Pale Blue-Green With Khaki. 47
Hand scour surface. Phosphoric acid clean. Cold foam brush wipe #47. Allow to react for 24 hours. Cold spray airbrush #47. Allow to react for 24 hours. Repeat cold spray airbrush application 3 times with 24 hours between each. Allow to complete reaction in open air for minimum 3 days. Apply matte liquid clearcoat.

See pages 242–249 for the listing of colorant formulas

50. Jet Black. 37
Power flap disc surface.
Phosphoric acid clean. Cold
immerse in #37 for 1 minute.
Water rinse. Dab dry. Buff to
remove loose patina. Acetone
wipe. Apply paste wax clearcoat.

1	2
3	4

1. Light Olive Green. 45, 46
Hand scour surface. Phosphoric acid clean. Cold immerse in #45 for 1 minute. Water rinse. Dab dry. Acetone wipe. Cold foam brush wipe #46. Allow to react for 24 hours. Cold spray airbrush #46. Allow to react for 24 hours. Repeat cold spray airbrush application 3 times with 24 hours between each. Allow to complete reaction in open air for minimum 3 days. Apply matte liquid clearcoat.

2. Brown Stipple Over Aged Bronze. 23
Power flap disc surface. Phosphoric acid clean. Hot bristle brush stipple #23 until desired value and pattern. Apply paste wax clearcoat.

3. Light Olive Green Over Masked Aged Bronze. 45, 46
Media blast surface. Phosphoric acid clean. Cold immerse in #45 for 2 minutes. Water rinse. Dab dry. Acetone wipe. Apply tape mask. Cold foam brush wipe #46. Allow to react for 24 hours. Cold spray mist #46. Allow to react for 24 hours. Repeat cold spray mist 3 times at 24 hour intervals. Remove tape mask. Allow to complete reaction in open air for minimum 3 days. Apply matte liquid clearcoat.

4. Aged Bronze With Dark Brown. 55
Media blast surface. Phosphoric acid clean. Hot immerse in #55 at just below boiling for 30 minutes. Stir solution every 5 minutes. Water rinse. Dab dry. Acetone wipe. Apply paste wax clearcoat.

See pages 242–249 for the listing of colorant formulas

5	6
7	8

5. Golden Brown. 49
Power synthetic wool disc surface. Phosphoric acid clean. Hot immerse in #49 at just below boiling for 30 minutes. Stir solution every 5 minutes. Water rinse. Dab dry. Apply paste wax clearcoat.

6. Violet Speckle Over Aged Bronze. 35
Media blast surface. Phosphoric acid clean. Cold immerse in #35 for 5 days. Stir solution every 24 hours. Water rinse. Dab dry. Acetone wipe. Apply satin liquid clearcoat.

7. Orange-Red. 44
Power synthetic wool disc surface. Phosphoric acid clean. Hot immerse in #44 at just below boiling for 2 minutes and 30 seconds. Water rinse. Dab dry. Apply paste wax clearcoat.

8. Red-Orange. 44
Power synthetic wool disc surface. Phosphoric acid clean. Hot immerse in #44 at just below boiling for 10 minutes. Stir solution at 5 minutes. Water rinse. Dab dry. Apply paste wax clearcoat.

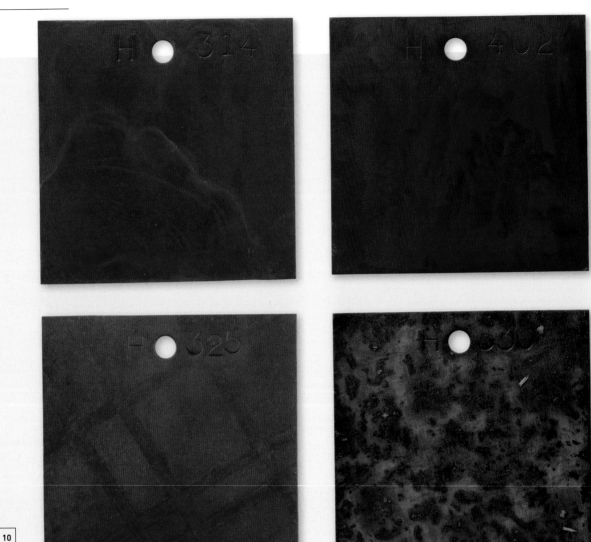

9. Orange-Red Striations In Brick Red. 44, 46

Hand scour surface. Phosphoric acid clean. Hot immerse in #44 at just below boiling for 30 minutes. Stir solution every 5 minutes. Water rinse. Dab dry. Cold foam brush wipe #46. Allow to react for 24 hours. Cold spray airbrush #46. Allow to react for 24 hours. Repeat cold spray airbrush 3 times at 24 hour intervals. Allow to complete reaction in open air for minimum 3 days. Apply matte liquid clearcoat.

10. Red-Violet. 50

Power synthetic wool disc surface. Phosphoric acid clean. Hot immerse in #50 at just below boiling for 30 minutes. Water rinse. Dab dry. Apply paste wax clearcoat.

11. Red-Violet Over Masked Brick Red. 35

Media blast surface. Phosphoric acid clean. Tape mask desired area. Hot immerse at just below boiling in #35 for 10 minutes. Remove from solution and carefully remove tape mask. Continue hot immersion for 10 minutes longer. Hot water rinse immerse at 140ºF (60ºC). Dab dry. Apply paste wax clearcoat.

12. Violet Speckled Texture Over Orange-Brown. 22, 35

Power synthetic wool disc surface. Phosphoric acid clean. Cold foam brush wipe #22. Water rinse. Dab dry. Acetone wipe. Dry burnish to blend. Saturate wood shavings with #35. Bury in moist shavings for 48 hours. Unbury and remove excess material from surface. Allow to complete reaction in open air for minimum 3 days. Remove any unwanted particles from surface. Apply matte liquid clearcoat.

See pages 242–249 for the listing of colorant formulas

13	14
15	16

13. Blue-Green and Golden Brown Stipple Over Brown. 21, 6, 23

Hand scour surface. Phosphoric acid clean. Cold foam brush wipe #21 until desired value. Water rinse. Dab dry. Acetone wipe. Dry burnish to blend. Hot bristle brush stipple #6 until desired color and pattern. Hot bristle brush stipple #23 until desired value and pattern. Apply matte liquid clearcoat.

14. Blue-Green Stipple Over Brown. 21, 6

Hand scour surface. Phosphoric acid clean. Cold foam brush wipe #21 until desired value. Water rinse. Dab dry. Acetone wipe. Dry burnish to blend. Hot bristle brush stipple #6 until desired color and pattern. Apply matte liquid clearcoat.

15. Pale Blue-Green With Tan. 26

Power synthetic wool disc surface. Phosphoric acid clean. Cold foam brush wipe #26. Allow to react for 24 hours. Cold spray mist #26. Allow to react for 24 hours. Repeat cold spray mist application 3 times with 24 hours between each. Allow to complete reaction in open air for minimum 3 days. Apply matte liquid clearcoat.

16. Pale Teal. 34

Hand scour surface. Phosphoric acid clean. Cold foam brush wipe #34. Allow to react for 24 hours. Cold spray airbrush #34. Allow to react for 24 hours. Repeat cold spray airbrush application 3 times with 24 hours between each. Allow to complete reaction in open air for minimum 3 days. Apply matte liquid clearcoat.

17	18
19	20

17. Blue-Green and Black Speckle. 35, 22

Hand scour surface. Phosphoric acid clean. Hot spray mist #35 until desired color and pattern. Hot spray mist #22 until desired value and pattern. Water rinse. Dab dry. Acetone wipe. Apply paste wax clearcoat.

18. Blue-Green and Olive With Texture. 38, 60

Hammer texture surface. Media blast surface. Phosphoric acid clean. Cold foam brush wipe #38. Water rinse. Dab dry. Dry burnish to highlight texture. Cold foam brush wipe #60. Allow to react for 24 hours. Cold spray mist #60. Allow to react for 24 hours. Repeat cold spray mist 3 times at 24 hour intervals. Allow to complete reaction in open air for minimum 3 days. Apply matte liquid clearcoat.

19. Blue-Green Over Dark Khaki. 56, 30

Hand scour surface. Phosphoric acid clean. Cold foam brush wipe #56 to wet surface. Fume for 7 days with #30 in bowl. Uncover and allow to react in open air for minimum 3 days. Apply matte liquid clearcoat.

20. Aged Bronze With Vibrant Blue-Green Texture. 25

Hammer texture surface. Media blast surface. Phosphoric acid clean. Cold foam brush wipe #25. Allow to react for 24 hours. Cold spray mist #25. Allow to react for 24 hours. Repeat cold spray mist application 3 times with 24 hours between each. Allow to complete reaction in open air for minimum 3 days. Dry burnish to highlight texture. Apply matte liquid clearcoat.

See pages 242–249 for the listing of colorant formulas

21	22
23	24

21. Blue-Green Speckled Texture Over Bronze. 28
Hand scour surface. Phosphoric acid clean. Saturate wood shavings with #28. Bury in moist shavings for 24 hours. Unbury and carefully remove excess material from surface. Allow to complete reaction in open air for minimum 3 days. Carefully remove any unwanted particles from surface. Apply matte liquid clearcoat.

22. Vibrant Green-Blue. 1
Power synthetic wool disc surface. Phosphoric acid clean. Cold foam brush wipe #1. Allow to react for 24 hours. Cold spray mist #1. Allow to react for 24 hours. Repeat cold spray mist application 3 times with 24 hours between each. Allow to complete reaction in open air for minimum 3 days. Apply matte liquid clearcoat.

23. Light Blue-Green Pattern Over Brown. 45, 52
Media blast surface. Phosphoric acid clean. Cold immerse in #45 for 2 minutes. Water rinse. Dab dry. Acetone wipe. Cold foam brush wipe #52. Saturate textured cloth with #52. Wrap surface with cloth. Allow to react for 24 hours. Unwrap and allow to complete reaction in open air for 3 days. Apply matte liquid clearcoat.

24. Light Green-Blue With Texture. 38, 32
Hammer texture surface. Media blast surface. Phosphoric acid clean. Cold foam brush wipe #38. Water rinse. Dab dry. Dry burnish to highlight texture. Cold foam brush wipe #32. Allow to react for 24 hours. Cold spray mist #32. Allow to react for 24 hours. Repeat cold spray mist 3 times at 24 hour intervals. Allow to complete reaction in open air for minimum 3 days. Apply matte liquid clearcoat.

25	26
27	28

25. Blue-Green. 33
Hand scour surface. Phosphoric acid clean. Cold foam brush wipe #33. Allow to react for 24 hours. Cold spray airbrush #33. Allow to react for 24 hours. Repeat cold spray airbrush application 3 times with 24 hours between each. Allow to complete reaction in open air for minimum 3 days. Apply matte liquid clearcoat.

26. Sky Blue. 25
Hand scour surface. Phosphoric acid clean. Cold foam brush wipe #25. Allow to react for 24 hours. Cold spray airbrush #25. Allow to react for 24 hours. Repeat cold spray airbrush application 3 times with 24 hours between each. Allow to complete reaction in open air for minimum 3 days. Apply matte liquid clearcoat.

27. Dark Blue-Green and Black Speckle. 29
Hand scour surface. Phosphoric acid clean. Cold foam brush wipe #29. Allow to react for 24 hours. Cold spray mist #29 . Allow to react for 24 hours. Repeat cold spray mist application 3 times with 24 hours between each. Allow to complete reaction in open air for minimum 3 days. Apply matte liquid clearcoat.

28. Pale Blue Over Greenish Brown. 45, 47
Hand scour surface. Phosphoric acid clean. Cold immerse in #45 for 1 minute. Water rinse. Dab dry. Acetone wipe. Cold foam brush wipe #47. Allow to react for 24 hours. Cold spray airbrush #47. Allow to react for 24 hours. Repeat cold spray airbrush application 3 times at 24 hour intervals. Allow to complete reaction in open air for minimum 3 days. Apply matte liquid clearcoat.

See pages 242–249 for the listing of colorant formulas

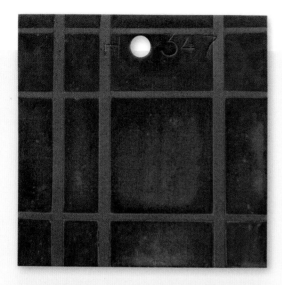

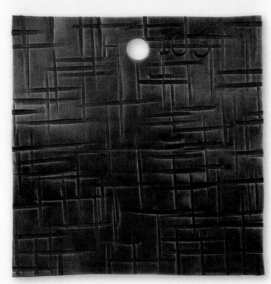

29	30
31	32

29. Blue-Green and Olive Over Masked Aged Bronze. 45, 48
Media blast surface. Phosphoric acid clean. Cold immerse in #45 for 2 minutes. Water rinse. Dab dry. Acetone wipe. Apply tape mask. Cold foam brush wipe #48. Allow to react for 24 hours. Cold spray mist #48. Allow to react for 24 hours. Repeat cold spray mist 3 times at 24 hour intervals. Remove tape mask. Allow to complete reaction in open air for minimum 3 days. Apply matte liquid clearcoat.

30. Grayish Brown. 45
Media blast surface. Phosphoric acid clean. Cold immerse in #45 for 2 minutes. Water rinse. Dab dry. Acetone wipe. Apply matte liquid clearcoat.

31. Pale Blue With Dark Tan. 47
Hand scour surface. Phosphoric acid clean. Cold foam brush wipe #47. Allow to react for 24 hours. Cold spray airbrush #47. Allow to react for 24 hours. Repeat cold spray airbrush application 3 times with 24 hours between each. Allow to complete reaction in open air for minimum 3 days. Apply matte liquid clearcoat.

32. Antiqued Bronze With Texture. 37
Hammer texture surface. Media blast surface. Phosphoric acid clean. Cold foam brush wipe #37 until desired value. Water rinse. Dab dry. Dry burnish to lighten and highlight texture. Acetone wipe. Apply paste wax clearcoat.

33 | 34

33. Brownish Black. 39
Power flap disc surface. Phosphoric acid clean. Cold immerse in #39 for 1 minute. Water rinse. Dab dry. Buff to remove loose patina. Acetone wipe. Apply paste wax clearcoat.

34. Translucent Brown. 42
Power flap disc surface. Phosphoric acid clean. Cold immerse in #42 for 1 minute. Water rinse. Dab dry. Buff to remove loose patina. Acetone wipe. Apply paste wax clearcoat.

35. Translucent Dark Reddish Brown. 20
Hand scour surface. Hot pickle bath clean. Cold immerse in #20 for 10 seconds. Water rinse. Dab dry. Acetone wipe. Apply paste wax clearcoat.

36. Translucent Bluish Black. 22
Hand scour surface. Hot pickle bath clean. Cold immerse in #22 for 10 seconds. Water rinse. Dab dry. Acetone wipe. Apply paste wax clearcoat.

See pages 242–249 for the listing of colorant formulas

37. Jet Black. 37
Power flap disc surface.
Phosphoric acid clean. Cold
immerse in #37 for 1 minute.
Water rinse. Dab dry. Buff to
remove loose patina. Acetone
wipe. Apply paste wax clearcoat.

Sterling silver

Sterling silver:
INTRODUCTION

Sterling silver is a silver-based alloy with a minimum silver
content of 92.5% (definite standard for U.S. and U.K.).
Because of its high silver content, sterling is considered
precious and carries with that label a high price tag. Thanks
to the main alloying element copper, sterling silver is harder
than pure silver and is better suited for functional works.
Sterling also retains silver's excellent workability properties of
ductility and malleability and its lustrous beauty. Sterling
silver can be brought to a high shine, but must be polished to
remove any tarnish that forms on the surface.

 Although pure silver has been used in civilization for
thousands of years for jewelry, ornaments, and coins, the
silver-copper alloy "sterling silver" first came about in
continental Europe during the 12th century. Silver and
sterling silver products were hugely popular prior to the
industrial revolution, but fell out of favor with the advent of
iron and steel products and production-oriented processes.
Silversmithing at the time was still a very labor-intensive
method to make metal goods. Sterling peaked in popularity
again in the mid-19th to early 20th century as sterling
tableware was in fashion. Pure silver is most often produced
as a by-product of copper, gold, lead, and zinc refining

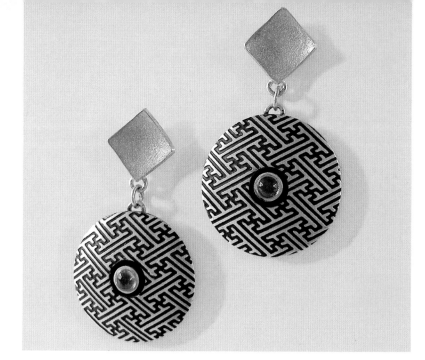

processes. With its precious metal status and low extraction percentages in alloyed compounds found in the earth, sterling silver raw material costs are approximately 200 times that of low-carbon steel (at the time of writing). Sterling scrap or goods can be recycled and sold for its percentage precious metal content at the daily virgin silver rate.

Properties

UNS P07932 is the designation given by the Unified Numbering System to sterling silver with a minimum silver content of 92.5%. The remaining 7.5% is typically copper, although this is not specified by the UNS designation. Other sterling alloys have been and are currently being developed to resist fire scale (oxidation caused by the heating process) and reduce tarnishing compared to the silver-copper sterling alloy. Sterling is most often found as sheet, small rod and tubing, various profile wire shapes, as well as casting grains. The freshly abraded color of P07932 sterling silver is a bright, whitish gray.

Sterling P07932 has relatively low strength, but is not used in applications where strength is the primary consideration. Sterling possesses excellent ductility and malleability, being the most favorable physical properties to the metalsmith. Sterling silver is almost exclusively worked cold, with proper annealing required to reduce the work hardening stresses. The proper annealing temperature

RIGHT: **RAMINTA JAUTOKAS**
Cracked Earth
Subtle texture or detail that could otherwise be lost within a monochromatic piece can be highlighted with the use of color. Here the sterling silver is patinated and burnished to remove all color except at the edges of the texture. There is enough coloration to define the texture, but not to overwhelm it.

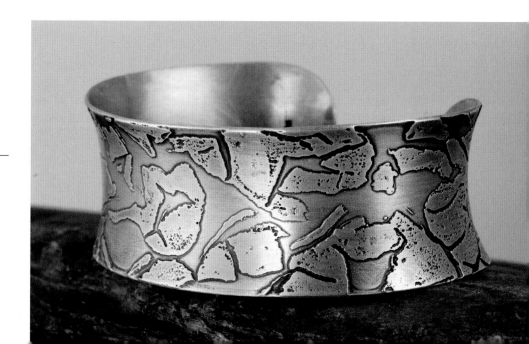

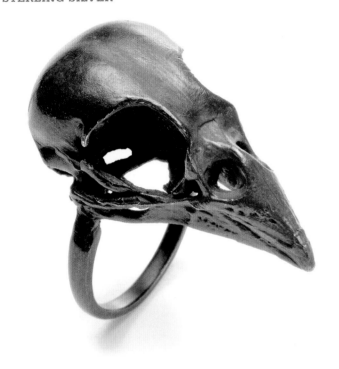

range is between 1200 and 1400°F (650 and 760°C) with either
an air cool or water quench cool.

UNS P07932 sterling can be readily soldered and brazed
by conventional means. With the growing accessibility to
laser processes, welding of sterling is becoming much more
feasible. As with other metals, it is important to understand
that differing hot joinery methods may or may not have a
color match at the joint, but only welding yields a color and
metal compositional match. This is important when using
reactive colorants. Sterling silver is a heavy metal, weighing
close to 10½ times that of water. P09732 sterling has a
melting temperature range of 1450–1635°F (790–890°C).

Because of its copper content UNS P07932 sterling
"tarnishes" more quickly than fine silver, that is, atmospheric
oxygen darkens the metal surface. Sterling has a broad
reactive coloration range, with blacks, browns, yellows,
reds, violets, greens, and blues available. However, most
colors tend to darken toward gray or black over time if not
sealed properly.

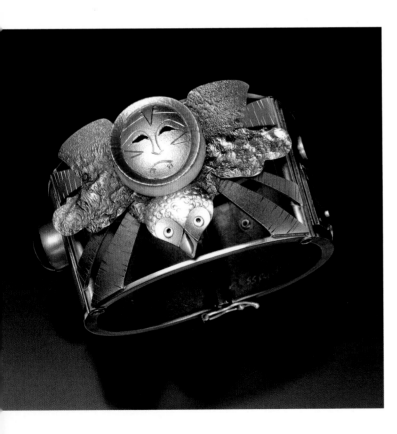

LEFT: **JOAN TENENBAUM**
Owl mask spirit helper bracelet
The use of differing metals and colorations can help draw the viewer's
eye to specific components or features within a single piece. Use colors
to highlight texture and help to differentiate parts that otherwise could
become visually lost in a monochromatic piece.

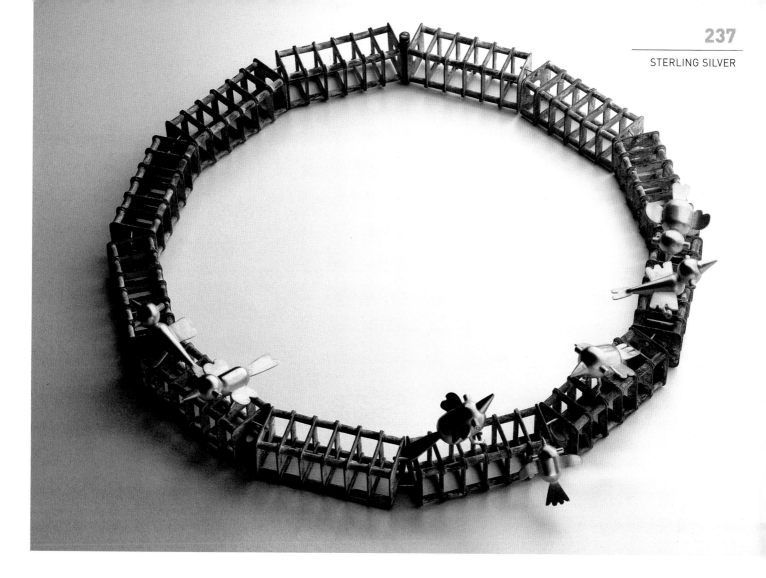

Advantages of P07932 sterling silver

The main advantage of P07932 sterling silver to the jeweler/
metalsmith is its precious metal status. Silver products
have historically been associated with wealth. Sterling also
is very easily cold worked, and with proper annealing can
be wrought and drawn into beautiful ornamentation.

Disadvantages of P07932 sterling silver

The main drawback to UNS P07932 sterling for both the
maker and the consumer is material cost. At current
pricing, sterling costs are approximately 200 times that
of plain, low-carbon steel. Sterling is a harder metal than
pure silver, but is still relatively soft with low strength and
a high weight.

NOTES ON SAMPLES USED IN THIS BOOK

In this book, silver alloy UNS P07932, commonly called sterling
silver, or 925 silver, sheet was used for all the samples. P07932
is comprised of a minimum 92.5% pure silver and a maximum
7.5% alloying element, most often copper. Fine silver or
sterling alloys of differing composition may yield variances
in reactive colorations.

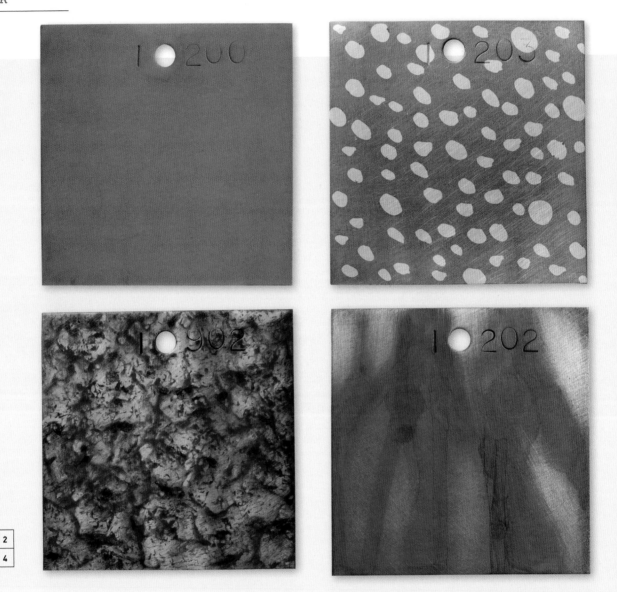

1	2
3	4

1. Tan. 45
Power synthetic wool disc surface. Phosphoric acid clean. Cold immerse in #45 for 2 minutes. Water rinse. Dab dry. Acetone wipe. Apply matte liquid clearcoat.

2. Golden Yellow Over Masked Silver. 21
Power synthetic wool disc surface. Phosphoric acid clean. Apply liquid latex mask in desired areas. Cold immerse in #21 until desired color develops. Water rinse. Dab dry. Remove latex mask. Acetone wipe. Apply paste wax clearcoat.

3. Sponged Red Over Golden Yellow. 10, 21
Power synthetic wool disc surface. Phosphoric acid clean. Hot sponge #10 until desired value and pattern. Cold immerse in #21 until desired value. Water rinse. Dab dry. Acetone wipe. Apply satin liquid clearcoat.

4. Translucent Orange Pattern Over Silver. 21, 11
Power synthetic wool disc surface. Phosphoric acid clean. Hot foam brush wipe #21 until desired value. Water rinse. Dab dry. Dry burnish to blend. Acetone wipe. Hot spray drip #11 until desired value and pattern. Abrade with synthetic wool pad to remove color in desired areas. Apply satin liquid clearcoat.

See pages 242–249 for the listing of colorant formulas

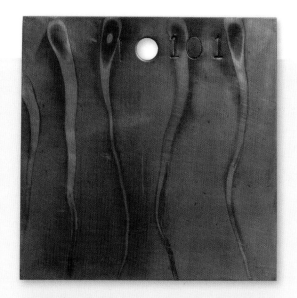

5	6
7	8

5. Translucent Pale Blue Over Masked Yellowish Brown. 21

Polish surface. Phosphoric acid clean. Apply liquid latex mask in desired areas. Cold immerse in #21 for 5 minutes. Water rinse. Dab dry. Remove latex mask. Acetone wipe. Cold immerse dip in #21 with no dwell time. Water rinse. Dab dry. Acetone wipe. Apply paste wax clearcoat.

6. Violet Striations Over Translucent Golden Brown. 21

Power flap disc surface. Phosphoric acid clean. Cold immerse in #21, partial sections at a time until desired colors appear. Darker color bands will develop at line of liquid solution level. Water rinse. Dab dry. Acetone wipe. Apply paste wax clearcoat.

7. Translucent Green With Dark Green Texture. 21, 15

Hammer texture surface. Phosphoric acid clean. Hot foam brush wipe #21 until desired value. Water rinse. Dab dry. Dry burnish to highlight texture. Acetone wipe. Hot foam brush wipe #15 until desired value. Dry burnish to blend. Apply satin liquid clearcoat.

8. Translucent Green-Blue Speckle Over Black With Silver. 21, 16, 15

Power synthetic wool disc surface. Phosphoric acid clean. Hot foam brush wipe #21 until desired value. Water rinse. Dab dry. Dry burnish to blend. Acetone wipe. Hot spray mist #16 until desired value and pattern. Hot spray mist #15 until desired value and pattern. Abrade with synthetic wool pad to remove color in desired area. Apply satin liquid clearcoat.

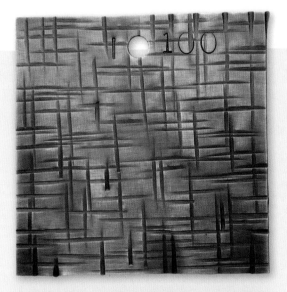

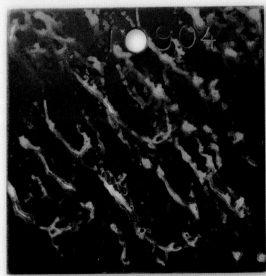

9	10
11	12

9. Burnished Black Over Masked Silver. 18

Polish surface. Phosphoric acid clean. Apply tape mask to desired area. Hot foam brush wipe #18 until desired value. Remove tape mask. Dry burnish blend. Apply satin liquid clearcoat.

10. Silvery Black With Texture. 22

Hammer texture surface. Phosphoric acid clean. Hot foam brush wipe #22 until desired value. Water rinse. Dab dry. Dry burnish to highlight texture. Acetone wipe. Apply paste wax clearcoat.

11. Silvery Black With Pastel Violet Texture. 21, 13, 14

Hammer texture surface. Phosphoric acid clean. Hot foam brush wipe #21 until desired value. Water rinse. Dab dry. Dry burnish to highlight texture. Acetone wipe. Hot foam brush wipe #13 until desired value. Dry burnish blend. Hot foam brush wipe #14 until desired value. Dry burnish to blend. Apply satin liquid clearcoat.

12. White Pattern Over Black. 21, 14

Power synthetic wool disc surface. Phosphoric acid clean. Hot foam brush wipe #21 until desired value. Water rinse. Dab dry. Acetone wipe. Hot sponge #14 until desired value and pattern. Apply matte liquid clearcoat.

See pages 242–249 for the listing of colorant formulas

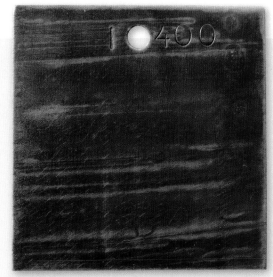

13	14
15	16

13. Brownish Black. 9
Power synthetic wool disc surface. Phosphoric acid clean. Cold foam brush wipe #9 until desired value. Water rinse. Dab dry. Acetone wipe. Apply matte liquid clearcoat.

14. Multi-Colored Striations. 21
Polish surface. Phosphoric acid clean. Cold foam brush wipe #21 until desired colors appear. Water rinse. Dab dry. Acetone wipe. Apply gloss liquid clearcoat.

15. Slate Black. 21
Power synthetic wool disc surface. Phosphoric acid clean. Hot foam brush wipe #21 until desired value. Water rinse. Dab dry. Dry burnish to blend. Acetone wipe. Apply satin liquid clearcoat.

16. Black Speckle Over Slate Black. 21
Polish surface. Phosphoric acid clean. Hot foam brush wipe #21 until desired value. Water rinse. Dab dry. Dry burnish to blend. Acetone wipe. Hot spray splatter #21 until desired value and pattern. Water rinse. Dab dry. Acetone wipe. Apply satin liquid clearcoat.

Colorant formulas

The following colorants are a combination of simple chemical formulas, branded pre-mixes, and household ingredients to allow for a broad spectrum of metal colorations on each of the seven metal families. This is by no means an exhaustive formula or product listing, but includes some of the most common and useful.

The recipes have been standardized to parts per weight (ppw) or parts per volume (ppv) measure to simplify working in either the International System of Units (SI) or the U.S. customary system. When using the ppw or ppv system, the ingredients can be measured in any corresponding weight or volume units such as grams or ounces (weight) and milliliters or fluid ounces (volume) so long as the units of measure are consistent with all the ingredients listed for a particular recipe. To increase or decrease the recipe yield, scale up or down each ingredient by the same amount.

Always follow safe chemical handling and mixing procedure by wearing appropriate gloves, eyewear, respirator and having adequate studio ventilation. As a rule, always mix reactive ingredients (acids, etc.) into the distilled water. Have clean, running water accessible to rinse any skin that has been in contact with a chemical.

FORMULA EXAMPLES

PPW Example, Recipe #3:

8.9ppw	cupric sulfate
100ppw	distilled water

SI, using 1ppw = 1g

8.9g	cupric sulfate
100g	distilled water

To estimate the volume yield, divide the weight of distilled water by the density of distilled water:

$$\frac{100g}{1g/ml} = 100ml$$

the above solution at 1ppw = 1g will yield approx. 100ml

U.S. customary system, using 1ppw = 1oz (weight)

8.9oz	cupric nitrate
100oz	distilled water

To estimate the volume yield, divide the weight of distilled water by the density of distilled water:

$$\frac{100oz}{1.0413oz/fl\ oz} = 96.03fl\ oz$$

the above solution at 1ppw = 1oz will yield approx. 96fl oz, or ¾ gallon.

For a smaller solution yield of approximately 4fl oz, use 1ppw = ¹⁄₂₅ oz, dividing each listed ingredient by 25.

PPV Example, Recipe # 4

1ppv	phosphoric acid solution
3ppv	distilled water

SI, using 1ppv = 25ml

25ml	phosphoric acid solution
75ml	distilled water

Total prepared solution volume yields 100ml

U.S. customary system, using 1ppv = 1fl oz

1fl oz	phosphoric acid solution
3fl oz	distilled water

Total prepared volume yields 4fl oz

DENSITY

Density = mass per unit volume of a substance

Density of distilled water:

= 1g/ml (SI)

= 1.041 oz/fl oz (U.S. customary system)

1l = 1000ml = 1000g of distilled water

1qt = 32fl oz = 33.31 oz of distilled water

CONVERSIONS

1oz dry weight = 28.350g

1fl oz = 29.574ml

Abbreviations:

fl oz = fluid ounce (volume)	ml = milliter	ppw = parts per weight
g = gram	oz = ounce (weight)	qt = quart
l = liter	ppv = parts per volume	

Ingredients used in colorant formulas

Below is a list of ingredients used in all the following colorant recipes. The goal was to keep the number of ingredients needed to a minimum; inclusion was based on accessibility and

versatility. The branded ingredients listed are used only to identify exactly what was used for each of the sample colorations. Similar products of differing brands may have slight coloration variations.

INGREDIENT NAME	BRAND	PURCHASED FORM
Aluma Black® A14	Birchwood Technologies	Pre-mix liquid
Antique Black® M24	Birchwood Technologies	Pre-mix liquid
Antique Brown™ M38	Birchwood Technologies	Pre-mix liquid
Presto Black® BST4	Birchwood Technologies	Pre-mix liquid
Dye Oxide, Black	Sculpt Nouveau	Pre-mix liquid
Dye Oxide, Blue	Sculpt Nouveau	Pre-mix liquid
Dye Oxide, Brown	Sculpt Nouveau	Pre-mix liquid
Dye Oxide, Green	Sculpt Nouveau	Pre-mix liquid
Dye Oxide, Orange	Sculpt Nouveau	Pre-mix liquid
Dye Oxide, Red	Sculpt Nouveau	Pre-mix liquid
Dye Oxide, Violet	Sculpt Nouveau	Pre-mix liquid
Dye Oxide, White	Sculpt Nouveau	Pre-mix liquid
Dye Oxide, Yellow	Sculpt Nouveau	Pre-mix liquid
Japanese Brown	Sculpt Nouveau	Pre-mix liquid
Stainless Black	Sculpt Nouveau	Pre-mix liquid
Acetic acid/white vinegar, 6% by volume		Pre-mix liquid
Acetic acid, glacial, 99.7% by volume		Pre-mix liquid
Ammonium chloride		Dry solid, granular
Ammonium hydroxide, 28-30% by weight		Pre-mix liquid
Ammonia, household, 5–10% by weight		Pre-mix liquid
Calcium carbonate[1]		Dry solid, granular
Cupric acetate		Dry solid, granular
Cupric nitrate		Dry solid, granular
Cupric sulfate		Dry solid, flake
Distilled water		Liquid
Ferric nitrate		Dry solid, granular
Phosphoric acid solution, 35–45% by volume		Pre-mix liquid
Rokusho (purchased or made; see recipe #43)		Wet precipitate
Sodium chloride		Dry solid, granular
Sodium hydroxide[1]		Dry solid, granular
Sulfurated potash (liver of sulfur)		Dry solid, chunk

[1] Chemicals used exclusively for rokusho making

RECIPE NUMBER/NAME	INGREDIENTS AS PARTS PER WEIGHT (PPW) OR PARTS PER VOLUME (PPV)		PREPARATION METHOD	NOTES
1	7.6ppw 0.7ppw 100ppw	ammonium chloride cupric sulfate distilled water	Crush cupric sulfate with mortar/pestle. Add all dry ingredients into water.	Mix thoroughly before each use.
2 **Sculpt Nouveau Japanese Brown**			Ready to use pre-mix, full strength.	Mix thoroughly before each use.
3	8.9ppw 100ppw	cupric sulfate distilled water	Crush cupric sulfate with mortar/pestle. Add dry ingredient into water.	Mix thoroughly before each use.
4 **Phosphoric acid solution (Pre-mix concentrate)**	1ppv 3ppv	phosphoric acid solution (35–45% phosphoric acid by volume) distilled water	Add phosphoric acid solution into water.	Mix thoroughly before each use.
5 **Sculpt Nouveau Dye Oxide Brown**			Ready to use pre-mix, full strength.	Mix thoroughly before each use.
6	4.2ppw 100ppw	cupric nitrate distilled water	Add dry ingredient into water.	Mix thoroughly before each use.
7	2.1ppw 100ppw	cupric nitrate distilled water	Add dry ingredient into water.	Mix thoroughly before each use.
8 **Birchwood Technologies Presto Black® BST4**	1ppv 0.5ppv	BST4 concentrate distilled water	Add liquid concentrate into water.	Mix thoroughly before each use.
9 **Birchwood Technologies Presto Black® BST4**			Ready to use pre-mix, full strength.	Mix thoroughly before each use.
10 **Sculpt Nouveau Dye Oxide Red**			Ready to use pre-mix, full strength.	Mix thoroughly before each use.
11 **Sculpt Nouveau Dye Oxide Orange**			Ready to use pre-mix, full strength.	Mix thoroughly before each use.
12 **Birchwood Technologies Aluma Black® A14**	1ppv 0.5ppv	A14 concentrate distilled water	Add liquid concentrate into water.	Mix thoroughly before each use.
13 **Sculpt Nouveau Dye Oxide Violet**			Ready to use pre-mix, full strength.	Mix thoroughly before each use.
14 **Sculpt Nouveau Dye Oxide White**			Ready to use pre-mix, full strength.	Mix thoroughly before each use.
15 **Sculpt Nouveau Dye Oxide Green**			Ready to use pre-mix, full strength.	Mix thoroughly before each use.
16 **Sculpt Nouveau Dye Oxide Blue**			Ready to use pre-mix, full strength.	Mix thoroughly before each use.
17 **Sculpt Nouveau Dye Oxide Yellow**			Ready to use pre-mix, full strength.	Mix thoroughly before each use.

RECIPE NUMBER/NAME	INGREDIENTS AS PARTS PER WEIGHT (PPW) OR PARTS PER VOLUME (PPV)		PREPARATION METHOD	NOTES
18 Sculpt Nouveau Dye Oxide Black			Ready to use pre-mix, full strength.	Mix thoroughly before each use.
19	0.8ppw	sulfurated potash (liver of sulfur)	Crush sulfurated potash with mortar/pestle. Add dry ingredient into water.	Mix thoroughly before each use. Solution has a short shelf life of 2–3 days; mix only the necessary quantity.
	100ppw	distilled water		
20	1.7ppw	sulfurated potash (liver of sulfur)	Crush sulfurated potash with mortar/pestle. Add dry ingredient into water.	Mix thoroughly before each use. Solution has a short shelf life of 2–3 days; mix only the necessary quantity.
	100ppw	distilled water		
21	2.5ppw	sulfurated potash (liver of sulfur)	Crush sulfurated potash with mortar/pestle. Add dry ingredient into water.	Mix thoroughly before each use. Solution has a short shelf life of 2–3 days; mix only the necessary quantity.
	100ppw	distilled water		
22	5.1ppw	sulfurated potash (liver of sulfur)	Crush sulfurated potash with mortar/pestle. Add dry ingredient into water.	Mix thoroughly before each use. Solution has a short shelf life of 2–3 days; mix only the necessary quantity.
	100ppw	distilled water		
23	0.8ppw	ferric nitrate	Add dry ingredient into water.	Mix thoroughly before each use.
	100ppw	distilled water		
24	1.7ppw	ferric nitrate	Add dry ingredient into water.	Mix thoroughly before each use.
	100ppw	distilled water		
25	15.6ppw	sodium chloride	Add all dry and liquid ingredients into water.	Mix thoroughly before each use. Wear safety goggles, respirator, and ensure adequate ventilation when using ammonium hydroxide and glacial acetic acid.
	12.5ppw	ammonium hydroxide (28–30% ammonium hydroxide by weight)		
	15.6ppw	ammonium chloride		
	12.5ppw	acetic acid, glacial (99.7% minimum acetic acid by volume)		
	100ppw	distilled water		
26	0.7ppw	ammonium chloride	Crush cupric sulfate with mortar/pestle. Add all dry ingredients into water.	Mix thoroughly before each use.
	7.6ppw	cupric sulfate		
	100ppw	distilled water		
27	25ppw	cupric sulfate	Crush cupric sulfate with mortar/pestle. Add cupric sulfate into water. Mix thoroughly. Add ammonium chloride to solution only when specified.	
	1000ppw	distilled water		
	0.5ppw	ammonium chloride		

COLORANT FORMULAS

RECIPE NUMBER/NAME	INGREDIENTS AS PARTS PER WEIGHT (PPW) OR PARTS PER VOLUME (PPV)		PREPARATION METHOD	NOTES
28	10ppw 20ppw 38.4ppw 40.2ppw 10ppw	cupric nitrate distilled water ammonia, household (5–10% ammonium hydroxide by weight) acetic acid/white vinegar (6% acetic acid by volume) ammonium chloride	Add cupric nitrate into water. Mix thoroughly. Add remaining ingredients into above solution in order given.	Mix thoroughly before each use. Wear safety goggles, respirator, and ensure adequate ventilation when using ammonium hydroxide.
29	1.6ppw 21.1ppw 100ppw	sulfurated potash (liver of sulfur) ammonium chloride distilled water	Crush sulfurated potash with mortar/pestle. Add all dry ingredients into water.	Mix thoroughly before each use. Solution has a short shelf life of 2–3 days; mix only the necessary quantity.
30 Ammonia, household (5–10% ammonium hydroxide by weight)			Ready to use pre-mix, full strength. Mix thoroughly before each use.	Wear safety goggles, respirator, and ensure adequate ventilation when using ammonium hydroxide.
31 Acetic acid/white vinegar (6% acetic acid by volume)			Ready to use pre-mix, full strength. Mix thoroughly before each use.	
32	2ppw 3.5ppw 100ppw	cupric acetate ammonium chloride distilled water	Add all dry ingredients into water.	Mix thoroughly before each use.
33	11ppw 11ppw 42.2ppw 44.3ppw 11ppw	cupric nitrate distilled water ammonia, household (5–10% ammonium hydroxide by weight) acetic acid/white vinegar (6% acetic acid by volume) ammonium chloride	Add cupric nitrate into water. Mix thoroughly. Add remaining ingredients into above solution in order given.	Mix thoroughly before each use. Wear safety goggles, respirator, and ensure adequate ventilation when using ammonium hydroxide.
34	20ppw 20ppw 100ppw	cupric nitrate sodium chloride distilled water	Add all dry ingredients into water.	Mix thoroughly before each use.
35	20ppw 100ppw	cupric nitrate distilled water	Add dry ingredient into water.	Mix thoroughly before each use.

RECIPE NUMBER/NAME	INGREDIENTS AS PARTS PER WEIGHT (PPW) OR PARTS PER VOLUME (PPV)		PREPARATION METHOD	NOTES
36	8ppw 100ppw 0.3ppw or 6 drops	cupric nitrate distilled water ammonia, household (5–10% ammonium hydroxide by weight)	Add all dry and liquid ingredients into water.	Mix thoroughly before each use. Wear safety goggles, respirator, and ensure adequate ventilation when using ammonium hydroxide
37 **Birchwood Technologies Antique Black® M24**			Ready to use pre-mix, full strength.	Mix thoroughly before each use.
38 **Birchwood Technologies Antique Black® M24**	1ppv 0.5ppv	M24 concentrate distilled water	Add liquid concentrate into water.	Mix thoroughly before each use.
39 **Birchwood Technologies Antique Black® M24**	1ppv 1ppv	M24 concentrate distilled water	Add liquid concentrate into water.	Mix thoroughly before each use.
40 **Birchwood Technologies Antique Brown™ M38**			Ready to use pre-mix, full strength.	Mix thoroughly before each use.
41 **Birchwood Technologies Antique Brown™ M38**	1ppv 0.5ppv	M38 concentrate distilled water	Add liquid concentrate into water.	Mix thoroughly before each use.
42 **Birchwood Technologies Antique Brown™ M38**	1ppv 1ppv	M38 concentrate distilled water	Add liquid concentrate into water.	Mix thoroughly before each use.
43 **Rokusho**	40ppw 14ppw 14ppw 1000ppw	cupric acetate calcium carbonate sodium hydroxide distilled water	Add all dry ingredients into water. Mix thoroughly. Cover and allow to rest undisturbed for 7 days. Filter precipitated rokusho through a coffee filter.	Store slightly moist rokusho in a lidded container until ready for use. Yields approx. 30ppw Rokusho.
44	5ppw 5ppw 1000ppw Small copper piece	cupric sulfate rokusho distilled water	Add clean, small copper piece to immersion tank with distilled water, unless vessel is copper. Crush cupric sulfate with mortar/pestle. Add cupric sulfate into water. Mix thoroughly. Add rokusho to the solution. Mix thoroughly.	Mix solution periodically during hot immersion process. Immersion solution has a typical life of 3–4 processes.
45	4ppw 1ppw 100ppw	cupric sulfate sodium chloride acetic acid/white vinegar (6% acetic acid by volume)	Crush cupric sulfate with mortar/pestle. Add all dry ingredients into acetic acid.	Mix thoroughly before each use.

RECIPE NUMBER/NAME	INGREDIENTS AS PARTS PER WEIGHT (PPW) OR PARTS PER VOLUME (PPV)		PREPARATION METHOD	NOTES
46	0.3ppw 100ppw	ammonium chloride distilled water	Add dry ingredient into water.	Mix thoroughly before each use.
47	0.3ppw 3ppw 100ppw	ammonium chloride cupric sulfate distilled water	Crush cupric sulfate with mortar/pestle. Add all dry ingredients into water.	Mix thoroughly before each use.
48	0.3ppw 3ppw 100ppw	ammonium chloride cupric acetate distilled water	Add all dry ingredients into water.	Mix thoroughly before each use.
49	5ppw 5ppw 1000ppw	cupric sulfate rokusho distilled water	Crush cupric sulfate with mortar/pestle. Add cupric sulfate into water. Mix thoroughly. Add rokusho to the solution. Mix thoroughly.	Mix solution periodically during hot immersion process. Immersion solution has a typical life of 3–4 processes.
50	25ppw 1000ppw	cupric sulfate distilled water	Crush cupric sulfate with mortar/pestle. Add cupric sulfate into water.	Mix thoroughly before each use.
51	5ppw 1000ppw	cupric sulfate distilled water	Crush cupric sulfate with mortar/pestle. Add cupric sulfate into water.	Mix thoroughly before each use.
52	3ppw 100ppw	ammonium chloride distilled water	Add dry ingredient into water.	Mix thoroughly before each use.
53	5ppw 10ppw 1000ppw Small copper piece	cupric sulfate rokusho distilled water	Add clean, small copper piece to immersion tank with distilled water, unless vessel is copper. Crush cupric sulfate with mortar/pestle. Add cupric sulfate into water. Mix thoroughly. Add rokusho to the solution. Mix thoroughly.	Mix solution periodically during hot immersion process. Immersion solution has a typical life of 3–4 processes.
54	5ppw 20ppw 1000ppw Small copper piece	cupric sulfate rokusho distilled water	Add clean, small copper piece to immersion tank with distilled water, unless vessel is copper. Crush cupric sulfate with mortar/pestle. Add cupric sulfate into water. Mix thoroughly. Add rokusho to the solution. Mix thoroughly.	Mix solution periodically during hot immersion process. Immersion solution has a typical life of 3–4 processes.

RECIPE NUMBER/NAME	INGREDIENTS AS PARTS PER WEIGHT (PPW) OR PARTS PER VOLUME (PPV)		PREPARATION METHOD	NOTES
55	5ppw 30ppw 1000pw Small copper piece	cupric sulfate rokusho distilled water	Add clean, small copper piece to immersion tank with distilled water, unless vessel is copper. Crush cupric sulfate with mortar/pestle. Add cupric sulfate into water. Mix thoroughly. Add rokusho to the solution. Mix thoroughly.	Mix solution periodically during hot immersion process. Immersion solution has a typical life of 3–4 processes.
56 **Distilled water**				
57 **Sculpt Nouveau Stainless Black**			Ready to use pre-mix, full strength.	Mix thoroughly before each use.
58 **Birchwood Technologies Aluma Black® A14**			Ready to use pre-mix, full strength.	Mix thoroughly before each use.
59	1ppw 9ppw 100ppw	ammonium chloride cupric sulfate distilled water	Crush cupric sulfate with mortar/pestle. Add all dry ingredients into water.	Mix thoroughly before each use.
60	9ppw 1ppw 100ppw	ammonium chloride cupric sulfate distilled water	Crush cupric sulfate with mortar/pestle. Add all dry ingredients into water.	Mix thoroughly before each use.
61 **Birchwood Technologies Presto Black® BST4**	1ppv 1ppv	BST4 concentrate distilled water	Add liquid concentrate into water.	Mix thoroughly before each use.
62 **Acetic acid, glacial (99.7% minimum acetic acid by volume)**			Ready to use pre-mix, full strength.	Wear safety goggles, respirator, and ensure adequate ventilation when using glacial acetic acid.
63 **Ammonium hydroxide (28–30% ammonium hydroxide by weight)**			Ready to use pre-mix, full strength.	Wear safety goggles, respirator, and ensure adequate ventilation when using ammonium hydroxide.

Glossary

ABRASIVE A compound worked over a metal surface to remove metal for functional cleaning or surface aesthetic purposes.

AIRBRUSH Type of sprayer using compressed air (or other compressed gas) to atomize and propel a substance.

AIR-FUEL TORCH A single gas flame torch using a flammable gas and atmospheric oxygen for combustion.

ALLOY Metal comprised of two or more pure elements.

ALUMINUM A soft, lightweight elemental metal with a whitish silver appearance.

ANNEALING Process of using heat to relieve internal stresses and hardness.

ANODIZING Electro-chemical process used for durable color dyeing of aluminum.

BINDER A substance mixed in a coating for adhesion to a material surface.

BRASS A copper alloy consisting primarily of copper and zinc, yellowish in color.

BRAZING A heat joining process using a dissimilar metal (with melting point above 840°F/450°C) to join two or more parent metals.

BRONZE A copper alloy traditionally consisting of copper and tin, but used to describe many copper-based alloys with a brownish color.

BRUSH APPLICATION An application method where the tool is loaded with colorant and physically touched to the metal surface.

BURNISH To mechanically abrade to remove some amount of surface color.

BURY APPLICATION A colorant application method where colorant-saturated absorbent material covers the metal surface.

CARRIER/VEHICLE The liquid component of a colorant or coating the solids are mixed into allowing for various application methods; can be solvent- or water-based.

CHEMICAL CLEANING Using an organic, acidic, or solvent-based chemical to remove light scale, oil, and grease from a metal surface.

CHEMICAL METAL PLATING A reactive process where two or more chemicals react with a parent metal, and deposit a thin layer of secondary metal chemically bound to the surface.

CLEARCOAT A transparent coating applied to a surface to seal and protect from oxidation and further surface color change.

COATING Any non-reactive layer applied to a metal surface that uses a binder for adhesion.

COLD APPLICATION Applying a colorant or coating to a metal surface without the use of heat.

COLD WORKING Bending, shaping, or manipulating metal without the use of heat.

COLD-ROLLED STEEL Steel that has been formed into shape and thickness at the steel mill via cold working processes, resulting in a silvery gray color.

COLOR QUALITY The overall coloration, value, and intensity of a surface resulting from raw metal color, reactive and non-reactive colorants, and coatings.

COLOR WHEEL A tool showing the 12 hues and harmonious color combinations.

COLORANT A product that adds color to a surface; can be either reactive or non-reactive.

COLORATION The result of coloring a surface.

COPPER A soft, elementary metal having a reddish orange color.

DENSITY The mass per unit volume of a substance.

DISTILLED WATER Water free of minerals and impurities.

DUCTILITY The ability of a metal to be worked in tension.

DYE A color particle that is soluble in its carrier, resulting in a translucent "tint" colorant.

ELEMENT A metal that is made of only one substance; aluminum, copper, and silver are examples.

ETCH To chemically remove surface metal.

FABRICATION The process of cutting, shaping, and joining material to create a form.

FINISHING The final aesthetic treatment of a metal surface; may include surface quality, color and/or protection.

FLAP DISC A wheel used on a power rotary tool with overlapping abrasive pieces.

FUME APPLICATION A reactive colorant application method where the fumes or vapors contact the metal surface to develop the colorations.

GLOSS Shiny; an option for many clearcoats and coatings.

GRINDING DISC An abrasive wheel for a power rotary tool considered to be the most aggressive for metal removal.

GRIT The designation of many abrasive wheels where the number correlates to the relative coarseness or fineness of the abrasive.

HAND SCOURING A manual abrading process to clean and roughen the surface of the metal.

HEAT OXIDATION/TEMPER COLORING Using a heat source to oxidize and color the metal; the color correlates to the metal composition and the temperature reached.

HOT APPLICATION A colorant application method where either the metal or colorant, or both, is heated.

HOT PICKLE BATH A chemical bath (typically acidic) used to clean certain metals of light scale, oil, and grease.

HOT WORKING A process of heating, and maintaining heat on a metal object to soften and make for easier bending and shaping.

HOT-ROLLED STEEL Steel that has been hot worked at the steel mill to create the desired shape and thickness, resulting in a bluish black surface color, or mill scale.

HUE The name for a color.

IMMERSION APPLICATION A colorant application method where the metal surface is partially or wholly dipped into the solution.

INERT A material that will not react with the compound it comes in contact with.

INTENSITY/SATURATION The purity of a color, determining its relative brightness.

LAYERING Multiple applications of colorant or coating; one on top of another.

LIQUID LATEX An air-curing rubber compound such as rubber cement or liquid frisket.

LOOSE COLORANT A colorant that has a vehicle, but no binder, resulting in a fragile, chalky substance that needs to be set with a fixative.

LUSTER Another name for shine.

MALLEABILITY A metal's ability to be hammered into shape, with compressive forces.

MASKING The process of blocking or resisting colorant from areas of the metal surface.

MATTE/FLAT A dull finish; an option with many coatings.

MECHANICAL CLEANING Process to physically remove surface contamination via abrasives; can be performed manually or with power tools.

MELTING TEMPERATURE The temperature or temperature range at which metals turn from solid to liquid.

METAL COATING A coating system consisting of a carrier, a binder, and actual suspended metal filings that can be applied to many materials; the metal filings are available for reactive colorations.

METAL COMPOSITION The specific ratio of all the elements that make up the metal or metal alloy.

MODULUS OF ELASTICITY A unit representing the stiffness of a metal.

MONOCHROMATIC Having only one color, or hue.

NON-REACTIVE A "what-you-see-is-what-you-get" colorant that uses a pigment or dye exclusively for the coloration.

OPAQUE Color that does not allow the underlying surface to be visible; most pigments are opaque.

OXIDATION A chemical reaction with a material surface and oxygen (atmospheric or other) resulting in a change of surface properties.

OXYGEN-FUEL TORCH A two-gas flame torch consisting of a flammable gas and pure oxygen, used for higher temperatures.

PAINT Typically an opaque, colored coating with a carrier and binder.

PARTICULATES Physical substance in the air such as dust.

PASTE WAX A translucent protective coating for surfaces resulting in a "soft luster" appearance.

PATINA Literally means to age; often used to describe the oxidation of metal surfaces, naturally or accelerated.

PIGMENT A color particle insoluble in its carrier, resulting in an opaque colorant.

PLASTICITY A property of metal referring to its ductility and malleability.

POLISHING An abrasive finishing process used to remove final scratches, or "tool" marks from a surface and bring about a high luster.

POWER BRUSHING A mechanical cleaning process using a bristle brush to remove loose scale, oxidation, and coloration from the metal surface.

PPV (parts per volume) A method to list ingredient ratios in terms of volume.

PPW (parts per weight) A method to list ingredient ratios in terms of weight.

REACTIVE A colorant that chemically affects the metal surface to develop the final coloration.

RUST A common name for the orange-brown oxidation of iron and steel.

SANDBLAST/MEDIA BLAST A mechanical cleaning method where abrasive particles are sprayed at high velocity through an air gun at a metal surface.

SANDING DISC A stiff paper disc with abrasive particles bonded to the surface used with a power rotary tool.

SATIN/SEMI-GLOSS A relative shine categorized between gloss and matte; an option with many coatings.

SCALE The oxidation layer formed with heating a metal surface.

SHADE Adding black to a color to decrease its value.

SOLDERING A heat joining process using a dissimilar metal (with melting point below 840°F/450°C) to join two or more parent metals.

SOLVENT-BASED A colorant or coating using a solvent as the carrier; often is quick to evaporate and dry.

SPECIFIC GRAVITY The ratio of the density of one substance to the density of water or air.

SPRAY APPLICATION Application methods where the colorant or coating is propelled onto the surface of the metal.

STAINLESS STEEL Steel often alloyed with chromium and nickel for resistance to oxidation; color is a bright, silvery gray.

STEEL A metal alloy of iron and carbon; is purchased as either cold-rolled or hot-rolled.

STERLING SILVER A silver alloy consisting of a very specific amount of pure silver, with an alloyed element.

STIPPLE A brush application using a dabbing motion on the surface to create a specific pattern with the colorant.

SURFACE QUALITY Refers to the texture and/or luster of the metal.

SYNTHETIC WOOL DISC A woven, abrasive plastic wheel used on a power rotary tool.

TARE To zero-out a weight scale.

TEMPER Degree of hardness; can refer to use of heat to alter the color or hardness of a metal.

TENSILE STRENGTH, ULTIMATE Amount of tensile stress required to cause a metal to fail.

TENSILE STRENGTH, YIELD Amount of tensile stress required to permanently deform a metal.

TINT Translucent color, or adding white to a color to increase its value.

TONE Adding gray to a color to decrease its value.

TOOTH The roughness of a metal surface as a result of using an abrasive tool.

TRANSLUCENT Not optically clear.

UNIFIED NUMBERING SYSTEM, UNS System for grouping metals and alloys based on composition.

VALUE The relative lightness or darkness of a color.

VERDIGRIS A blue-green coloration.

WATER-BASED A colorant or coating using water as its carrier; can use heat to speed up evaporation and drying.

WELDING A hot joining process where like metal is melted with like metal.

WORK HARDENING A build up of internal metal stress and resulting hardness that is often caused by cold working.

WRAP APPLICATION An application method where an absorbent cloth is saturated with colorant and laid upon the metal surface.

Index

Credits

The author would like to thank the following people and companies for their support during the writing of this book:

Atlas Metal Sales
Metalliferous
The Science Company

Morgan Cole for her incredible studio assistance.

Darlys Ewoldt for her insight into the world of jewelry and metalsmithing.

Sandra Stone for her never-ending encouragement throughout this process.

The author and publisher can accept no liability for the use or misuse of any materials mentioned in this book. Always read product labels and take all necessary precautions.

Quarto would like to thank the following artists, agencies, and manufacturers for supplying images for inclusion in this book:

Alex459, Shutterstock, p.27cr; Armstrong, Melody, www. melodyarmstrong.com, pp.15t, 21b, 36l; Bennett, Leonie, www. leoniebennett.co.uk, Photography by Agness Lugovska www.agness. co.uk, p.149b; Binnion, James, www.mokume-gane.com, Photography by Hap Sakwa, p.55br; Bjork, Ingvar, Shutterstock, p.31br; Bonner, Myia, www.myiabonner. co.uk, p.20t; Bréchault, Dominique, www.dbrechault.com, pp.16b, 20b ; Brown, Ruta www.rutabrown.com, p.17b; Bruford, Ann, www. annbrufordjewellery.com, p.18, 149t; Collier, J, http://jlcollier.com, p.113tr; Coprid, Shutterstock, p.28bc; Cox, Joanne, www.joannecox.co.uk, p.42b; Day, Sharon, Shutterstock, p.31tr; De Baecke, Jane, Photographs by the artist, janedebaecke2000@yahoo.com, pp.48t, 147t; DeVille, Julia, www. discemori.com, Photography by Terence Bogue, p.236t; Endeavor, Shutterstock, p.31cr; Ewoldt, Darlys, www.darlysewoldt.com, Photography by the artist, p.45tr; Feliks, Shutterstock, p.39cr; Fox, Katja, www.katjafox.com, p.16t; Freeman, Mishele, Loa Designs Loa Designs.com, p.178b; Gavran333, Shutterstock, p.28bc; Gent, Claire, http://folksy.com/shops/ clairegentdesign, p.21t; Hannon, Rebecca, www.rebeccahannon.com, p.15b; Hartley, Caren, www. carenhartley.com, p.178t; Holden, Sarah, www. sarahholdenmetalsmithing.com, Photography by Guy Nicol, www. guynicol.com, pp.111b, 112b; Huang, David, www.davidhuang. org, Photography by the artist, p.147b; Igor, Terekhov, Shutterstock, p.30bl ; Jautokas, Raminta, www. raminta.com, p.235b; Karst, Sarah, Sweet Harriet Design Co. www. sweetharriet.ca, p.177t; Kichigin, Shutterstock, p.38t; Kocetoiliev, Shutterstock, p.38c; Lagui, Shutterstock, p.39br; Leungchopan, Shutterstock, p.39tl M. Unal Ozmen, Shutterstock, p.31tc; Marziali, Lieta, www.lietamarziali.co.uk, p.19t McCallum, Amanda, www. furionstudios.com, p.177b; Mikadun, Shutterstock, p.38bl Newbrook, Jill, www.jillnewbrook.co.uk, p.235t; Noguchi, Yoko, p.234b; Nordling, Shutterstock, p.32bl; O'Rourke, Meghan, www. meghanorourkejewellery.com, pp.110b, 112t; Optionm, Shutterstock, p.39tr; Paganin, Barbara, paganinb@hotmail.com, pp.54tl, 237; Parady, Judy, www. judyparady.com, Photography by TW Meyer, p.146b; Pidd, Sharla, www.tidalwarejewelry.com, Photography by the artist, p.176b; Poupazis, Chris & Joy, www. cjpoupazis.com, p.19b; Rai, Julia, www.juliarai.co.uk, p.148t; Silky, Shutterstock, p.39cl; Spot-h, Shutterstock, p.31tl; Sumioka, Mariko, www.marikosumioka.com, pp.41, 207; Sutton Tools, www. suttontools.co.uk, p.33tr; Swan, Helen, www.hswanjewellery.co.uk, pp.14b, 37l, 47b; Talbot, Anna, www.annatalbot.com, p.17t; Tankist276, Shutterstock, p.28bl; Taras, Kompaniets, Shutterstock, p.39bl ; Tenenbaum, Joan, www. joantenenbaum.com, Photography by Doug Yaple, p.236b; Thakker, Salima, www.salimathakker.com, p.234t; The Rave 'N' Iron, Giselle Duval & Tim Andrew, www. theraveniron.com, pp.111t, 126-127; Tsimpiskaki, Maria, www. tsimpiskakimaria.com, p.179; Wabro, Karin, Shutterstock, p.38br; Waddington, Daniel, www. danielwaddington.com, p.176t; Warner, Carol, www.carolwarner. com, p.148b

All step-by-step and other images are the copyright of Quarto Publishing plc. While every effort has been made to credit contributors, Quarto would like to apologize should there have been any omissions or errors - and would be pleased to make the appropriate correction for future editions of the book.

Author's website
www.mattrunfola.com

SUPPLIERS

ATLAS METAL SALES
Distributor of non-ferrous metals
www.atlasmetals.com

BIRCHWOOD TECHNOLOGIES
Metal patina and finishing products
www.birchwoodtechnologies.com

BLICK ART MATERIALS
Art supplies
www.dickblick.com

HARBOR FREIGHT TOOLS
Discount tools
www.harborfreight.com

JAX CHEMICALS
Metal patinas and finishing products
www.jaxchemicals.com

MCMASTER-CARR
Industrial supply, metal
www.mcmaster.com

METAL SUPERMARKETS
Online metal sales
www.metalsupermarkets.com

METALLIFEROUS
Jewelry supply, metal
www.metalliferous.com

METALS DEPOT
Online metal sales
www.metalsdepot.com

RIO GRANDE
Jewelry supply, metal
www.riogrande.com

SCULPT NOUVEAU
Metal patina and finishing products
www.sculptnouveau.com

SKS BOTTLES
Bottles and containers
www.sks-bottle.com

THE SCIENCE COMPANY
Raw patina chemicals, measuring
www.sciencecompany.com